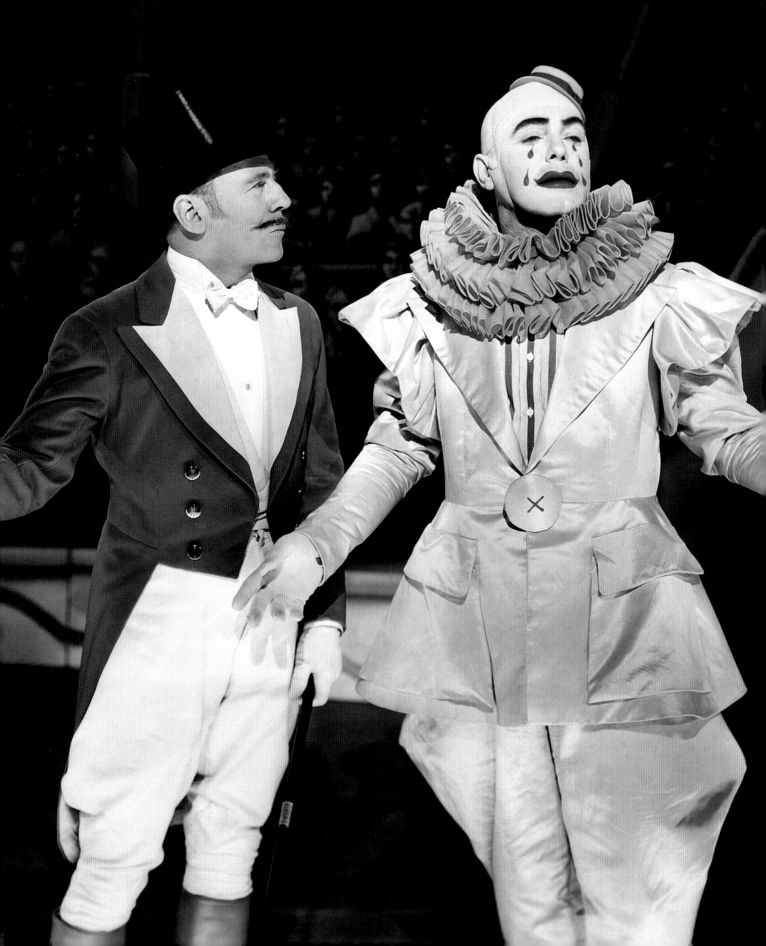

1000 CLOWNS
MORE OR LESS

A VISUAL HISTORY
OF THE AMERICAN CLOWN

DIE GESCHICHTE DES AMERIKANISCHEN CLOWNS IN BILDERN
L'HISTOIRE EN IMAGES DU CLOWN AMÉRICAIN

H. THOMAS STEELE

TASCHEN

KÖLN LONDON LOS ANGELES MADRID PARIS TOKYO

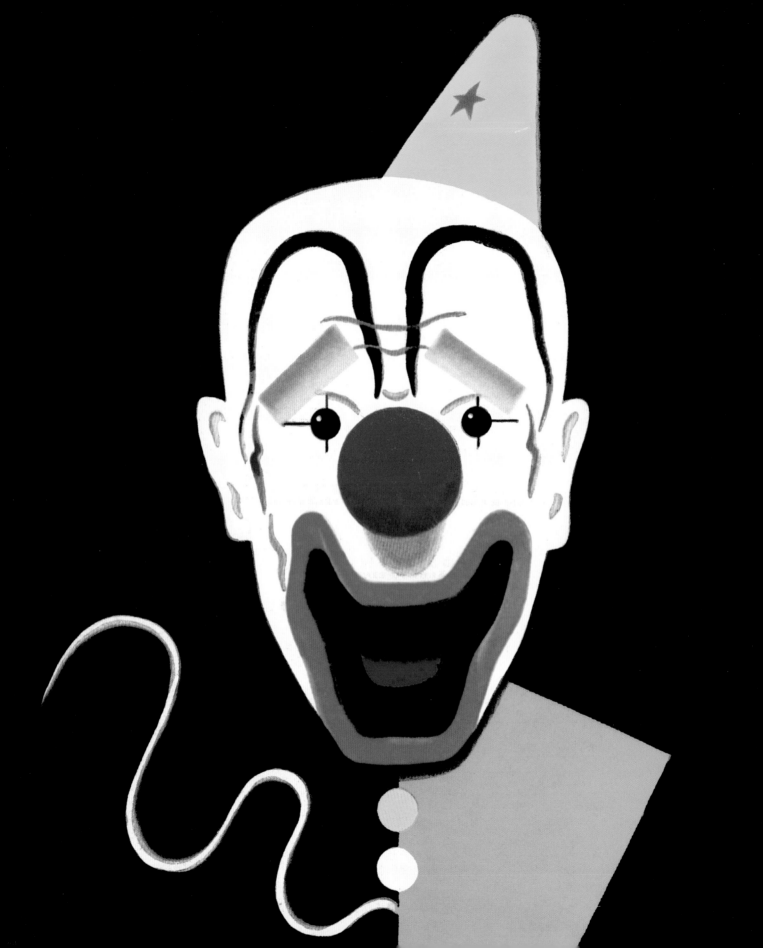

CONTENTS

8

INTRODUCTION
SEND IN THE CLOWNS / AUFTRITT DER CLOWNS / LES CLOWNS ... EN PISTE !

26

PHOTOGRAPHY
FOTOGRAFIE / PHOTOGRAPHIE

120

FILM & TELEVISION
FILM & FERNSEHEN / FILM & TÉLÉVISION

150

PAINTINGS
GEMÄLDE / PEINTURES

186

GRAPHICS
ILLUSTRATIONEN / GRAPHISMES

276

AMERICA'S CLOWNS
AMERIKAS CLOWNS / LES CLOWNS D'AMÉRIQUE

278

CLOWNS IN MOVIES
FILMCLOWNS / LES CLOWNS AU CINÉMA

280

CLOWN CODE OF ETHICS
DER VERHALTENSKODEX DER CLOWNS / CODE DE DÉONTOLOGIE DU CLOWN

DEDICATED TO ALL THE CLOWNS
WHO HAVE ENTERTAINED AND MADE US LAUGH,
AND TO MY DAUGHTERS, JANE AND ANNIE,
WHO STILL MAKE ME LAUGH.

To stay informed about upcoming TASCHEN titles, please request our magazine at
www.taschen.com or write to TASCHEN, Hohenzollernring 53, D–50672 Cologne, Germany,
Fax: +49-221-254919. We will be happy to send you a free copy of our magazine which is
filled with information about all of our books.

© 2004 TASCHEN GmbH
Hohenzollernring 53, D–50672 Köln
www.taschen.com

Editor: Jim Heimann, Los Angeles
Design: H. Thomas Steele & Cindy Vance, Modern Art & Design, Los Angeles
Cover design: Sense/Net, Andy Disl, Cologne
Prepress production: Cindy Vance, Modern Art & Design, Los Angeles
Production: Tina Ciborowius, Cologne
Project management: Sonja Altmeppen, Cologne
English-language editor: Nina Wiener, Los Angeles
German translation: Anke Caroline Burger, Berlin
French translation: Lien, Amsterdam

Printed in Spain
ISBN: 3–8228–2623–5

Cover: Circus program, detail, illustration by Roland Butler, 1936
Endpapers: Maquette for fabric design, 1950sx
Frontispiece: Decorative celluloid clown pin, 1930s
Page 2: Pat O'Brien with Ringmaster Roland Young in The Night of Nights, publicity still, 1939
Page 4: Illustration by graphic designer Edwin McKnight Kauffer, 1948
Page 5: Sterling silver brooch, 1930s
Page 6: Die-cut Valentine, 1930s

Page 7: Joe Coyle, producing clown (one who created the skits he performed) from
Chicago, photograph by Rialto, cabinet card, 1920s
Back cover: Clown pranksters (top, from left: Joe Sherman, Locke Lorraine, Ray Sinclair,
Javier Peluga, John Thomson, Johnny Cicillino, and Chester Sherman), publicity photograph,
ca. 1955

Umschlagvorderseite: Zirkusprogramm, Ausschnitt, Illustration von Roland Butler, 1936
Vorsatzpapier: Entwurf für ein Stoffmuster, 1950er Jahre
Frontispiz: Clownanstecker, 1930er Jahre
Seite 2: Pat O'Brien mit Zirkusdirektor Roland Young in The Night of Nights, Werbefoto, 1939
Seite 4: Illustration von Grafikdesigner Edwin McKnight Kaufer, 1948
Seite 5: Silberbrosche, 1930er Jahre
Seite 6: Glanzbild zum Valentinstag, 1930er Jahre
Seite 7: Joe Coyle, ein Clown aus Chicago, der alle seine Sketche selbst schrieb, Foto von
Rialto, Karte im Kabinettformat, 1920er Jahre
Umschlagrückseite: Zu Scherzen aufgelegte Clowns (oben, v. l.: Joe Sherman, Locke
Lorraine, Ray Sinclair, Javier Peluga, John Thomson, Johnny Cicillino und Chester Sherman),
Werbefoto, um 1955

Couverture: Programme de cirque, détail, illustration de Roland Butler, 1936
Pages de garde: Maquette pour un dessin d'étoffe, années 50
Frontispice: Epingle de revers ornementale en celluloïde, clown, années 30
Page 2: Pat O'Brien en compagnie du chef de piste Roland Young dans The Night of Nights,
photographie publicitaire, 1939
Page 4: Illustration de l'artiste graphique Edwin McKnight Kaufer, 1948
Page 5: Broche en argent, années 30
Page 6: Carte de Saint-Valentin découpée, années 30
Page 7: Joe Coyle, clown producteur de Chicago (qui créait les parodies qu'il présentait),
photographie de Rialto, carte format cabinet, années 20
Dos de couverture: Clowns farceurs (en haut, à partir de la gauche: Joe Sherman, Locke
Lorraine, Ray Sinclair, Javier Peluga, John Thomson, Johnny Cicillino et Chester Sherman),
photographie publicitaire, vers 1955

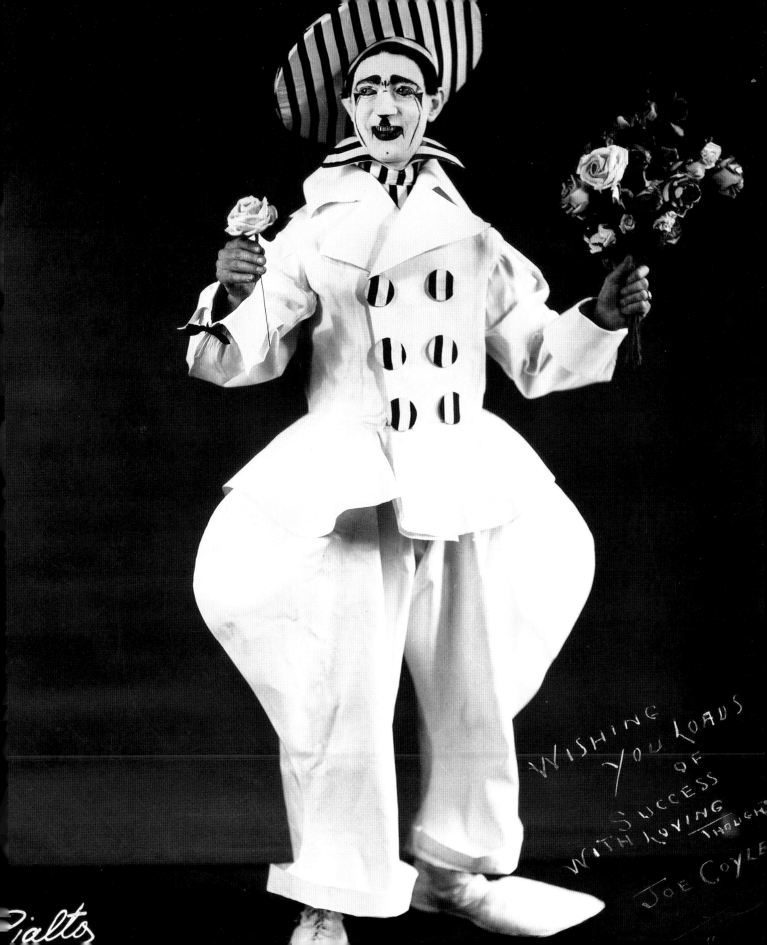

WISHING YOU LOADS
OF
SUCCESS
WITH LOVING THOUGHT

JOE COYLE

Rialto

SEND IN THE CLOWNS

Those with curious minds seek to decipher the soul that inhabits the body of the clown behind the façade of grotesque face makeup and colorfully outlandish costume. In equal parts comedy and tragedy, joy and pathos, practical joker and devilish prankster, the clown has long been a fixture, both embraced and feared, in American entertainment. From movie star Charlie Chaplin's endearing role in the silent film *The Circus* (1928) to the repulsive horror classic *Freaks* (1932), America's polarizing views of the archetypal jester have thrived in the popular imagination. Advertising, packaging, and television, especially in its early years, were rife with examples of clowns as pitchmen for everything from sugary candy to youthful roller skates to utilitarian car tires. Products sold well through the visual association of the clown as spokesperson. Advertisers reaped financial rewards using the clown's wholesome connection to childhood, even if the product was not so healthy after all, as seen in early cigarette ads.

The ubiquitous clown is not an exclusively American image. History shows us that humans have instinctively recognized the need to inject elements of comedy and caricature into the most sacred and mysterious of rituals. Clown-like figures appeared in ancient Greek theater, then later in Roman culture, and even in the North American Hopi Indian tribes of New Mexico as shamanistic priests. Kokopelli, whose shortened name

Koko may have inspired initial clown monikers, was a trickster from Native American mythology who loved to play pranks. Pygmy clowns entertained the court of Egyptian pharaohs around 2500 BC and the national hero Yu Sze was a jester of the Chinese emperor around 300 BC. The court jesters in feudal Europe represented a societal relief valve and collective conscience. These privileged scofflaws were granted immunity from reprisal by kings and bishops and given the freedom to speak the truth through their candid humor and parody, thereby subtly influencing court decision-making and public policies. The Italian troupe, the Commedia dell' Arte, which performed throughout Europe during the Middle Ages, undoubtedly influenced the lands it visited. In France, for instance, the patchwork-costumed Arlecchino inspired the argyle-patterned Arlequin (reinvented in England as Harlequin and Punch), the dreamy Pedrolino the white-faced Pierrot. The Elizabethan theater of Shakespeare showcased fools who recited sharp commentary on contemporary society in their performances. The Victorian actor, acrobat, and pantomimist, Englishman Joseph Grimaldi, left such a lasting legacy that clowns today are still known as "Joeys."

The classic, American three-ring circus actually originated in London in the mid-eighteenth century with Philip Astley's daring exhibition of trick horse riding in a single circular ring. Its popularity inspired his comedic version of the

act, called "Billy Buttons" or the "Tailor's Ride to Brentford," in which an inept equestrian tries to ride to an election, but spends more time falling off the horse than actually riding it. In America, a descriptive account of this heroic routine by the Dan Rice Circus (ca. 1880) in Hannibal, Missouri – featuring a drunken man weaving his way from the audience to the ring and interrupting the equestrian act, only to surprise viewers with his expert skills and instant sobriety – is chronicled in the American storyteller Mark Twain's evocative novel *The Adventures of Huckleberry Finn.*

The American clowns of the twentieth century provided the color and pageantry for the public drama of the circus, as immediately seen in their iconic images on programs and posters. While featured performers, animals and their trainers, and the ringmaster all readied their acts and organized their equipment in a darkened circus tent, clowns announced the beginning of the show, ushered audiences to their seats, stalled for time, and supplied comic diversion between scenes and set changes. Clowns rarely received top billing and were generally saddled with menial chores to help keep the show on the road, but they easily won the hearts of their audiences with their antics during show time.

The costume of the clown was influenced by the harlequin, as standardized by Grimaldi. Baggy pants hid assorted props and pointed hats served as spinning

tops or flying discs for a game of ringtoss, with tufted wigs adding to the comical sight. Acrobatic clowns wore tight-fitting clothes for their routines, based on the look and style of the medieval court jester. Whatever the cut of the cloth, its identifying elements remained consistent – exaggerated color and decoration, bright stripes, large polka dots, undulating frills around the neck, oversized bow ties, and floppy shoes – all the more visible under the roaming spotlights of the Big Top.

The French pantomimes, in the tradition of Gilles (an unmasked, white-costumed figure, who himself was a variant of the Pierrot mime), introduced their main comic characters in white face. This was originally achieved by the application of simple pastry flour and later, before the invention of grease paint, with a mixture of zinc oxide, lard, and an irritating tincture of benzoin. The ruddy cheeks of the English stage yokel were stylized by Grimaldi into neatly painted circles or triangles. In Germany, the clown was dubbed "Der dumme August" – "Stupid August". This is presumed to date back to a character invented and popularised some time around 1870 by the clown Tom Belling of Circus Renz. He exaggerated his clothes and makeup with a false nose, wide red mouth, short

pants, and undersized hats for a particularly zany appearance. His foil, the white-faced clown, played the haughty, pompous character who gave the orders, while the auguste became the embodiment of chaos and disorder. Stupid yet artful, misunderstanding requests, beaten, drenched with water, or pelted with pies, he emerged triumphant. Every major culture seemed to have borrowed from the rich European clown tradition: Russia, Poland, even Mexico with el payaso.

The American tradition gave birth to a new character, that of the hobo or tramp clown, a genre that originated in vaudeville theater. One of the greatest American clowns was Emmett Kelly, who created the character of the hobo clown known as "Weary Willie" during the Great Depression, coinciding with the failure of his marriage. With roots in the stories of real-life tramps or homeless people who spent their days traveling from place to place, stealing rides on cross-country trains, and begging food or small change for a living, Kelly's character was forlorn and melancholy, with a constant run of bad luck, but filled

Gentry Bros. Circus, poster detail, chromolithograph, ca.1920
Gentry Bros. Circus, Plakat (Ausschnitt) Chromolithographie, um 1920
Gentry Bros. Circus, détail de l'affiche, chromo, vers 1920

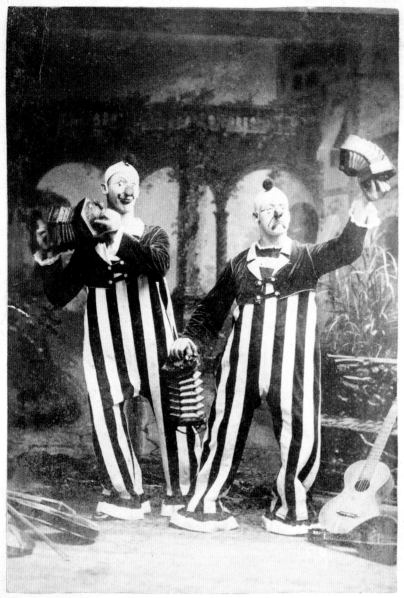

BOLOSSY KIRALFY'S COMBINATION.

HILL BROS., Photo. 30th ST. & BROADWAY, N. Y

with enormous optimism. He was the antithesis of circus clowns of his day, never smiling. His audiences steadfastly howled with laughter at his feigned incompetence, all the while personally identifying with his supposed misfortunes.

Famous clowns abound, especially the endearing ones with a style and routine unique to themselves: the acrobatic Paul Jung; the high-domed Lou Jacobs; the "King of Clowns" Felix Adler, with his jewel-encrusted false nose; and Otto Griebling with his sad-sack countenance. Emmett Kelly would try to open a peanut by obliterating it with a large mallet, only to discover dust in its wake. Bobby Kaye's long shirt gag ended in a cloth tube unfolding into an American flag that covered an entire circus ring. But it was the relatively anonymous clowns who entertained to preserve what was unique and celebrated about early twentieth-century America, in spite of world wars, economic depressions, and cultural shifts. These unsung heroes mirrored Everyman, keeping humor alive when it was needed most, allowing their audiences to laugh out loud at just plain silliness, forget troubles at home, and enjoy the vicarious thrill of a cream pie on someone else's face. Today they inspire nostalgia for a time when entertainment thrived, live in the flesh, rather than as simulated reality on a screen.

Musical clown act, cabinet card, ca. 1900
Musikalische Clownnummer, Kabinettkarte, um 1900
Numéro de clown musical, carte format cabinet, vers 1900

The increasingly popular medium of television in 1950s America provided the newest platform to appreciate one's favorite clowns: Bozo the Clown, an immensely popular television character, initially made famous as a recording artist for Capitol Records in 1949; Clarabell the Clown, the silent presence on a weekday afternoon television show featuring a marionette named Howdy Doody; and Chucko the Birthday Clown, popular with the after-school set. With television came advertising and the launch of the now-global fast-food icon, Ronald McDonald.

Behind the guffaws it is the clown's more sinister side that fascinates and terrifies many. The mystery of what lurks underneath the makeup and costumes cannot be ignored. Such fears, compounded by disturbing news coverage of flagrant bank robberies, burglaries, and other mayhem perpetrated by criminals in clown clothing, have spawned many a scenario in Hollywood. Actor Jimmy Stewart, usually cast in humble, husbandly roles, played a criminal clown in Cecil B. DeMille's cinematic epic *The Greatest Show on Earth* (1952). *Killer Klowns from Outer Space* (1988), although clearly B-movie material, likewise taps into the human psyche's deepest fear of clowns. For many children, clowns smack of panic, anxiety, and abject fear. Witness the Academy Award-

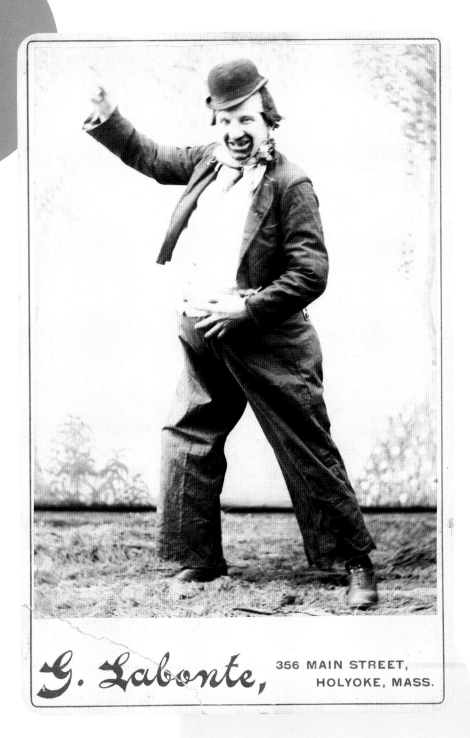

G. Labonte, 356 MAIN STREET, HOLYOKE, MASS.

Vaudevillian character, cabinet card, ca. 1900
Figur aus dem Vaudeville-Theater, Kabinettkarte, um 1900
Personnage de vaudeville, carte format cabinet, vers 1900

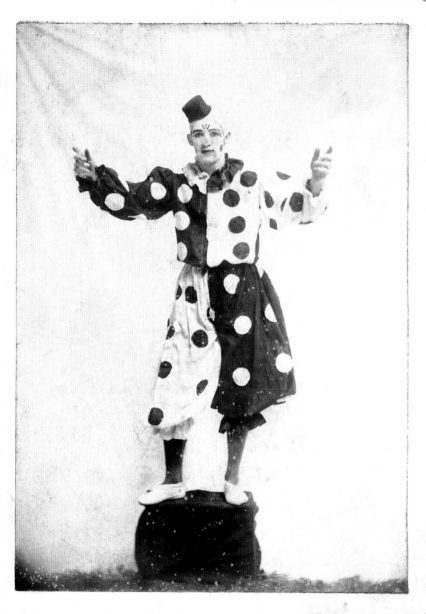

Maycraft

106 N. Main Street,
WICHITA.

nominated documentary film, *Capturing the Friedmans* (2003), which initially set out to record the phenomenon of birthday-party clowns in New York City and ended up profiling a pedophile. The makeup has also provided the perfect excuse to break social norms and indulge in anti-social behavior through characters like cartoonist Matt Groening's Krusty the Klown (Bart Simpson's afternoon idol) or Homey the Clown, an angry, black, ghetto clown portrayed by actor Damon Wayans in rancorous skits on the television show *In Living Color*. Behind the mask and the veneer of mean-spiritedness, both characters utter elements of truth that most people would leave unsaid. Stephen King's horror novel *It* (1990) relies on the even more extreme perception of clowns as creatures of terror. There is a well-documented neurotic fear of clowns – "coulrophobia" or "clownophobia" – sparked by a basic suspicion that grown people in strange clothes and weird makeup may, in fact, be more than just strange. After all, serial killer and registered clown John Wayne Gacy meant it literally when he said: "You know, clowns can get away with murder."

Harry Morrissey of the Coronado Minstrels, cabinet card, ca. 1906
Harry Morrissey von den Coronado Minstrels, Kabinettkarte, um 1906
Harry Morrissey du groupe Coronado Minstrels, carte format cabinet, vers 1900

▶ **Victorian cabinet card, 1910s**
Viktorianische Kabinettkarte, 1910er Jahre
Carte de l'époque victorienne, format cabinet, vers 1900

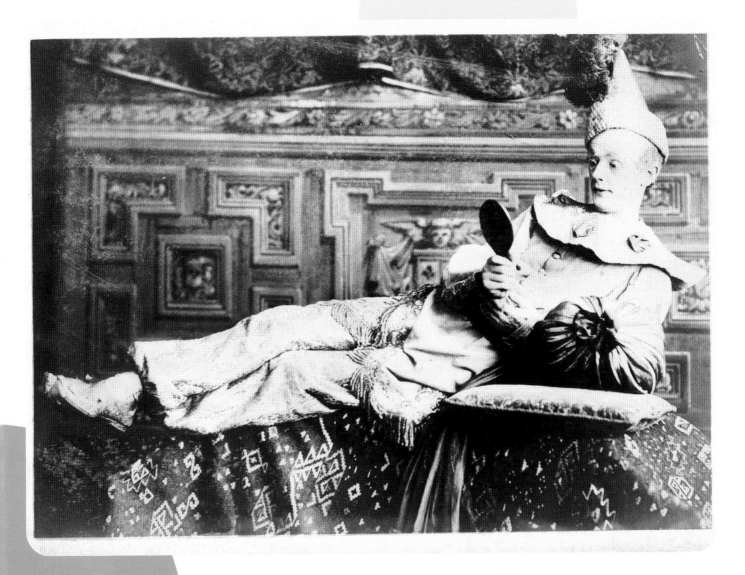

"DAMN EVERYTHING BUT THE CIRCUS!" – E. E. CUMMINGS

„AUSSER DEM ZIRKUS KANN ALLES ZUM TEUFEL GEHEN!" – E. E. CUMMINGS

« OUBLIEZ TOUT SAUF LE CIRQUE ! » – E. E. CUMMINGS

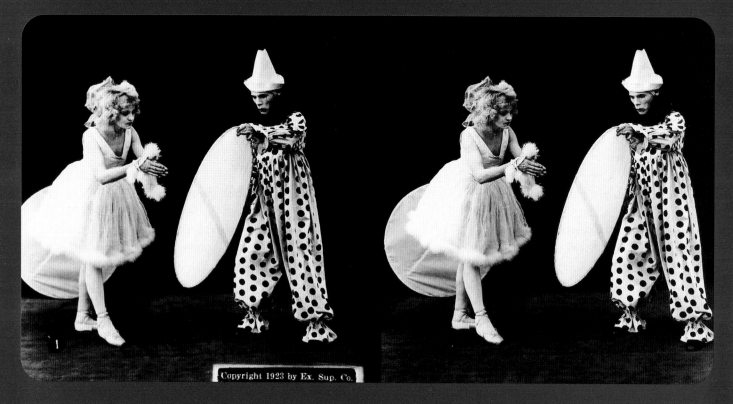

Copyright 1923 by Ex. Sup. Co.

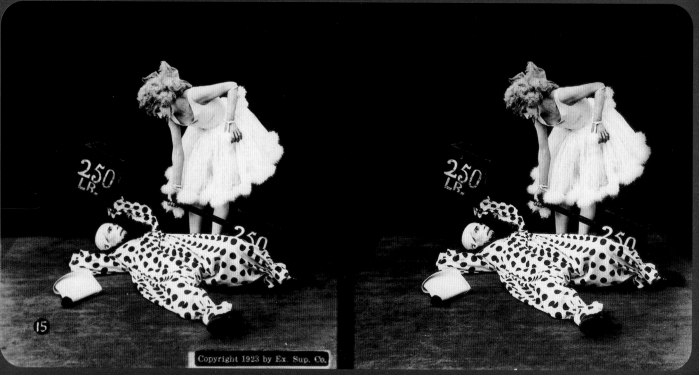

Copyright 1923 by Ex. Sup. Co.

Stereoscope cards, 1923.
Stereoskopische Karten, 1923
Cartes stéréoscopiques, 1923

AUFTRITT DER CLOWNS

Der Neugierige wünscht sich nichts mehr, als hinter der Fassade aus grotesker Schminke und farbenfroh-absurdem Kostüm die Seele zu erkennen, die den Körper des Clowns bewohnt. Der Clown, der Komödie und Tragödie, Spaß und Pathos verkörpert, ist eine der ältesten Figuren der amerikanischen Unterhaltung – geliebt und gefürchtet zugleich. Von dem liebenswerten Stummfilm *The Circus* (1928) bis zum abstoßenden Horrorklassiker *Freaks* (1932) haben die beiden völlig gegensätzlichen Seiten des archetypischen Spaßmachers die Fantasie Amerikas beschäftigt. In der Werbung, auf Verpackungen und im Fernsehen besonders der Anfangsjahre tauchten ständig Clowns als Fürsprecher für die unterschiedlichsten Produkte auf. Werbekunden profitierten von der gesunden Assoziation des Clowns mit der Kindheit, auch wenn das Produkt selbst in keiner Weise gesund war, wie im Falle der frühen Zigarettenwerbung.

Der allgegenwärtige Clown ist kein auf Amerika beschränktes Phänomen. Aus der Geschichte lässt sich erkennen, dass die Menschen instinktiv die Notwendigkeit erkannt haben, auch den heiligsten und geheimnisvollsten Ritualen einen komischen oder karikierenden Aspekt zu verleihen. Clowneske Figuren gab es im Theater der alten Griechen, später in der römischen Kultur und sogar bei nordamerikanischen Indianerstämmen wie z. B. den Hopi, wo sie als Schamanenpriester auftraten. Kokopelli – eine Bezeichnung, deren

Kurzform Koko möglicherweise frühe Clownsnamen inspiriert hat – war eine in vielen Indianermythen bekannte Trickster-Figur, die den Menschen gerne Streiche spielte. Pygmäenclowns unterhielten den Hof der ägyptischen Pharaonen bereits um 2500 v. Chr., und in China war der Nationalheld Yu Sze um 300 v. Chr ein Hofnarr des Kaisers. In der europäischen Feudalgesellschaft spielten die Hofnarren eine wichtige gesellschaftliche Rolle als Ventil der Volksmeinung. Diese Spaßmacher waren vor der Rache von Königen und Bischöfen geschützt und besaßen die Freiheit, auf subtile Weise die Wahrheit zu sagen und so die höfische Entscheidungsfindung und Sozialpolitik ein wenig zu beeinflussen. Die italienische Commedia dell'Arte, eine Stegreifkomödie, die im 16. und 17. Jahrhundert von Wandertruppen in ganz Europa aufgeführt wurde, nahm ganz zweifellos Einfluss auf die Kultur der jeweiligen Länder. In Frankreich diente der mit einem Flickenkostüm ausgestattete Arlecchino als Vorbild für den rautengemusterten Arlequin (der in England als Harlequin und Punch, Kasperle, umgedeutet wurde), aus dem verträumten Pedrolino wurde der weißgesichtige Pierrot. Im elisabethanischen Theater der Shakespeare-Zeit gab es immer Narrenfiguren, die beißende Kommentare zur damaligen Gesellschaft vortrugen. In England hinterließ der Schauspieler, Akrobat und Pantomime Joseph Grimaldi ein solch einflussreiches Erbe, dass Clowns dort heute immer noch als „Joeys" bekannt sind.

Der klassische amerikanische Drei-Manegen-Zirkus stammt ursprünglich aus London, wo Philip Astley eine gewagte Pferdeakrobatikschau präsentierte. Ihre große Beliebtheit führte zu einer komödiantischen Version der Schau, die „Billy Buttons" oder „The Tailor's Ride to Brentford" hieß, in der ein unfähiger Reiter versucht, zu einer Wahl zu reiten, aber mehr Zeit damit verbringt, vom Pferd zu fallen als darauf zu sitzen. Die plastische Schilderung einer Darbietung dieser Art im amerikanischen Dan Rice Circus (um 1880) in Hannibal, Missouri, ist in Mark Twains berühmtem Roman *Die Abenteuer des Huckleberry Finn* zu finden.

Die amerikanischen Clowns verliehen dem Zirkus Farbigkeit und Pomp, was sich an ihren ikonenhaften Abbildungen auf Programmen und Plakaten leicht ablesen lässt. Während Artisten und Dompteure sich auf ihre Nummern vorbereiteten und im verdunkelten Zirkuszelt die Requisiten zurechtlegten, wiesen Clowns den Zuschauern die Plätze an, füllten die Pausen und sorgten zwischen den Darbietungen und während der Szenenwechsel für Komik. Die Clowns wurden nur selten als Hauptattraktionen angepriesen und hatten im Alltag meist Handlangertätigkeiten auszuführen, um das fahrende Gewerbe am Laufen zu halten, aber während der Vorführungen eroberten sie die Herzen des Publikums im Fluge.

Das Clownskostüm wurde von dem durch Grimaldi modernisierten Harlekin beeinflusst. In weiten Pluderhosen ließen

Book, linen clothbound, 1924
Buch, Leineneinband, 1924
Livre, reliure en toile de lin, 1924

▶ **Photograph, 1908**
Fotografie, 1908
Photographie, 1908

sich diverse Requisiten verstecken, und spitze Hüte wurden als Kreisel oder Flugscheiben zweckentfremdet, wobei die büschelige Haarperücke den lustigen Eindruck noch verstärkte. Akrobatikclowns trugen bei ihren Vorführungen eng anliegende Kostüme, die dem des mittelalterlichen Hofnarren nachempfunden waren. Die übrigen Merkmale der Kleidung glichen sich: übertriebene Farben, bunte Streifen, große Punkte, weiße Halskrausen, überdimensionierte Fliegen und schlabberige Schuhe.

Die französischen Pantomimen in der Tradition des Gilles (eine ungeschminkte, weiß kostümierte Figur, die wiederum eine Variante des Mimen Pierrot war) führten das weiß geschminkte Gesicht ein. Dieses wurde anfänglich durch das Auftragen von Mehl erreicht und später, vor der Erfindung der Fettschminke, mit einer Mischung aus Zinkoxid, Schmalz und Benzointinktur. Die roten Backen des Bauerntrampels auf englischen Bühnen wurden von Grimaldi zu Kreisen oder Dreiecken stilisiert. In Deutschland bekam der Clown den Namen „Der dumme August" – er geht vermutlich auf eine Rolle zurück, die der Clown Tom Belling aus dem Zirkus Renz um 1870 erfand und populär machte. Mit falscher Knollennase, breitem roten Mund, kurzen Hosen und einem viel zu kleinen Hut besaß er ein besonders hanswurstiges Aussehen. Sein Gegenpart, der Weißclown, spielte die Rolle des Überheblichen, der die Befehle gab, während der

August für Chaos sorgte. Doof, aber gewitzt missverstand er sämtliche Anweisungen, wurde pitschnass gemacht oder mit Torten beworfen und triumphierte am Ende doch. Alle großen Kulturen scheinen Anleihen bei der vielschichtigen europäischen Clownstradition genommen zu haben.

Aus der amerikanischen Clowntradition entwickelte sich eine neue Figur, die des Hobo- oder Landstreicherclowns, ein im Vaudeville-Theater entstandenes Genre. Einer der Größten war Emmett Kelly, der während der großen Depression die Figur des fahrenden Clowns Weary Willie erschuf. Kellys Figur hatte ihre Wurzeln in den Geschichten von echten Landstreichern, die von einem Ort zum nächsten zogen, illegal in Güterzügen mitfuhren und von Erbetteltem lebten. Der Hoboclown wirkte verloren und melancholisch, hatte eine Pechsträhne nach der nächsten, war aber trotzdem von großem Optimismus erfüllt. Er war das krasse Gegenteil der damaligen Zirkusclowns und lächelte nie. Sein Publikum wollte sich vor Lachen über seine vorgebliche Unfähigkeit geradezu ausschütten und identifizierte sich doch zugleich auch mit seinen Schicksalsschlägen.

Berühmte Clowns, von denen viele einen ganz eigenen, liebenswerten Stil hatten, gab es viele: den akrobatischen Paul Jung, den eierköpfigen Lou Jacobs, Felix Adler, den „King of Clowns" mit seiner juwelenbesetzten falschen Nase, und

Otto Griebling mit seinem Trauerkloßgesicht. Emmett Kelly hatte eine Nummer, bei der er eine Erdnuss zu knacken versuchte, indem er mit einem großen Holzhammer darauf schlug und hinterher nur Staub übrig blieb. Doch es waren die relativ unbekannten Clowns, deren Späße das bewahrten, wofür das Amerika des frühen 20. Jahrhunderts berühmt war, trotz der Weltkriege, Wirtschaftskrisen und kulturellen Umwälzungen. Diese unbesungenen Helden hielten dem Jedermann einen Spiegel vor und den Humor am Leben, als er am nötigsten gebraucht wurde. Sie brachten das Publikum dazu, alle Sorgen zu vergessen. Heute erwecken sie nostalgische Erinnerungen an eine Zeit, in der die Live-Unterhaltung noch nicht durch die simulierte Realität auf der Mattscheibe verdrängt worden war.

Das Fernsehen, das in den fünfziger Jahren in den USA sehr schnell an Popularität gewann, bot den Clowns ein neues Medium: Bozo the Clown, eine ungemein beliebte Fernsehfigur, war ursprünglich mit Schallplattenaufnahmen für Capitol Records 1949 bekannt geworden. Clarabell, der schweigende Clown, begleitete mit seiner Marionette Howdy Doody das nachmittägliche Kinderprogramm, und Chucko the Birthday Clown war bei Jugendlichen besonders beliebt. Mit dem Fernsehen kam auch die Werbung und die Erfindung eines heute weltweit bekannten Fast-Food-Maskottchens namens Ronald McDonald.

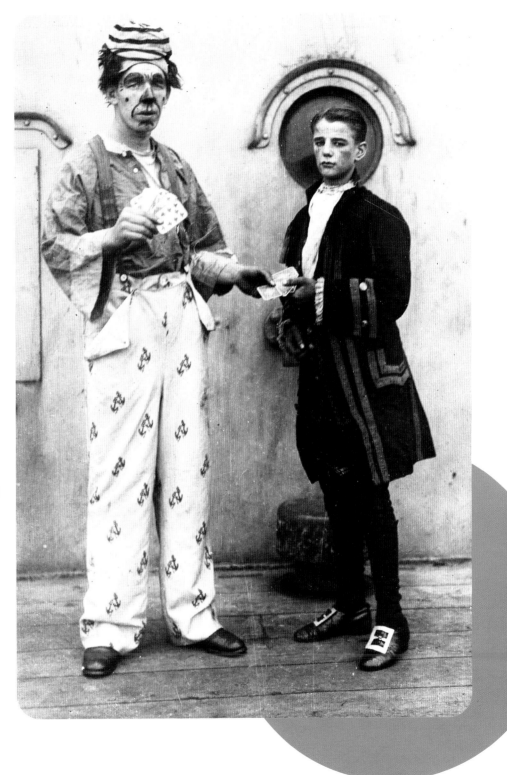

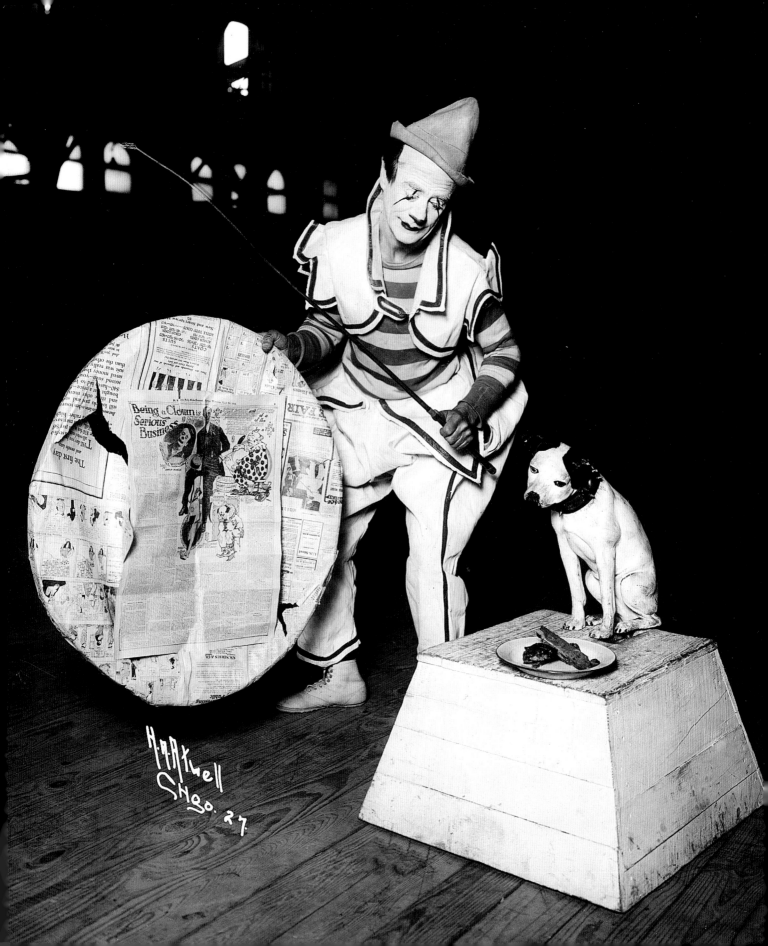

Es ist die eher finstere, hinter dem schallenden Gelächter verborgene Seite des Clowns, die viele Menschen fasziniert und ängstigt. Die Befürchtung, dass unter Schminke und Kostüm womöglich etwas ganz anderes lauern könnte, lässt sich nicht leugnen. Diese Ängste sowie aufwühlende Zeitungsberichte über Bankräuber, Einbrecher und andere Kriminelle in Clownsverkleidung haben viele Drehbuchschreiber in Hollywood angeregt. James Stewart, der für gewöhnlich als braver Ehemann besetzt wurde, spielte in Cecil B. DeMilles Leinwandepos *Die größte Schau der Welt (The Greatest Show on Earth,* 1952) einen kriminellen Clown. *Killer Klowns from Outer Space* (1988) mag zwar ein B-Film sein, spricht jedoch nicht minder die tief in der menschlichen Psyche verwurzelten Ängste an. Bei vielen Kindern lösen Clowns Panik aus. Man braucht sich nur den für einen Oskar nominierten Dokumentarfilm *Capturing the Friedmans* (2003) anzusehen, der anfangs das Phänomen der vielen Kindergeburtstagsclowns in New York porträtieren wollte und mit der Darstellung eines Pädophilen endet. Hinter der dicken Schminke ist es leicht, gesellschaftliche Normen zu durchbrechen und zu verletzen. Beispiele dafür sind Figuren wie Krusty the Klown von Zeichner Matt Groening (Bart Simpsons Fernsehheld) oder Homey the Clown, ein zorniger schwarzer Ghettoclown, der in wüsten Sketchen bei der Fernsehshow *In Living Color* von Schauspieler Damon Wayans verkörpert wird. Beide Figuren geben Wahrheiten zum Besten, die die meisten Menschen nicht aussprechen würden. Stephen Kings Horrorroman *Es* (1990) steht für die noch extremere Sichtweise von Clowns als Figuren des Grauens. Es gibt eine viel dokumentierte neurotische Angst vor Clowns – in den USA als „coulrophobia" oder „clownophobia" bekannt –, die von dem Verdacht genährt wird, dass erwachsene Menschen in komischer Clownsaufmachung womöglich mehr als merkwürdig sind. Immerhin meinte es John Wayne Gacy, Serienmörder und Clown, tödlich ernst, als er sagte: „Wissen Sie, Clowns kommen sogar mit Mord durch."

Arthur Borello, Sells-Floto Circus' head clown, photograph by Atwell, 1927
Arthur Borello, Hauptclown des Sells-Floto Circus, Fotografie von Atwell, 1927
Arthur Borello, le clown vedette du cirque Sells-Floto, photographie d'Atwell, 1927

LES CLOWNS ... EN PISTE !

L'esprit curieux cherche à découvrir l'âme dissimulée derrière le maquillage grotesque et le costume bariolé du clown. A la fois comique et tragique, joyeux et pathétique, blagueur et malicieux, le clown a toujours été un personnage familier mais craint de la culture américaine. De la star Charlie Chaplin, irrésistible dans son rôle dans le film muet *Le Cirque* (1928), au répugnant classique de l'horreur *Freaks* (1932), ces représentations diamétralement opposées de l'archétype du bouffon ont trouvé un terrain fertile dans l'imaginaire américain. La publicité, les emballages et la télévision, surtout à ses débuts, affichaient toutes sortes de clowns faisant de la réclame pour n'importe quoi, des bonbons aux patins à roulettes en passant par les pneus de voitures. Les produits se vendaient bien grâce à leur association avec l'image du clown. Les publicitaires faisaient de gros profits en exploitant le lien entre l'enfance et le clown même si, après tout, le produit n'était pas très recommandable, comme on le voit dans les premières publicités pour les cigarettes.

L'omniprésence du clown n'est pas un concept exclusivement américain. L'histoire nous montre que les hommes ont toujours éprouvé le besoin d'introduire des éléments de comédie et de caricature dans leurs rituels les plus mystérieux et les plus sacrés. Il y avait déjà un genre de clown dans le théâtre de la Grèce ancienne, puis plus tard chez les Romains et même chez les tribus nord-américaines des indiens Hopi du Nouveau-Mexique où il occupait la fonction de shaman – Kokopelli, dont le diminutif Koko est peut-être à l'origine des premiers noms de clowns, était un bouffon de la mythologie indienne qui adorait jouer des tours. Des clowns pygmées divertissaient la cour des pharaons égyptiens vers 2 500 avant J.C. et le héros national Yu Sze était le fou de l'empereur de Chine vers 300 avant J.C. Les fous du roi de l'Europe féodale étaient une soupape pour la société en incarnant la conscience collective. Ces bouffons privilégiés bénéficiaient d'une immunité contre les représailles, qui leur avaient été accordée par les rois et les évêques ainsi que le droit de dire la vérité par leur humour direct et par leurs parodies, influençant subtilement les édits de la cour et les mœurs du temps. La troupe italienne la Commedia dell Arte en donnant des représentations à travers toute l'Europe au Moyen Age a eu une influence incontestable sur les pays qu'elle traversa. En France, par exemple, Arlecchino et son costume de patchwork inspira l'Arlequin au costume à losanges (repris en Angleterre sous le nom de Harlequin et Punch) et le rêveur Pedrolino celui de Pierrot au visage blanc. Dans le théâtre élisabéthain de Shakespeare, des bouffons récitaient des pamphlets cinglants sur la société de l'époque. L'acteur victorien anglais Joseph Grimaldi, acrobate et pantomime, laissa une telle empreinte que, aujourd'hui encore, les clowns sont appelés des «Joeys».

Le cirque américain classique à trois pistes est originaire de Londres, au milieu du XVIIIe siècle, où Philip Astley exécutait un numéro périlleux de voltige équestre sur une piste ronde. Son succès inspira une version comique du numéro, appelée «Billy Boutons» ou «La chevauchée du tailleur pour Brentford», dans laquelle un cavalier maladroit se rendant à une élection passe le plus clair de son temps à tomber de son cheval plutôt que de le chevaucher. En Amérique, le récit détaillé d'une représentation par le cirque Dan Rice (vers 1880) à Hannibal, Missouri – avec un ivrogne se frayant un passage dans le public jusqu'à la piste où il interrompait le numéro équestre pour surprendre les spectateurs par sa dextérité et sa sobriété soudaine – est rapporté par Mark Twain, le conteur d'histoires américain, dans son roman évocateur «Les aventures de Huckleberry Finn». Les clowns du XXe siècle ont introduit la couleur et le faste dans les spectacles de cirque, comme le montrent les affiches et les programmes. Pendant que les artistes vedettes, les animaux et leurs dresseurs et le chef de piste se préparaient et installaient leurs équipements dans l'obscurité du chapiteau, les clowns annonçaient le spectacle, accompagnaient les spectateurs jusqu'à leurs sièges, gagnaient du temps et offraient une diver-

Emmett Kelly playing a game of solitaire, photograph, 1940s
Emmett Kelly spielt Solitär, Fotografie, 1940er Jahre
Emmett Kelly faisant une patience, photographie, années 40

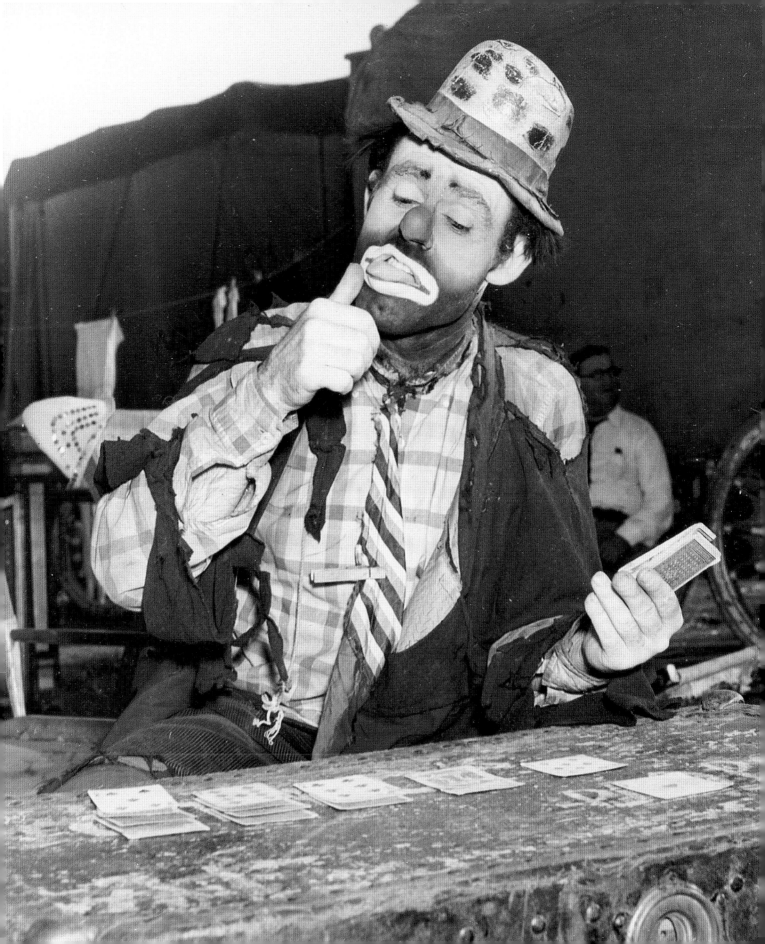

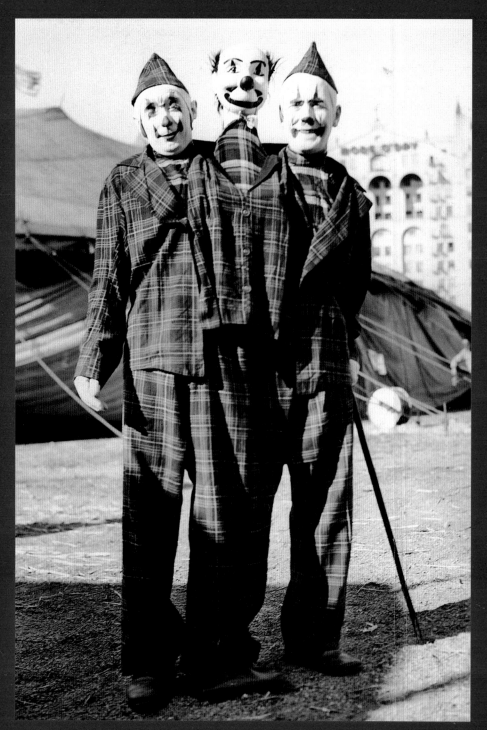

sion comique entre les changements de décors ou de numéros. Rarement bien payés, les clowns se chargeaient des basses besognes pendant la tournée, mais ils volaient le cœur du public par leurs pitreries pendant le spectacle.

Le costume du clown s'est inspiré de celui de l'Arlequin tel que Grimaldi l'avait défini. Le pantalon bouffant cachait les accessoires indispensables et le chapeau pointu tournait ou servait de disque volant dans le jeu du lancer des anneaux, avec des touffes de cheveux rajoutées pour créer un effet comique. Les clowns acrobates portaient des vêtements près du corps, imitant l'allure et le style du fou médiéval. Quelle que soit la forme du vêtement, ses éléments caractéristiques restaient les mêmes — exagérément coloré et décoré, des raies voyantes, des gros pois, une fraise autour du cou, un nœud papillon trop grand et des chaussures molles —, d'autant plus visibles sous les faisceaux des projecteurs du Grand Chapiteau.

Les pantomimes français, dans la tradition du Gilles (un personnage sans masque en costume blanc, lui-même une variante du Pierrot) se blanchissaient la face pour accentuer l'effet comique. A l'origine, les visages étaient blanchis par application de simple farine blanche puis plus tard, avant l'invention du fard gras, d'un mélange d'oxyde de zinc, de lard et d'une teinture de benjoin irritante. Grimaldi stylisa les joues rouges du pay-

san du théâtre anglais par des cercles et des triangles précisément appliqués. En Allemagne, le clown fut surnommé « Der dumme August » (Auguste le stupide). Ce nom remonte certainement à un personnage inventé en 1870 et rendu populaire par le clown Tom Belling du cirque Renz. Avec un faux-nez, une large bouche rouge, des pantalons trop courts et un chapeau trop petit, son effet était particulièrement cocasse. Son repoussoir, le clown blanc, tenait le rôle du personnage hautain et pompeux qui donnait les ordres, tandis que l'Auguste symbolisait le chaos et le désordre. Stupide mais habile, ne comprenant pas ce qu'on lui demandait, battu (aspergé d'eau ou recevant des tartes), il triomphait. On retrouve des éléments de la riche tradition européenne du clown dans toutes les grandes cultures : la Russie, la Pologne et même le Mexique avec son *el payaso*.

La culture américaine donna naissance à un nouveau personnage, celui du hobo ou clown vagabond, un personnage qui vient du vaudeville. L'un des plus grands clowns américains, Emmett Kelly, créa le personnage du clown vagabond « Weary Willie » pendant la Grande Dépression, au moment où son mariage se soldait par un échec. Prenant ses racines dans les histoires des véritables vagabonds et des sans-logis qui voyageaient de place en place, traversant le pays en train comme passagers clandestins et mendiant de la nourriture ou de petites pièces de mon-

naie, le personnage de Kelly était solitaire et mélancolique, jouant toujours de malchance mais rempli d'un inlassable optimisme. Ne souriant jamais, il était l'antithèse des clowns de cirque de son temps. Son public ne manquait jamais d'hurler de rire à sa fausse maladresse tout en s'identifiant à ses prétendus malheurs.

Il y a beaucoup de clowns célèbres, particulièrement ceux qui nous sont chers par leur propre style et leur numéro unique : Paul Jung l'acrobate ; Lou Jacob et son haut chapeau ; le « roi des clowns » Felix Adler et son faux nez incrusté de pierreries ; Otto Griebling et son allure de sac à pommes de terre. Emmett Kelly voulait ouvrir une cacahuète avec un maillet pour découvrir à la fin qu'il ne restait plus que de la poussière. Bobby Kane et sa longue chemise dont le gag final était un long tube de tissu se déployant en un drapeau américain recouvrant toute la piste. Mais c'était les clowns relativement peu connus qui, en continuant à faire leurs numéros, préservaient ce qui était unique et adulé de l'Amérique du début du XX^e siècle, en dépit des deux guerres mondiales, des crises économiques et des changements culturels. Ces héros méconnus incarnaient monsieur tout le monde, gardaient l'humour bien vivant dans les situations les plus difficiles et donnaient au public l'occasion de rire à gorge déployée aux blagues les plus bêtes, d'oublier leurs soucis et de se réjouir d'envoyer par personne interposée une tarte à la crème à la

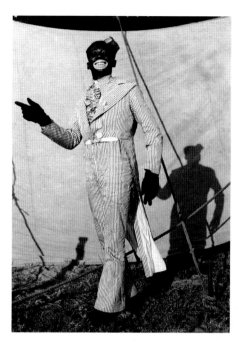

Blackface clown, photograph, 1930s
,,Blackface"-Clown, Fotografie, 1930er Jahre
Clown maquillé en Noir, photographie, années 30

◀ Three-headed clown, informal snapshot, 1950s
Clown mit drei Köpfen, Amateurschnappschuss, 1950er Jahre
Clown à trois têtes, instantané informel, années 50

tête d'un d'autre. Aujourd'hui ces clowns nous remplissent de nostalgie pour une époque où le divertissement était bien vivant au lieu d'être une imitation de la réalité sur le petit écran.

La télévision, de plus en plus populaire dans l'Amérique des années 50, fournit un nouveau moyen de voir ses clowns préférés : Bozo le Clown, un personnage de télévision d'une immense popularité, déjà connu comme artiste exécutant pour Capitol Records en 1949 ; le clown Clarabelle, la présence silencieuse aux côtés de la marionnette Howdy Doody des après-midi de semaine ; et Chucko le clown des anniversaires, l'idole des enfants qui rentraient de l'école. La télévision amena la publicité et le lancement du symbole du fast-food à travers le monde, Ronald McDonald.

Derrières les éclats de rire, c'est le côté inquiétant du clown qui fascine et terrifie. On ne peut ignorer le mystère qui se cache derrière le maquillage et le cos-tume. De telles peurs, alimentées par la presse relatant des braquages de banques, des cambriolages et autres délits perpé-trés par des criminels habillés en clowns, ont inspiré plus d'un scénario à Hollywood. L'acteur Jimmy Stuart, habi-tuellement jouant des rôles de mari, était un clown criminel dans la grande épopée cinématographique *Sous le plus grand chapi-teau du monde* (1952). *Les Clowns tueurs venus d'ailleurs* (1988), bien qu'un film de série B, n'en exploite pas moins la peur profonde des clowns dans la psyché humaine. Chez beaucoup d'enfants, le clown suscite la panique, l'anxiété et la peur abjecte. Preuve s'il en est, le docu-mentaire nominé aux Oscars *Capturing the Friedmans* (2003) commence par une étude sur le phénomène des clowns de fêtes d'anniversaire à New York et se ter-mine par le portrait d'un pédophile. Le maquillage est aussi l'alibi parfait pour enfreindre les normes de la société et adopter une attitude antisociale, comme le fait le personnage de Matt Groening, Krusty the Klown (l'idole des après-midi de Bart Simpson) ou Homey, un clown Noir révolté venant du ghetto, joué par l'acteur Damon Wayans, et dont les sketchs douteux apparaissaient dans le show télévisé *In Living Color*. Derrière le masque de la méchanceté, les deux carac-tères assènent des vérités que la plupart des gens préféreraient ne pas entendre. Le roman de Stephen King « Ça » (1990) pré-sente la plus terrifiante image d'un clown. La peur des clowns, une névrose très bien documentée – la « coulrophobie » ou « clownophobie » – est basée sur la méfiance instinctive pour des adultes maquillés et habillés bizarrement et la sus-picion qu'ils peuvent, en fait, dissimuler autre chose derrière leur étrangeté. Après tout John Wayne Gacy, tueur en série et clown accrédité, parlait en connaissance de cause lorsqu'il disait : « Vous savez, les clowns peuvent commettre un meurtre en toute impunité. »

Musical songbook, 1893
Musik-Liederbuch, 1893
Recueil de chansons, 1893

THE CLOWN'S BIG SONG BOOK

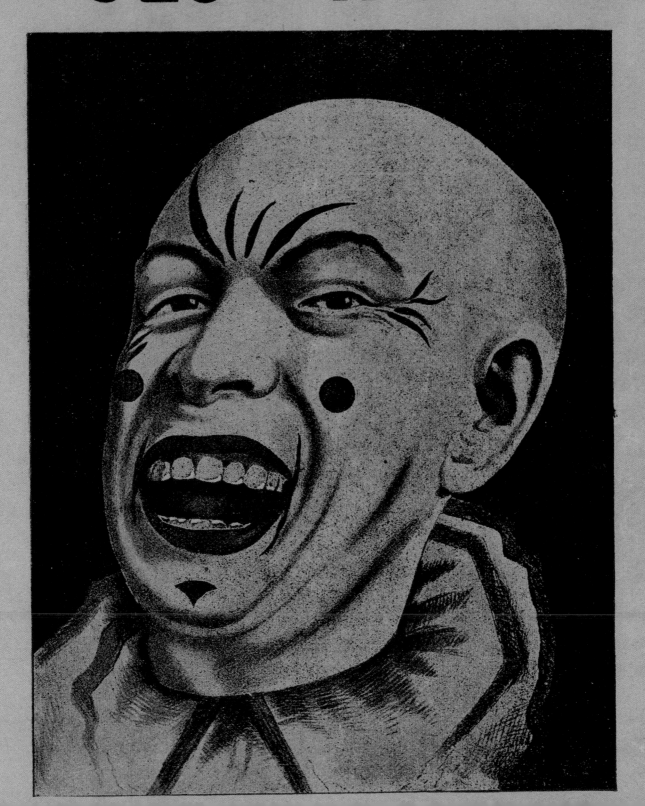

PHOTOGRAPHY

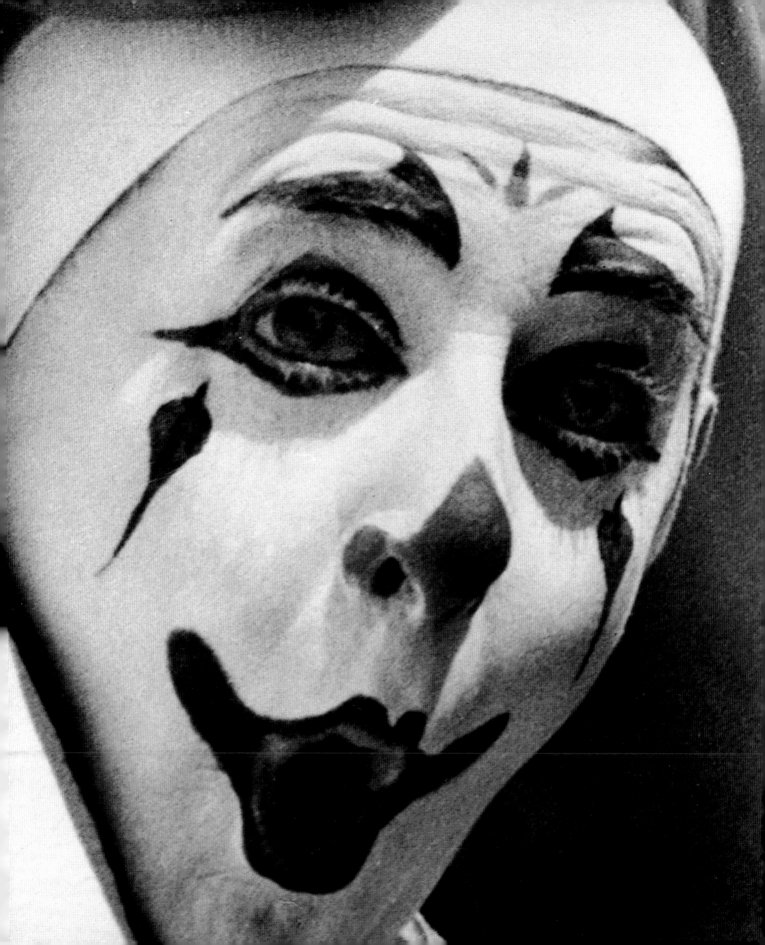

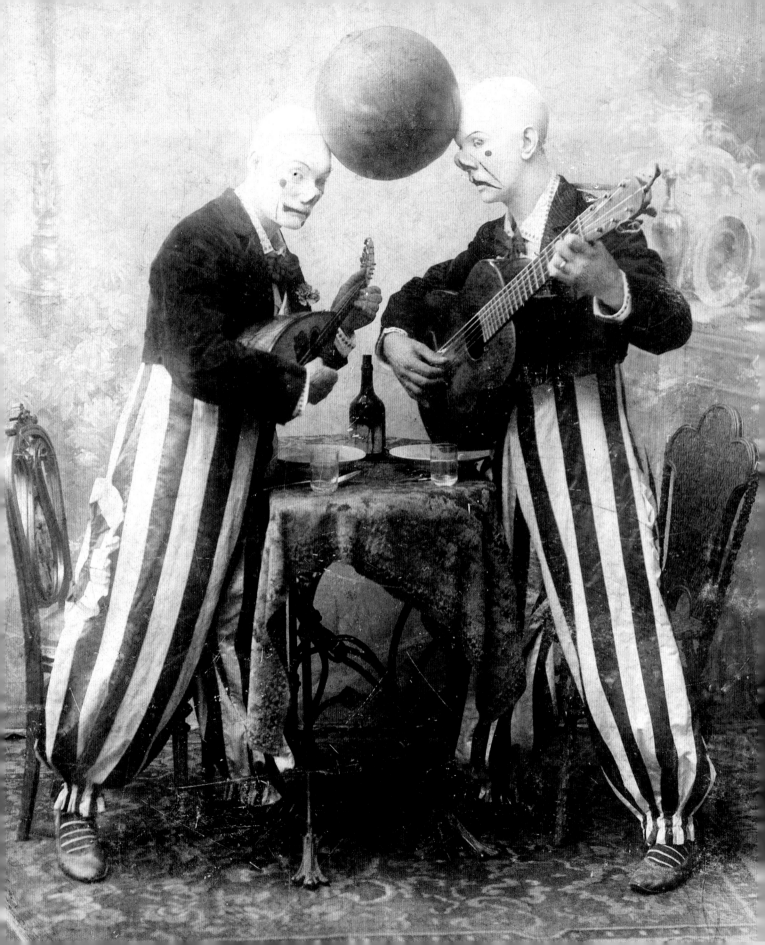

PHOTOGRAPHY

As photography came into its own at the turn of the twentieth century, professional and amateur photographers alike captured the essence of the colorful circus scene, primarily in simple black-and-white. A far cry from the early studio sittings of staid Victorian families and proper, small-town politicians, the animated subjects created flamboyant portraits for the lens. Rather than merely snapping a picture, photographers began to study expressions, and clowns were the perfect subject. Their candid demeanor relieved photographers from a repertoire of stiffly posed people and static landscapes. Clowns came with wild props, shiny instruments, and small animals to provide variety and spontaneity.

Capturing their routines on film ensured audience familiarity. In the decades to follow, it was the publicity stills clowns handed out to young fans or candid snapshots with admirers after the show that earned them a loyal audience. Many clowns, including Emmett Kelly, Lou Jacobs, and Felix Adler among others, became celebrities in their own right because of the popularity and expanded usage of the camera. The notable lensman Weegee actually donned a clown costume to inhabit and record on film the world of the circus from the inside. The picture magazine *Life*, as well as other periodicals of the 1940s, frequently used editorial space to cover the American circus environment.

Photography also captured the myriad personalities of the thousands of working clowns in America. No two clowns' make-up was ever the same, as it went against circus etiquette to copy another clown's facial creation. Their distinctive styles, individual designs, and endless array of costumes created unique characters who became indelibly etched into popular culture through photographs. No medium was more successful than photography at capturing the everyday or anonymous clown, the exaggerated smile or overstated frown, and the depths of human emotion expressed explicitly and implicitly each time a clown put on his mask of makeup and grease paint.

◄◄ Photograph, detail, 1940s
Fotografie, Ausschnitt, 1940er Jahre
Photographie, détail, années 40

◄ Musical clowns, cabinet card, ca. 1908
Musizierende Clowns, Kabinettkarte, um 1908
Clowns musicaux, carte format cabinet, vers 1908

FOTOGRAFIE

Als sich die Fotografie um 1900 zu einem eigenständigen Ausdrucksmittel entwickelte, versuchten Profi- und Amateurfotografen das Wesen der bunten Zirkusszenerie zu erfassen, zumeist noch in Schwarz-Weiß. Weit entfernt von den frühen Atelieraufnahmen steifer viktorianischer Familien und wohlanständiger Lokalpolitiker gelangen außergewöhnliche Porträts dieser bewegten Motive. Statt nur einen Schnappschuss zu machen, begannen die Fotografen jetzt, die menschliche Mimik genauer zu studieren, und Clowns waren dafür perfekt geeignet. Der freimütige Blick des Spaßmachers ersparte dem Fotografen die üblichen steif posierenden Menschen und statischen Landschaf-

ten. Clowns besaßen unglaubliche Requisiten, glänzende Musikinstrumente und kleine Tiere, die allesamt für Abwechslung sorgten. Ihre Nummern auf Film zu bannen, verstärkte ihre Bekanntheit beim Publikum. In den folgenden Jahrzehnten waren es die von den Clowns an ihre kleinen Fans verteilten Starfotos oder die Schnappschüsse mit Bewunderern, die für eine treue Anhängerschaft sorgten. Viele Clowns, darunter Emmett Kelly, Lou Jacobs und Felix Adler, wurden auf diesem Wege zu unverwechselbaren Stars. Der bekannte Fotoreporter Weegee legte sogar selbst ein Clownskostüm an, um die Zirkuswelt von innen kennen lernen und aufnehmen zu können. Die Fotoillustrierte *Life* und andere widme-

ten ihre Seiten in den vierziger Jahren regelmäßig dem amerikanischen Zirkus.

Auf Fotografien wurden auch die vielgestaltigen Persönlichkeiten der Tausenden von Clowns festgehalten. Kein Clown glich dem anderen, da es gegen den Ehrenkodex verstieß, die Maske eines anderen zu kopieren. Aus den individuellen Stilen und den endlosen Kostümvariationen erwuchsen einmalige Charaktere, die sich durch Fotografien unauslöschlich in die Populärkultur einprägten. Kein anderes Medium fing die namenlosen Clowns besser ein: das überbreite Grinsen oder übertriebene Stirnrunzeln, die ganze Bandbreite menschlicher Gefühle, die zum Ausdruck kam, sobald ein Clown seine Maske aus Farbe und Fettschminke aufgetragen hatte.

Clown announcing the start of the circus, publicity photograph, 1940s
Ein Clown kündigt den Beginn der Vorstellung an, Werbefoto, 1940er Jahre
Clown annonçant le début du spectacle, photographie publicitaire, années 40

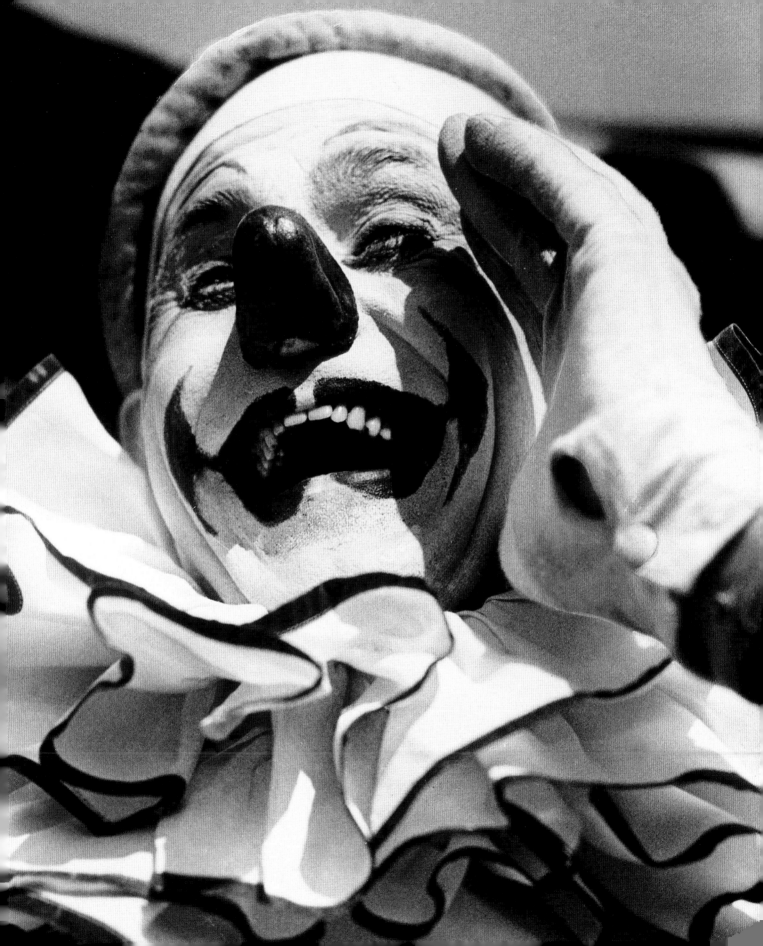

PHOTOGRAPHIE

La photographie devenant de plus en plus populaire à l'aube du XXᵉ siècle, les photographes amateurs et professionnels en profitèrent pour saisir l'essence du monde du cirque, principalement en noir et blanc. A des années-lumière des séances de poses figées des austères familles victoriennes et des respectables politiciens locaux, les sujets pleins de mouvements produisaient des portraits hauts en couleurs devant l'objectif. Plutôt que de prendre simplement des photos, les photographes se mirent à étudier les expressions et les clowns étaient des modèles rêvés. Leurs attitudes naturelles offraient une heureuse alternative aux habituelles séances de studio et aux paysages immobiles. Les clowns s'accompagnaient d'accessoires les plus divers, d'instruments brillants et de petits

animaux qui assuraient la variété et la spontanéité. Photographier leurs numéros permettait de les faire connaître auprès du public. Dans les décennies suivantes, ce furent les photos publicitaires que les clowns distribuaient à leurs jeunes fans ou les instantanés pris après le spectacle en compagnie de leurs admirateurs qui assurèrent la fidélité des spectateurs. De nombreux clowns, Emmett Kelly, Lou Jacobs et Felix Adler parmi tant d'autres, devinrent célèbres grâce à la vogue et à l'usage extensif de l'appareil photographique. Weegee, le célèbre photographe, s'était vraiment déguisé en clown pour observer et photographier le monde du cirque de l'intérieur. Le magazine *Life* et plusieurs autres publications des années 40 ont souvent consacré leurs pages au phénomène du cirque.

La photographie a aussi permis d'immortaliser les innombrables personnages incarnés par des milliers de clowns en Amérique. Il n'y avait pas deux maquillages de clown identiques, puisque c'était contre les règles du cirque de copier la face d'un autre. Leurs styles distinctifs, leurs dessins particuliers et l'infinie diversité des costumes en faisaient des personnages uniques qui se sont intégrés dans la culture populaire grâce à la photographie. La photographie, plus qu'aucun autre médium, nous a permis de découvrir le clown ordinaire ou anonyme, le sourire ou le froncement de sourcils exagérés et la profondeur des émotions humaines exprimées explicitement ou implicitement à chaque fois qu'un clown applique son masque de maquillage et de fard gras.

Photograph, 1958
Fotografie, 1958
Photographie, 1958

▶▶ Ringling Bros. clowns at winter home in Florida (second from left, Albert White; tall one at back, Gene Lewis; far right, Paul Jung), postcard, 1960s
Die Clowns des Ringling Bros. Circus in ihrem Winterquartier in Florida (zweiter v. l.: Albert White; der Große hinten: Gene Lewis; ganz rechts: Paul Jung), Postkarte, 1960er Jahre
Clowns du cirque Ringling au quartier d'hiver en Floride (deuxième à partir de la gauche, Albert White; le grand au fond, Gene Lewis; à l'extrême droite, Paul Jung), carte postale, années 60

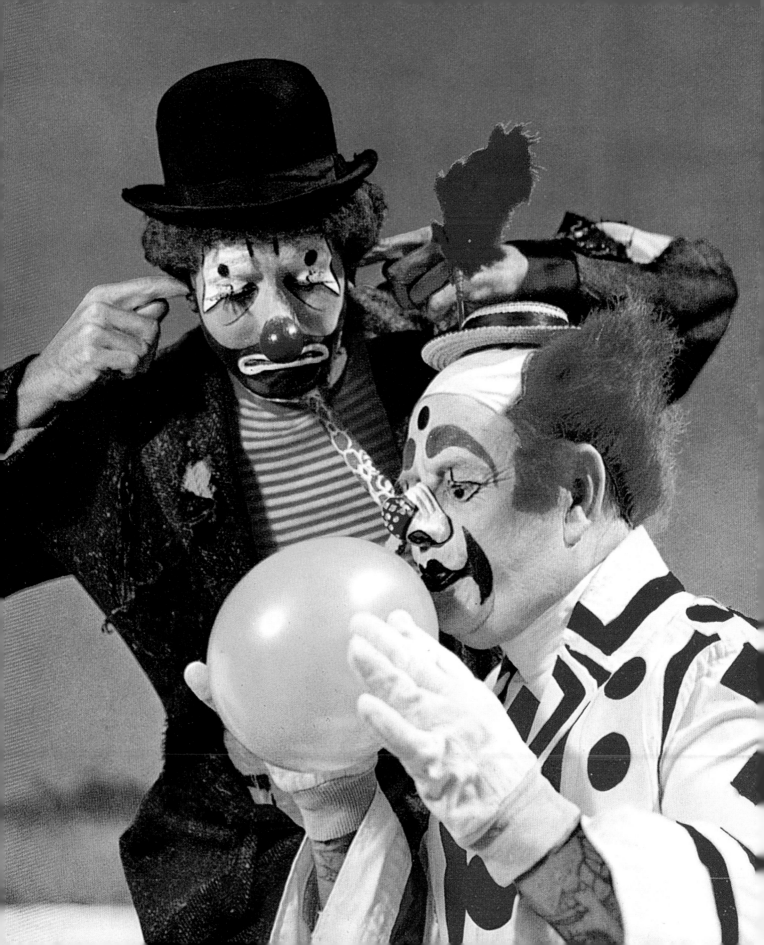

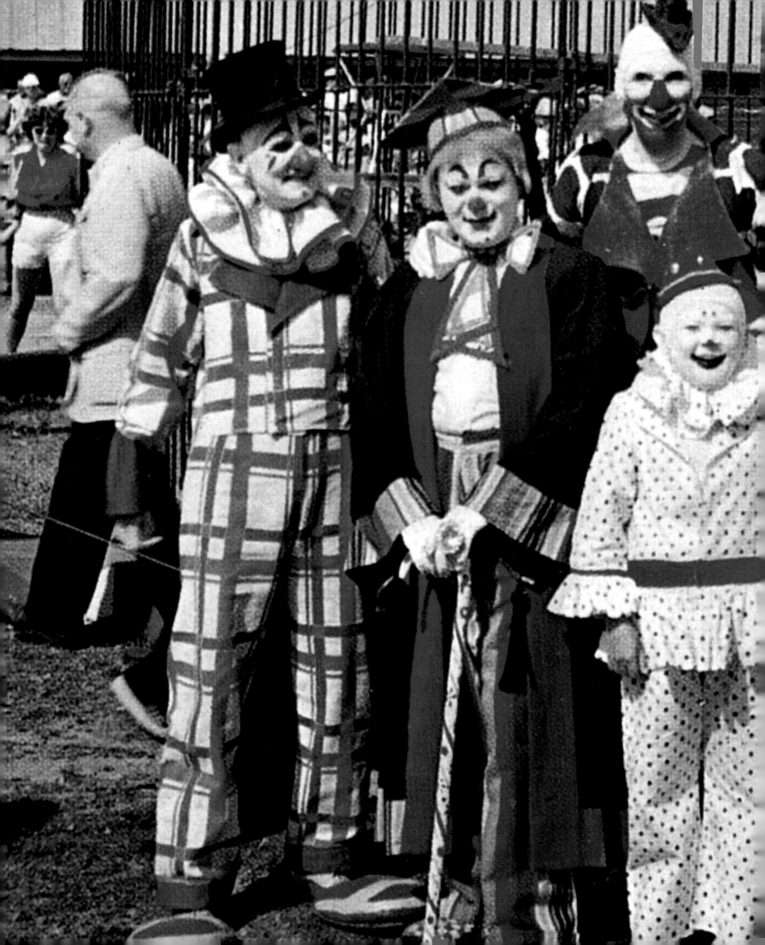

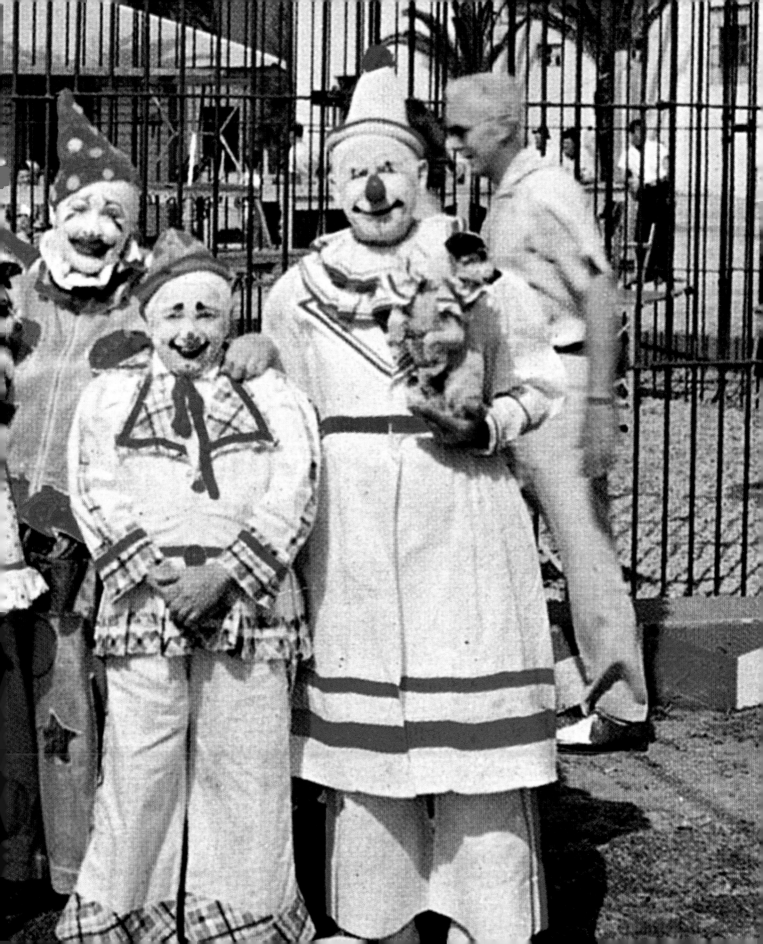

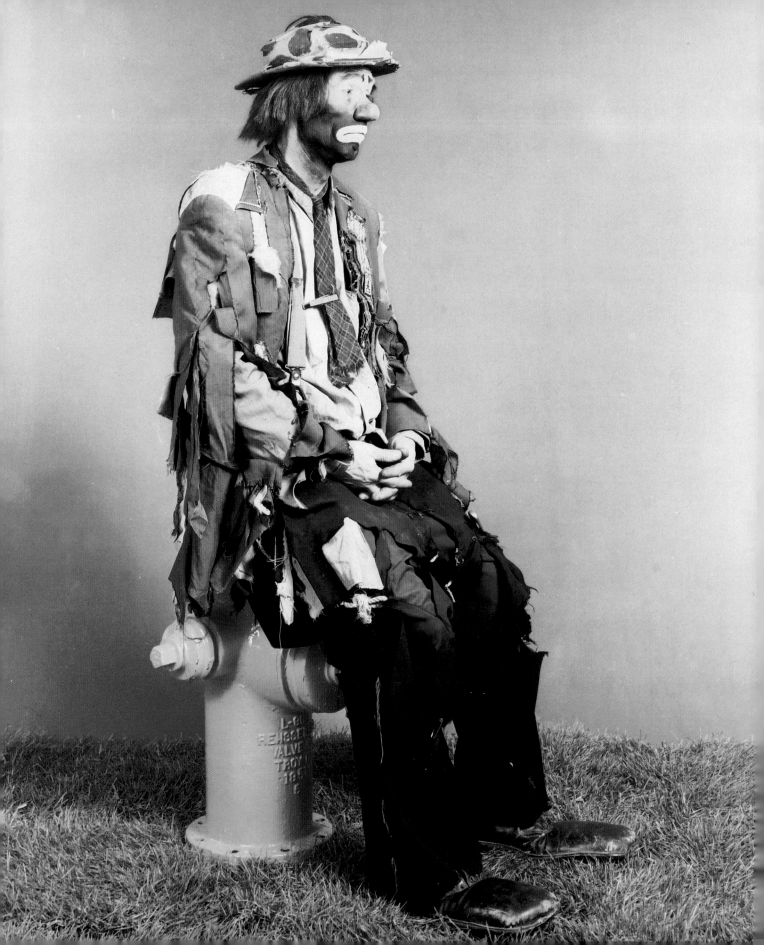

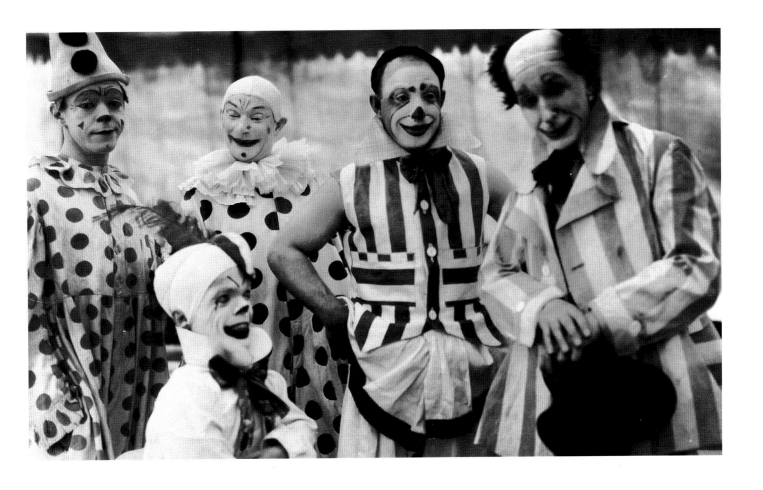

◄ Hobo clown on fire hydrant, photograph, 1959
Abgerissener Hoboclown auf einem Feuerhydranten, Fotografie, 1959
Clown vagabond sur une borne d'incendie, photographie, 1959

Clowns in silent film classic, *Polly of the Circus*, film still, 1917
Clowns in dem Stummfilmklassiker *Polly of the Circus*, Standfoto, 1917
Clowns dans un classique du muet *Polly of the Circus*, photographie du film, 1917

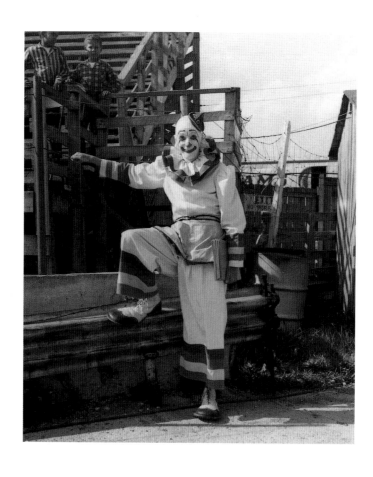

Bill Griffen, photograph, ca. 1960
Bill Griffen, Fotografie, um 1960
Bill Griffen, photographie, vers 1960

▶ Clown pranksters (top, from left: Joe Sherman, Locke Lorraine, Ray Sinclair, Javier Peluga, John Thomson, Johnny Cicillino, and Chester Sherman), publicity photograph, ca. 1955
Zu Scherzen aufgelegte Clowns (oben v. l.: Joe Sherman, Locke Lorraine, Ray Sinclair, Javier Peluga, John Thomson, Johnny Cicillino und Chester Sherman), Werbefoto, um 1955
Clowns farceurs (en haut, à partir de la gauche: Joe Sherman, Locke Lorraine, Ray Sinclair, Javier Peluga, John Thomson, Johnny Cicillino et Chester Sherman), photographie publicitaire, vers 1955

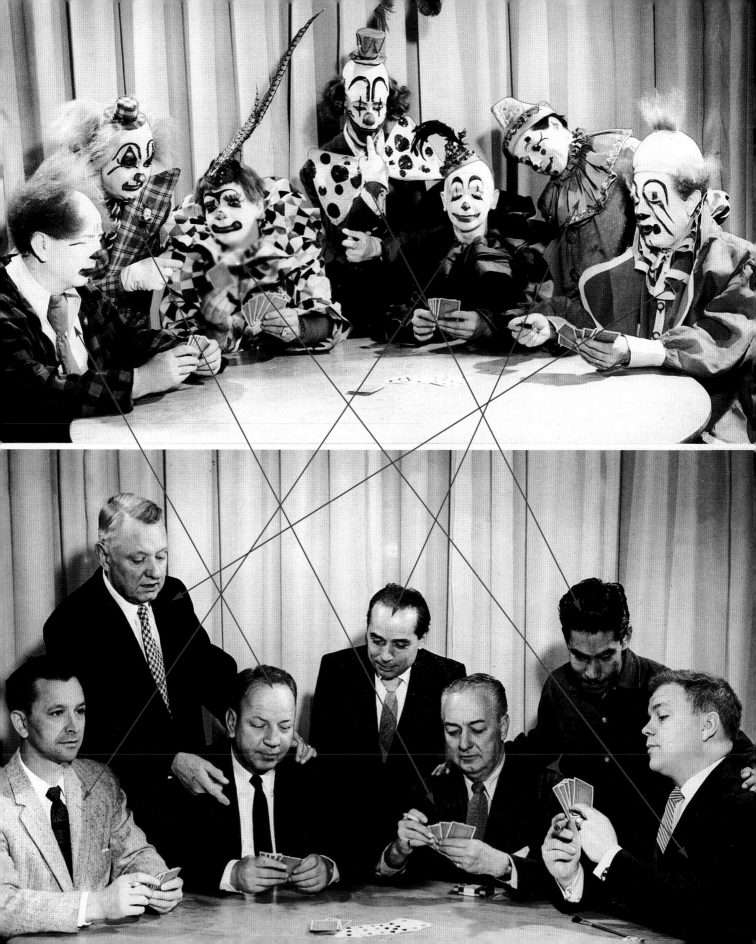

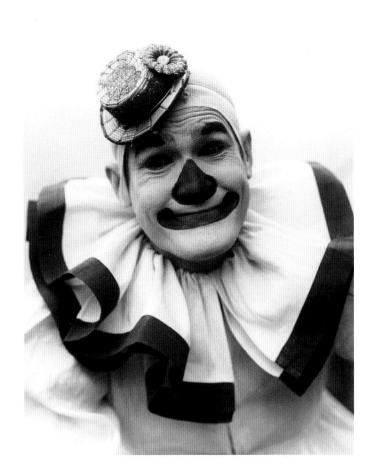

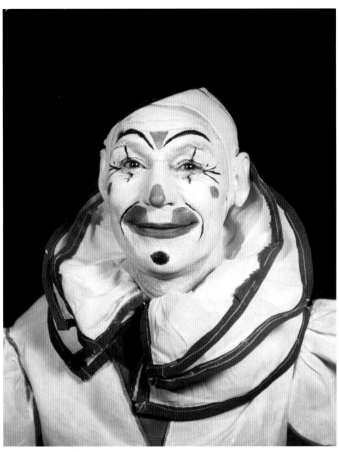

Anonymous clowns, photographs, 1950s
Unbekannte Clowns, Fotografien, 1950er Jahre
Clowns anonymes, photographies, années 50

▶ Otto Griebling, photograph by Ted Sato, 1953
Otto Griebling, fotografiert von Ted Sato, 1953
Otto Griebling, photographie de Ted Sato, 1953

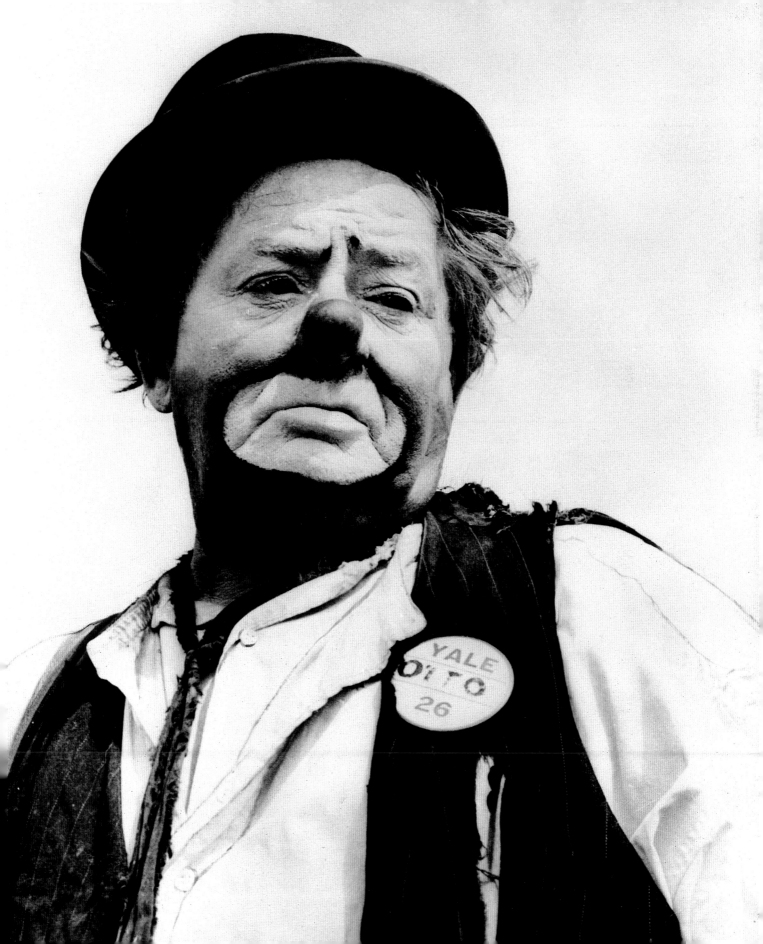

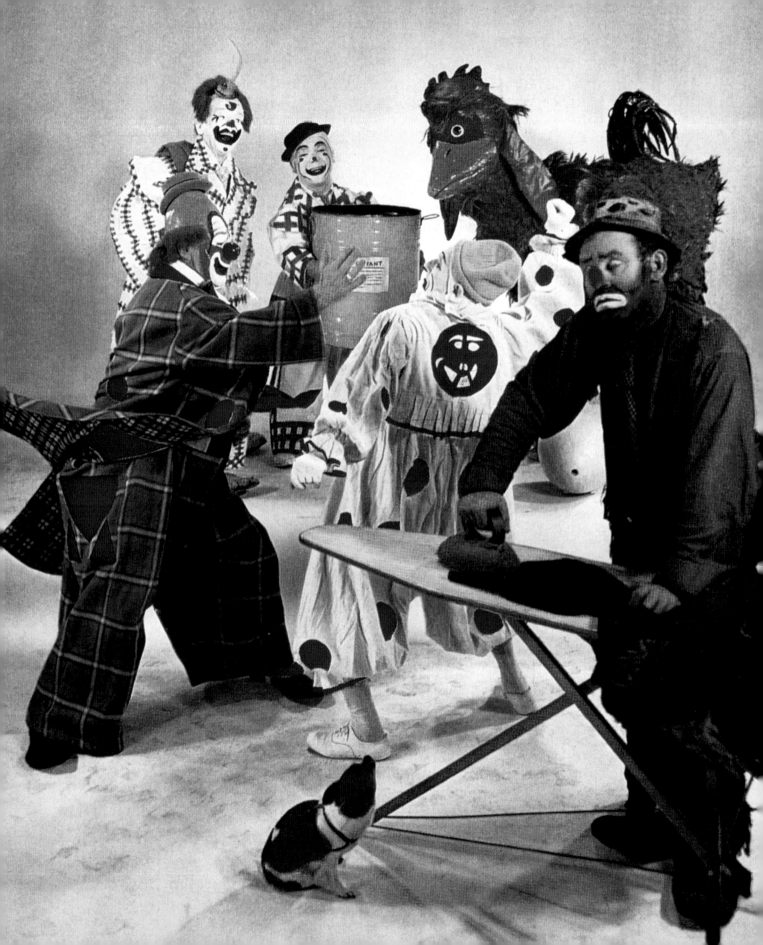

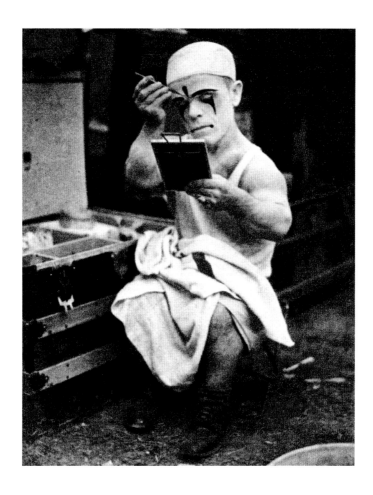

◄ Lou Jacobs (left), Emmett Kelly (right), and other clowns in Kodachrome,
photograph by Gjon Mili, 1951
Lou Jacobs (links), Emmett Kelly (rechts) und andere Clowns, Kodachrome,
Fotografie von Gjon Mili, 1951
Lou Jacobs (à gauche), Emmett Kelly (à droite) et d'autres clowns, Kodachrome,
photographie de Gjon Mili, 1951

Midget clown donning greasepaint, photograph, 1945
Zwergwüchsiger Clown beim Schminken, Fotografie, 1945
Clown nain se maquillant, photographie, 1945

►► Mardi Gras at Coney Island, New York, photograph, 1948
Mardi Gras auf Coney Island, New York, Fotografie, 1948
Mardi gras à Coney Island, New York, photographie, 1948

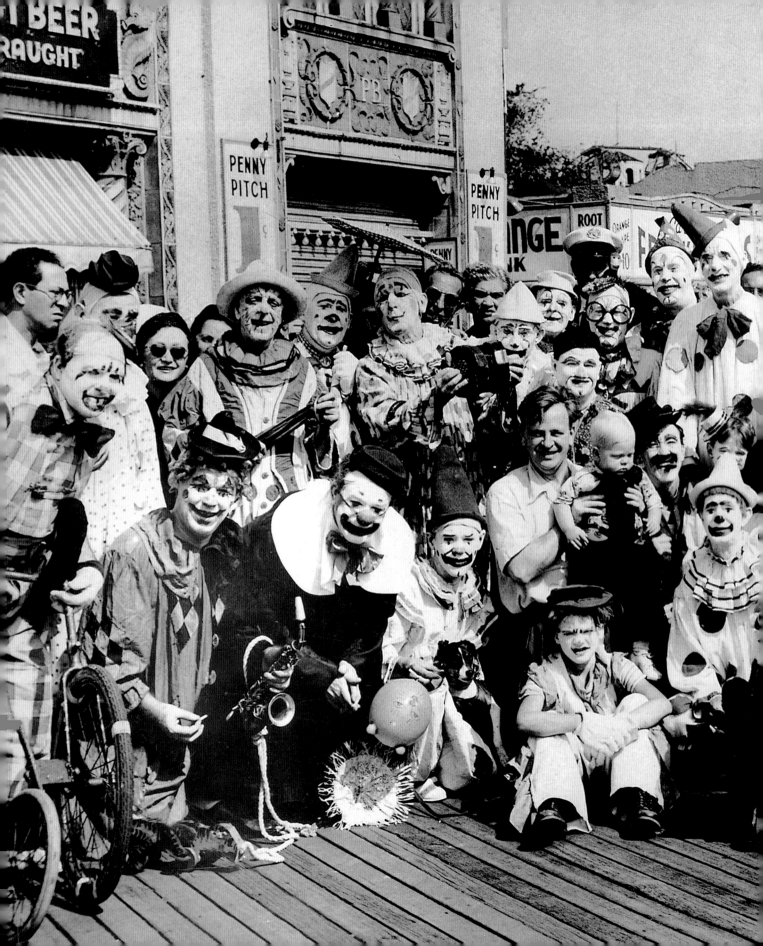

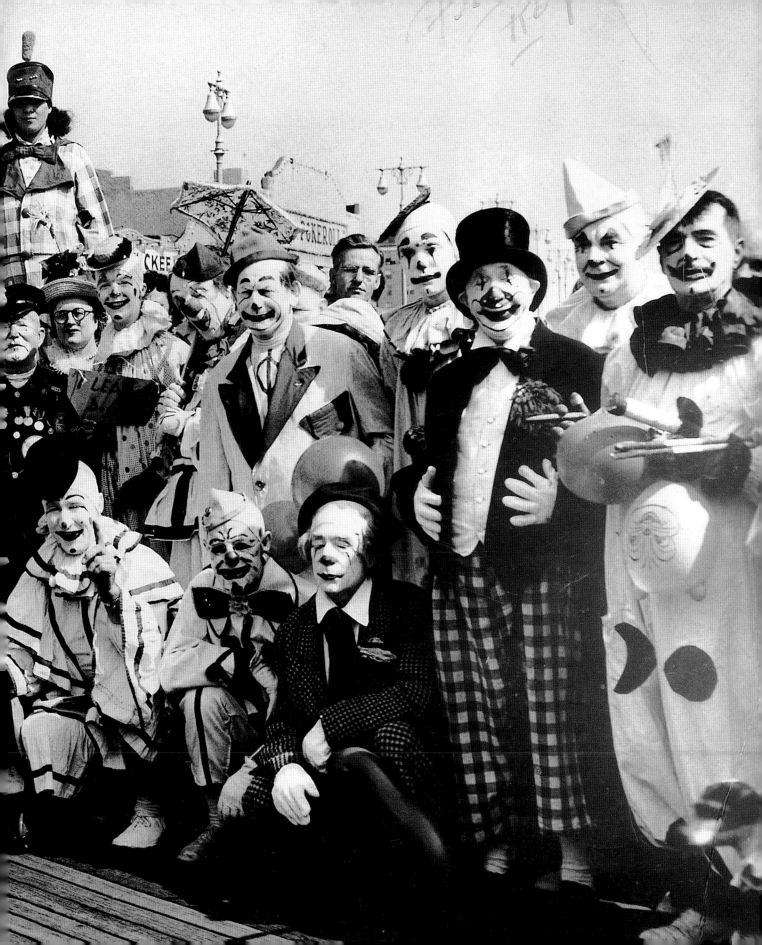

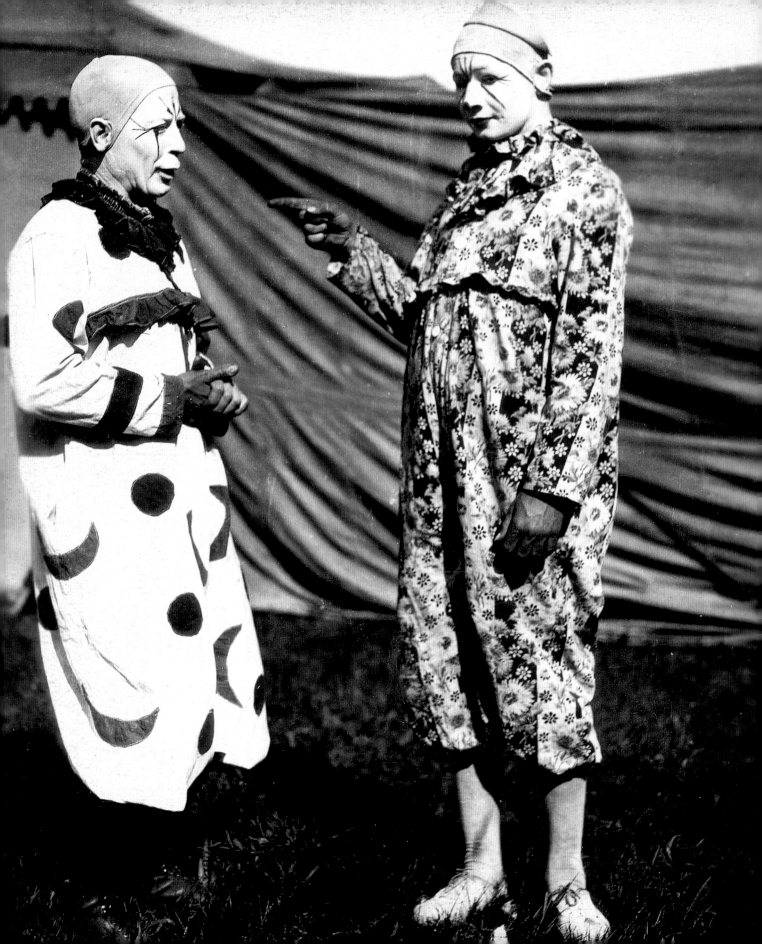

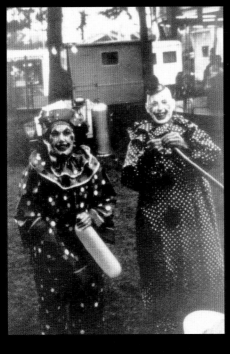
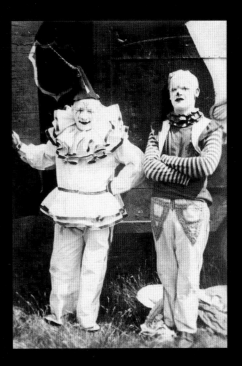
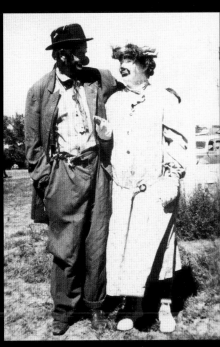
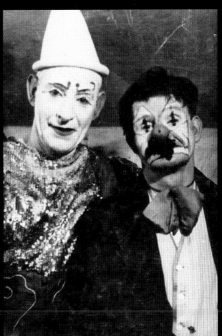

Assorted clown teams, photographs, 1940s–50s
Diverse Clownteams, Fotografien, 1940er bis 1950er Jahre
Duos de clowns, photographies, années 40–50

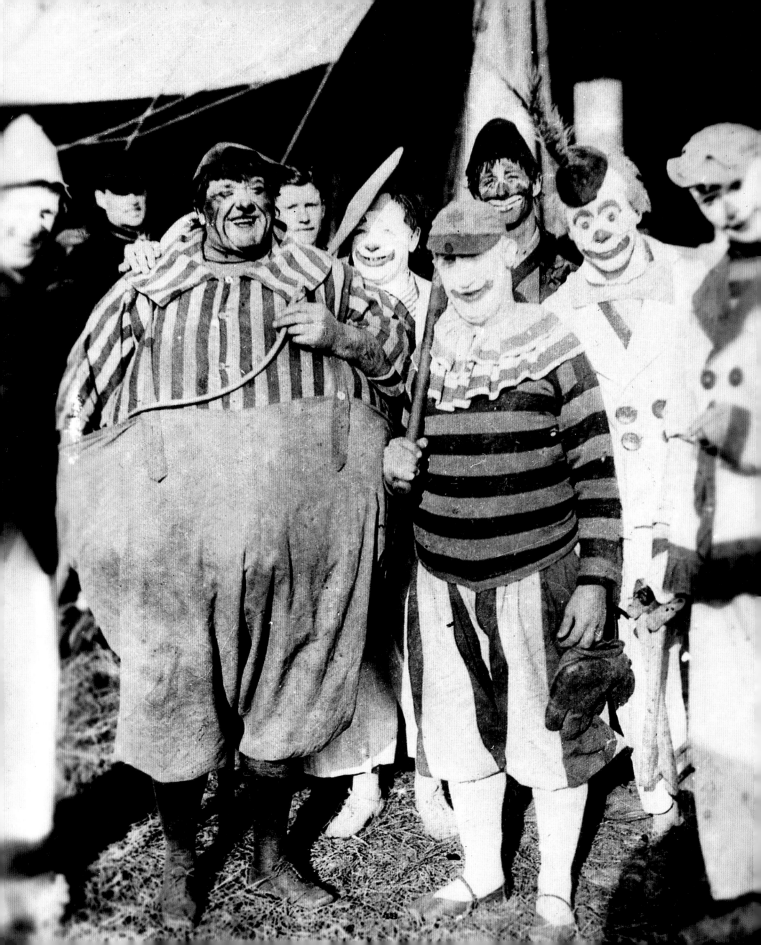

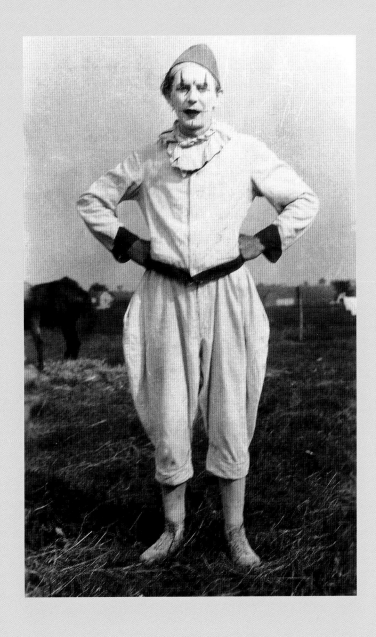

Anonymous clown in field, snapshot, 1940s
Unbekannter Clown auf einer Wiese, Schnappschuss, 1940er Jahre
Clown anonyme dans un champ, instantané, années 40

◄ Barnum & Bailey clown troupe, photograph, 1913
Clowntruppe des Zirkus Barnum & Bailey, Fotografie, 1913
La troupe des clowns de Barnum & Bailey, photographie, 1913

►► Photographs, 1940s
Fotografien, 1940er Jahre
Photographies, années 1940

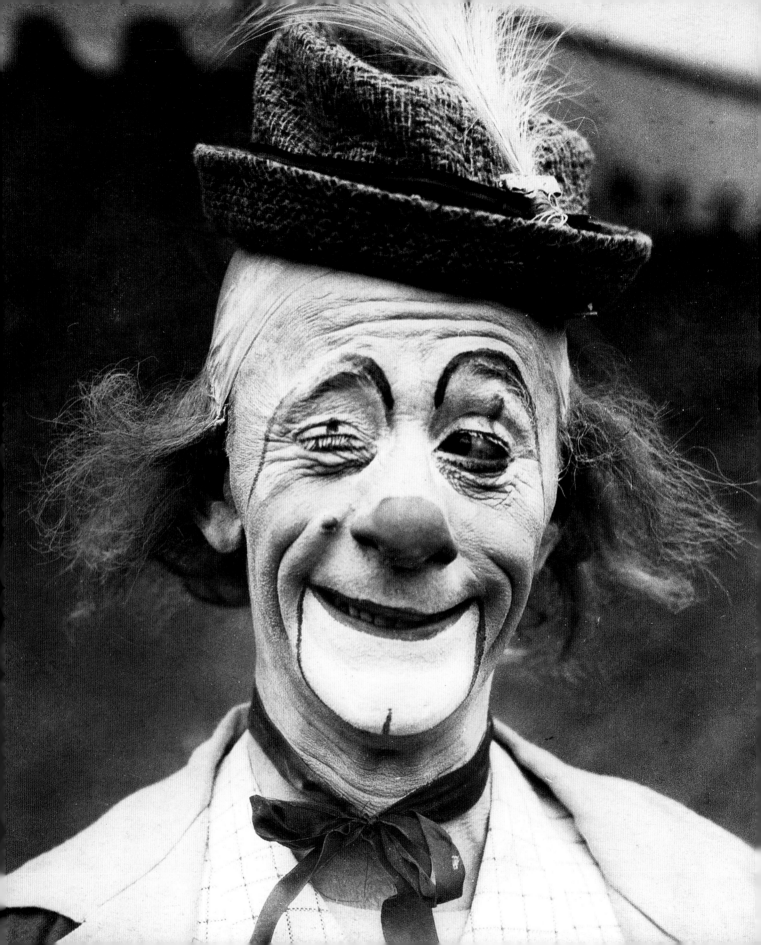

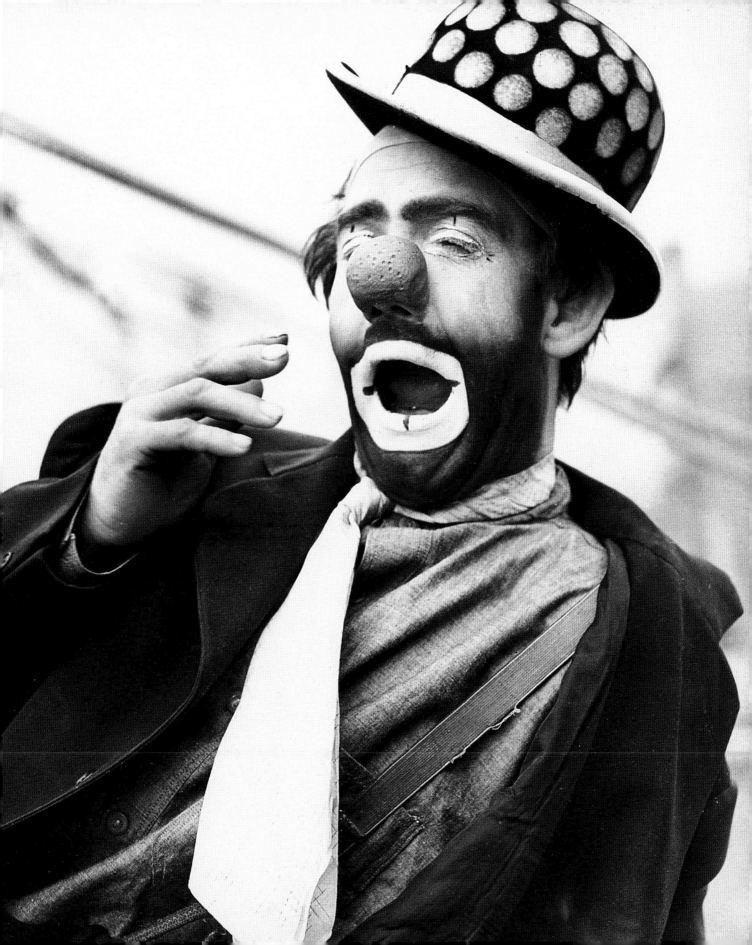

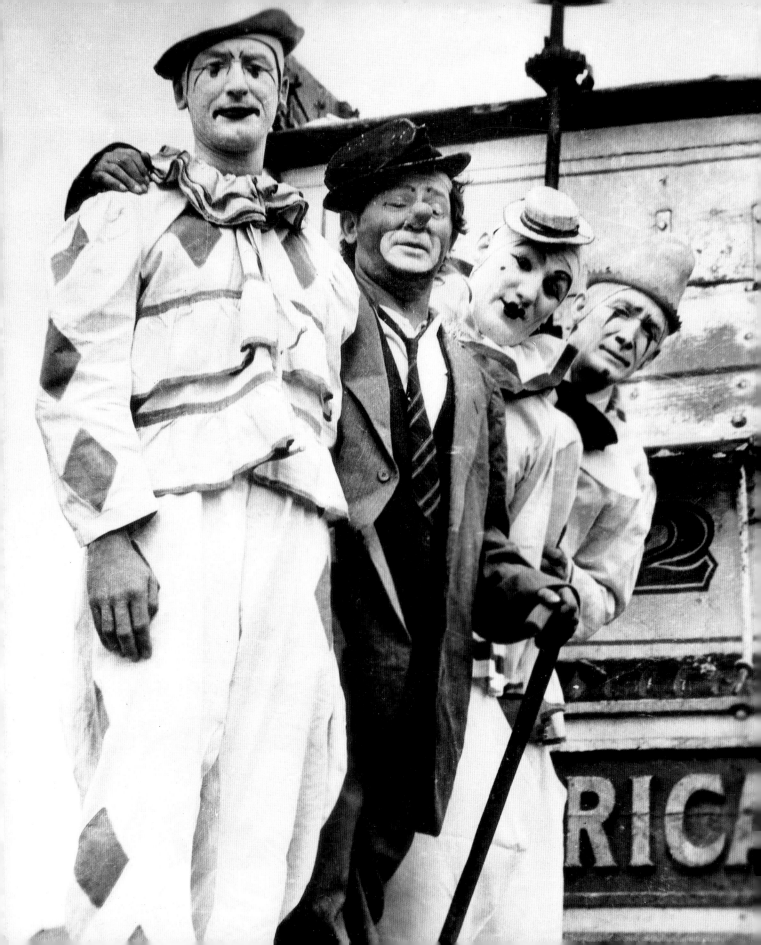

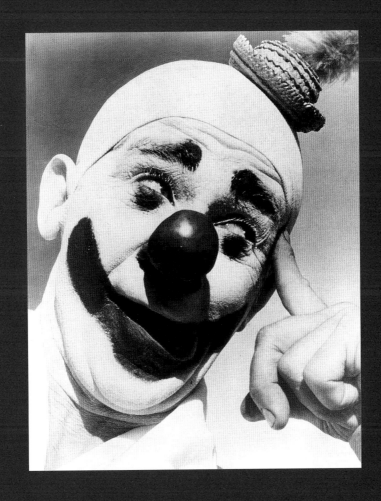

Paul Jung, famous producing clown who created and performed in his own skits,
publicity photograph, 1940s
Paul Jung, ein berühmter Clown, der seine eigenen Sketche erarbeitete und
aufführte, Werbefoto, 1940er Jahre
Paul Jung, célèbre clown inventeur, qui créait et jouait ses propres sketchs,
photographie publicitaire, années 40

◀ Circus of America clowns, photograph, 1930s
Clowns des Circus of America, Fotografie, 1930er Jahre
Clowns du Circus of America, photographie, années 30

▶ ▶ Amateurs at Chicago clown school, photograph, 1940s
Amateure an der Clownschule in Chicago, Fotografie, 1940er Jahre
Amateurs à l'école de clowns de Chicago, photographie, années 40

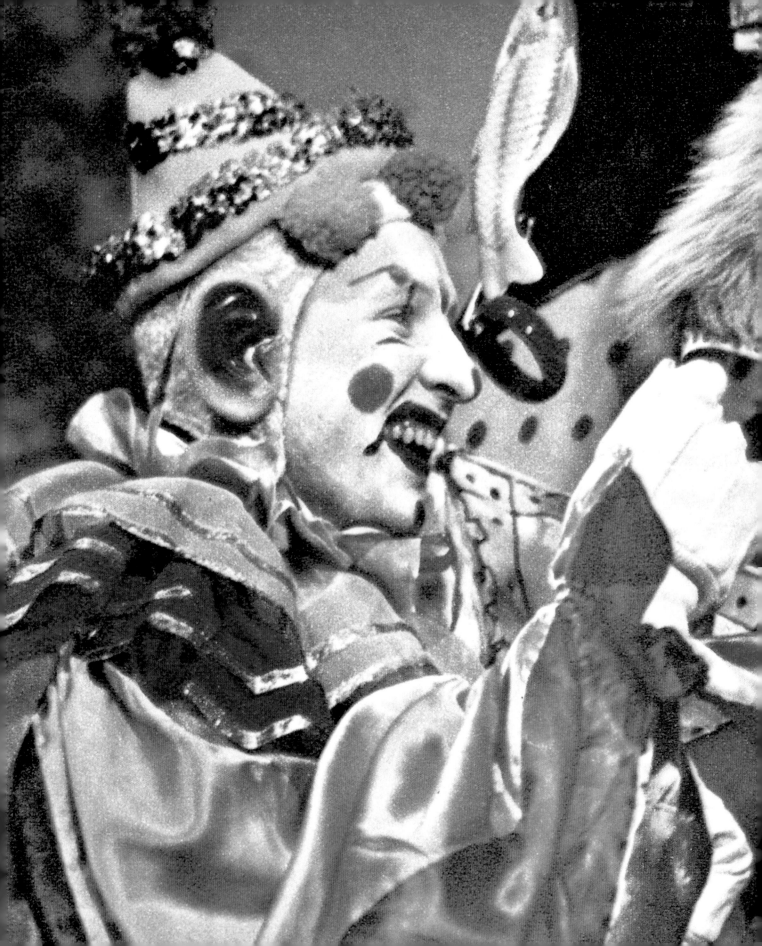

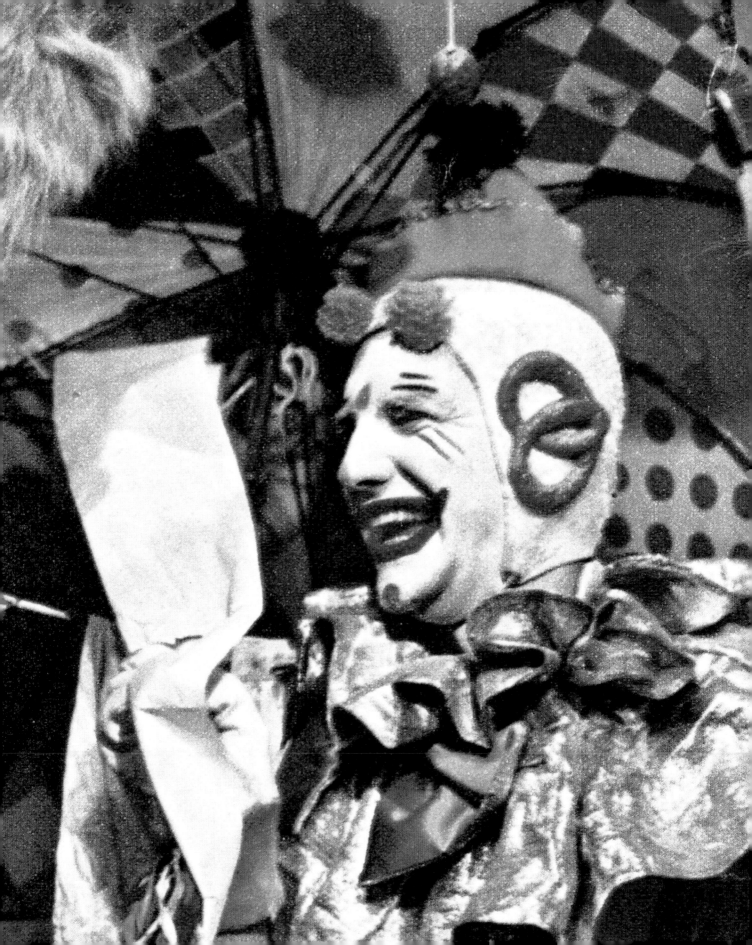

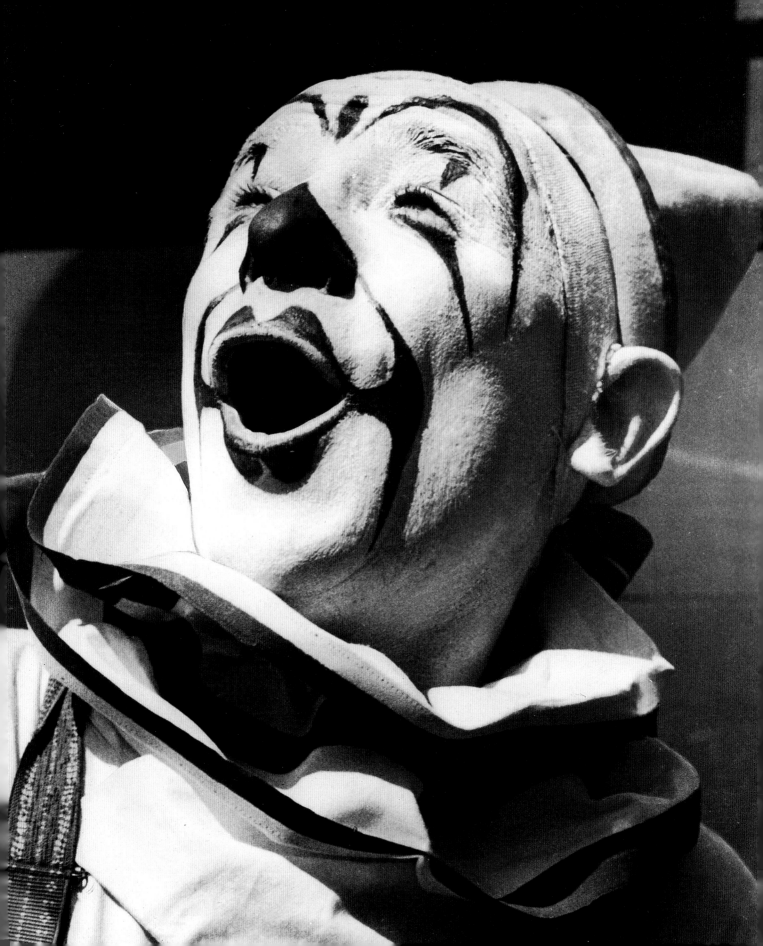

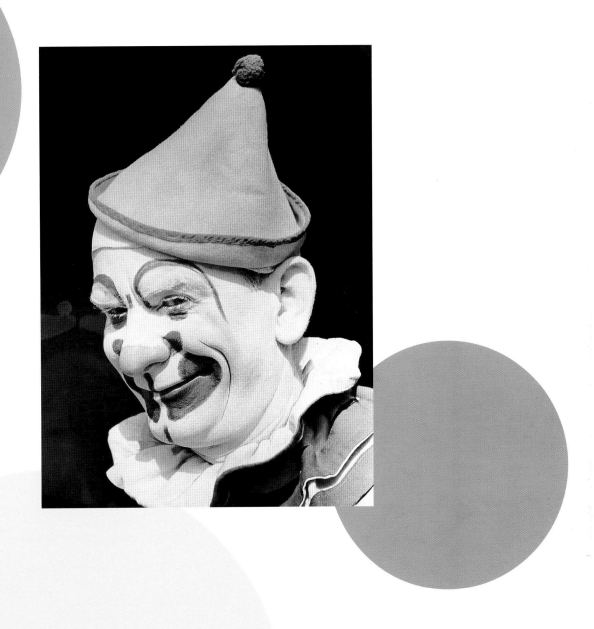

Publicity stills, 1940s
Werbefotos, 1940er Jahre
Photographies publicitaires, années 40

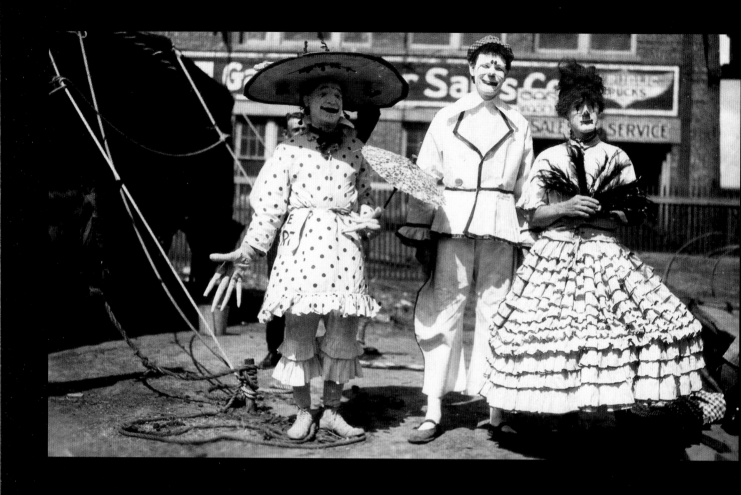

Outlandish clown trio, informal snapshot, 1930s
Clowntrio in absurden Kostümen, Amateurschnappschuss, 1930er Jahre
Trio de clowns excentriques, instantané informel, années 30

▶ Blackface clown, Campbell Bros. Circus, photograph, 1930s
„Blackface"-Clown, Campbell Bros. Circus, Fotografie, 1930er Jahre
Clown noir, cirque Campbell, photographie, années 30

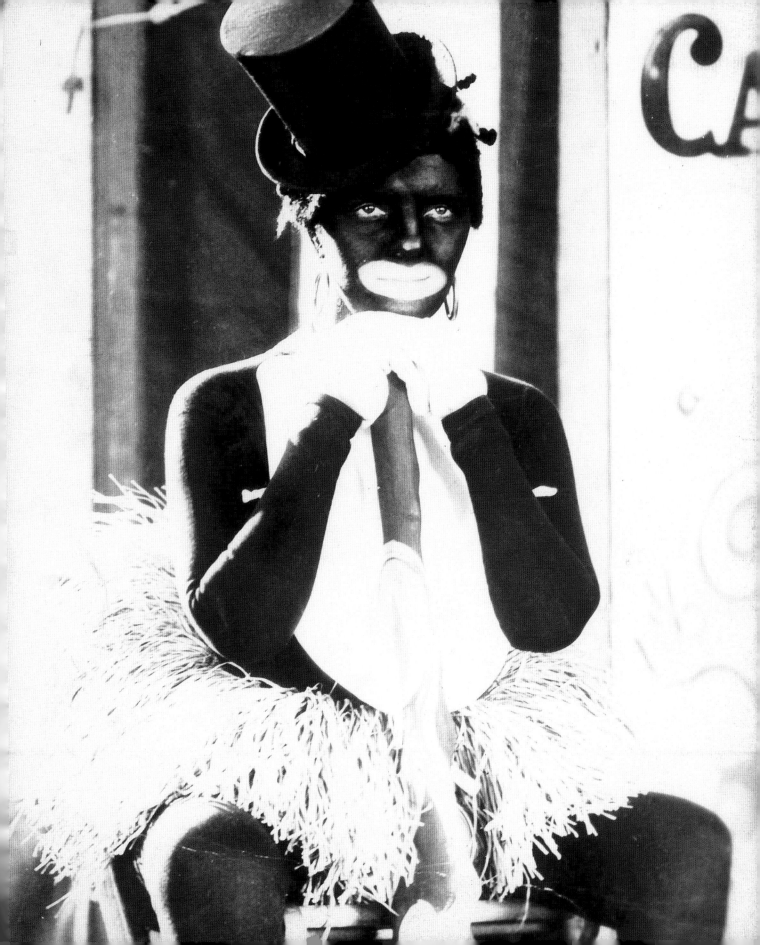

Heavyweight clown, Horace Laird, photograph, 1940s
Der schwergewichtige Clown Horace Laird, Fotografie, 1940er Jahre
Clown obèse, Horace Laird, photographie, années 1940

◄ Celebrity clown, Paul Jerome, photograph, 1958
Der Starclown Paul Jerome, Fotografie, 1958
Clown vedette Paul Jerome, photographie, 1958

►► Clown gallery, left to right, top row: Buzzie Potts, Myron Orton, Frank Luley, Ernie "Blinko" Burch, Edwin F. Green, Paul "Prince Paul" Alpert; middle row: Frankie Saluto, John Reilly, Irvin Romig, Jackie Gerlich, John Tripp, Paul "Chesty" Mortier; bottom row: Art Cooksey, Lou Jacobs, Jimmy Armstrong, Carl Stephan, Eddie Buresh, Felix Adler; photographs by George Karger, 1949

Clowngalerie, v. l. n. r., oben: Buzzie Potts, Myron Orton, Frank Luley, Ernie „Blinko" Burch, Edwin F. Green, Paul „Prince Paul" Alpert; Mitte: Frankie Saluto, John Reilly, Irvin Romig, Jackie Gerlich, John Tripp, Paul „Chesty" Mortier; unten: Art Cooksey, Lou Jacobs, Jimmy Armstrong, Carl Stephan, Eddie Buresh, Felix Adler; Fotografien von George Karger, 1949

Portraits de clowns, de gauche à droite, 1ère rangée en haut: Buzzie Potts, Myron Orton, Frank Luley, Ernie «Blinko» Burch, Edwin F. Green, Paul «Prince Paul» Alpert; 2e rangée du milieu: Frankie Saluto, John Reilly, Irvin Romig, Jackie Gerlich, John Tripp, Paul «Chesty» Mortier; 3e rangée: Art Cooksey, Lou Jacobs, Jimmy Armstrong, Carl Stephan, Eddie Buresh, Felix Adler; photographies de George Karger, 1949

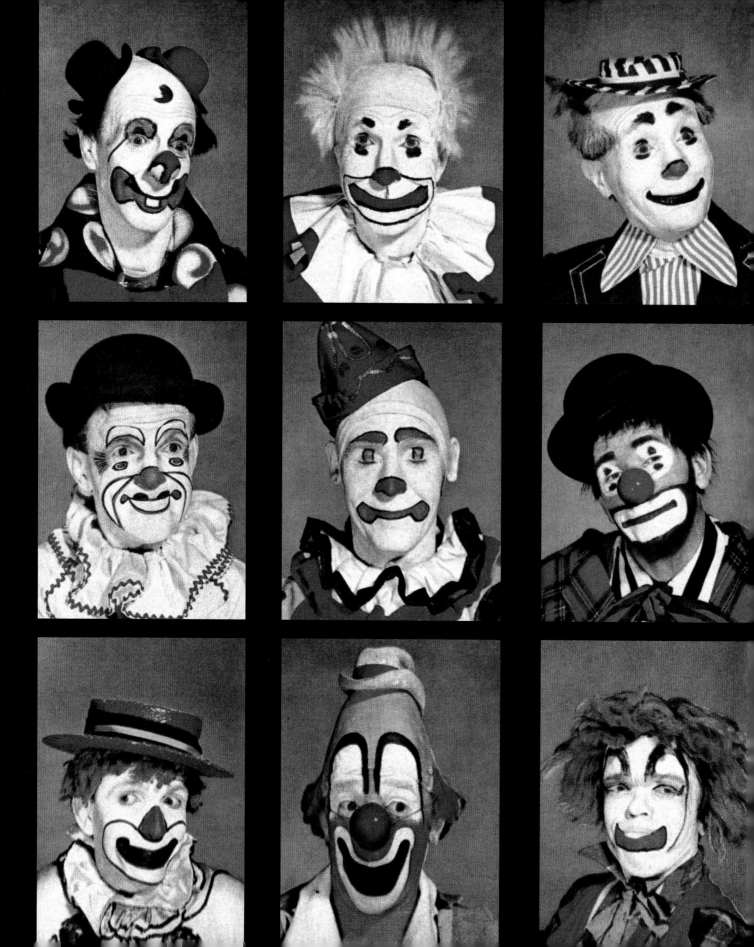

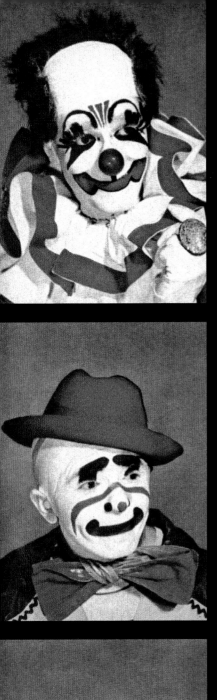
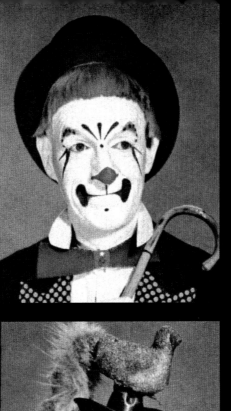
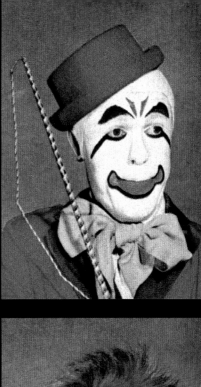
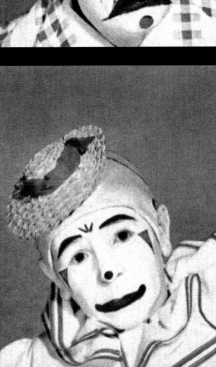
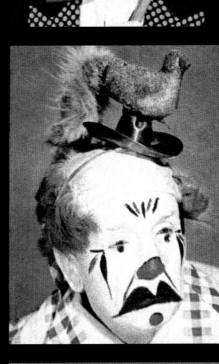
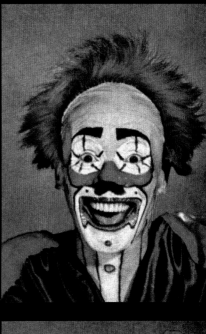

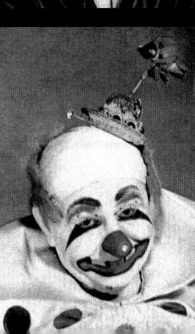

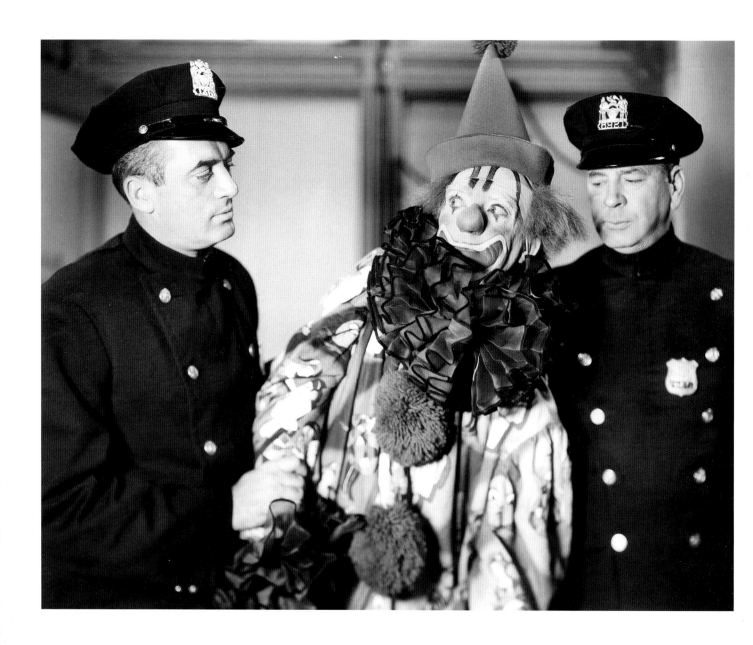

Pat Lane, Larry Parks (clown), and Billy Lally in a scene from *Alias Boston Blackie*, film still, 1942

Pat Lane, Larry Parks (Clown) und Billy Lally in einer Filmszene aus *Alias Boston Blackie*, Standfoto, 1942

Pat Lane, Larry Parks (clown) et Billy Lally dans une scène de *Alias Boston Blackie*, photographie du film, 1942

▶ Chalk Hill Drive-In Theatre on Highway 80, Dallas, Texas, photograph Steve Fitch, 1973

Chalk-Hill-Autokino am Highway 80, Dallas, Texas, Fotografie von Steve Fitch, 1973

Drive-In cinéma Chalk Hill sur la Route 80, Dallas, Texas, photographie de Steve Fitch, 1973

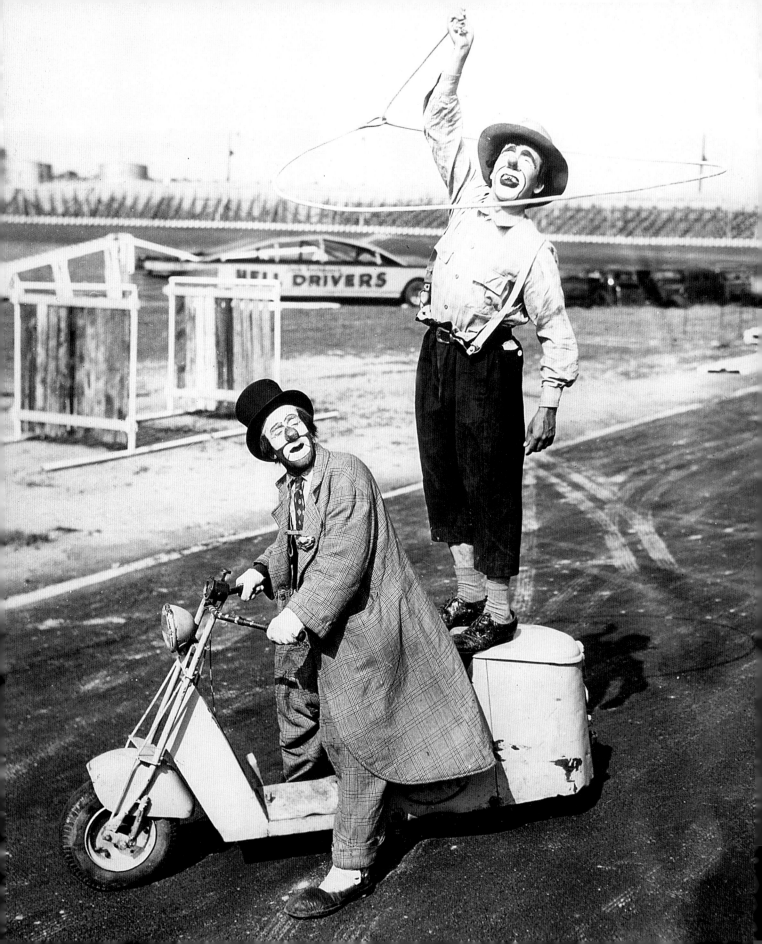

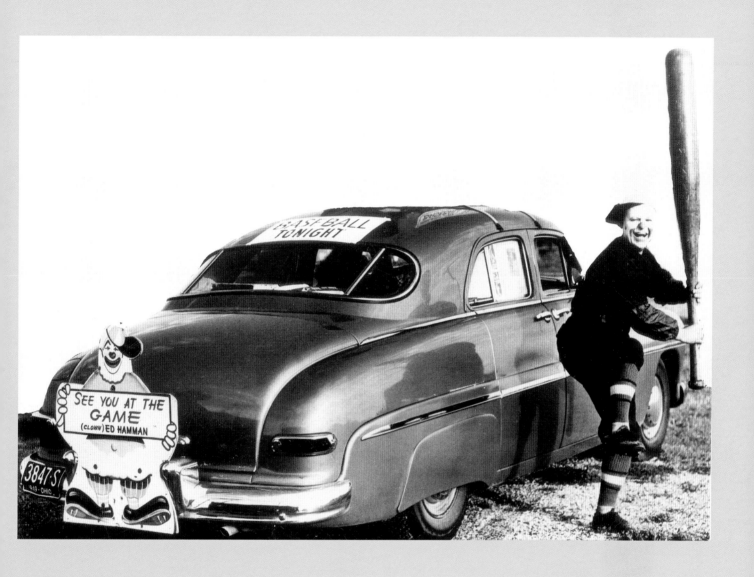

◀ Clowns at auto raceway featuring Hell Drivers stunt team, photograph, 1950s
Clowns an der Autorennbahn mit Hell Drivers Stuntmen, Fotografie, 1950er Jahre
Clowns lors d'une course automobile parodiant l'équipe de cascadeurs Hell Drivers,
photographie, années 50

Baseball clown Ed Hamman, photograph, ca. 1950
Baseballclown Ed Hamman, Fotografie, um 1950
Ed Hamman, le clown à la batte de base-ball, photographie, vers 1950

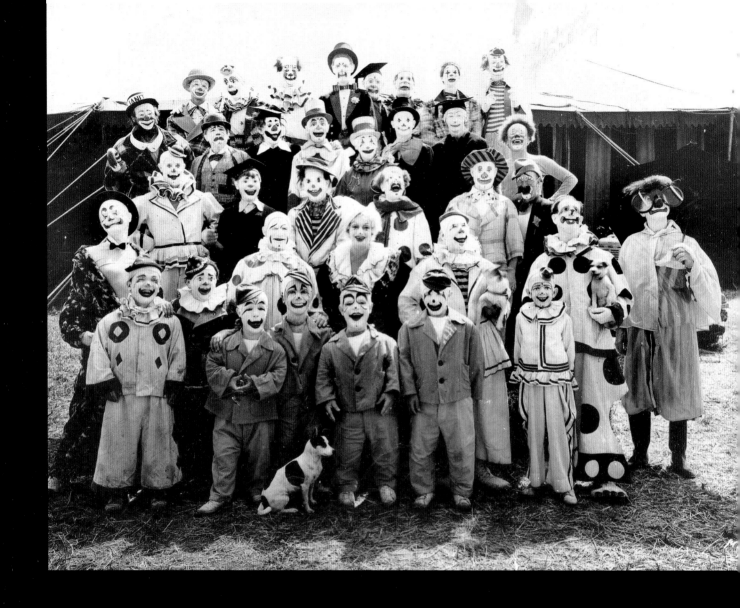

Group of clowns including Paul Jerome and Paul Wentzel, snapshot, 1940s
Gruppe von Clowns mit Paul Jerome und Paul Wentzel, Schnappschuss,
1940er Jahre

▶ High Pockets the Stilt Walker, whose motto was "tops in clowning," business
card, detail, 1950s
High Pockets, der Stelzenläufer, der sich das Motto „Der Größte im
Clowngewerbe" gegeben hatte, Visitenkarte, Ausschnitt, 1950er Jahre
High Pockets l'échassier dont la devise était « Les sommets de la clownerie », carte

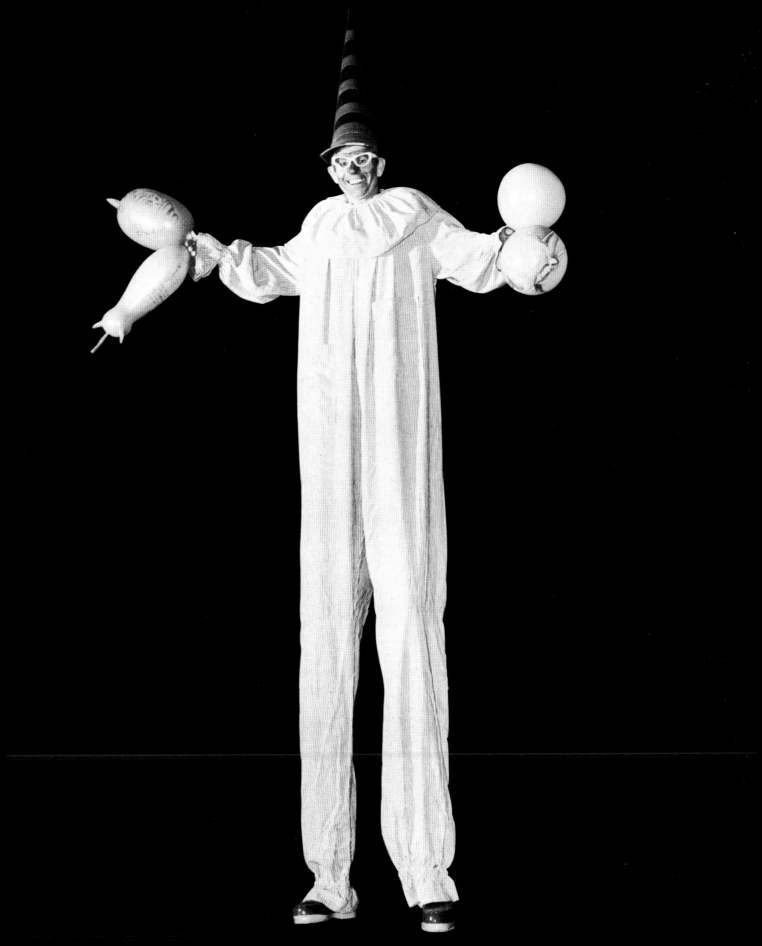

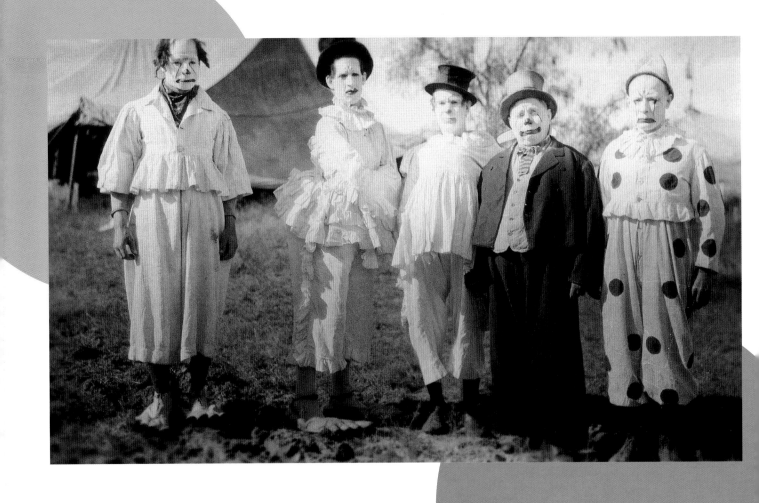

Motley crew of clowns, photograph, 1920s
Clowngrüppchen, Fotografie, 1920er Jahre
Equipe hétéroclite de clowns, photographie, années 20

▶ Polka-dotted Felix Adler, noted for his costume jewelry, photograph, 1958
Der getupfte Felix Adler, der für seinen Modeschmuck bekannt war, Fotografie, 1958
Felix Adler en costume à pois; les bijoux de ses costumes étaient célèbres, photographie, 1958

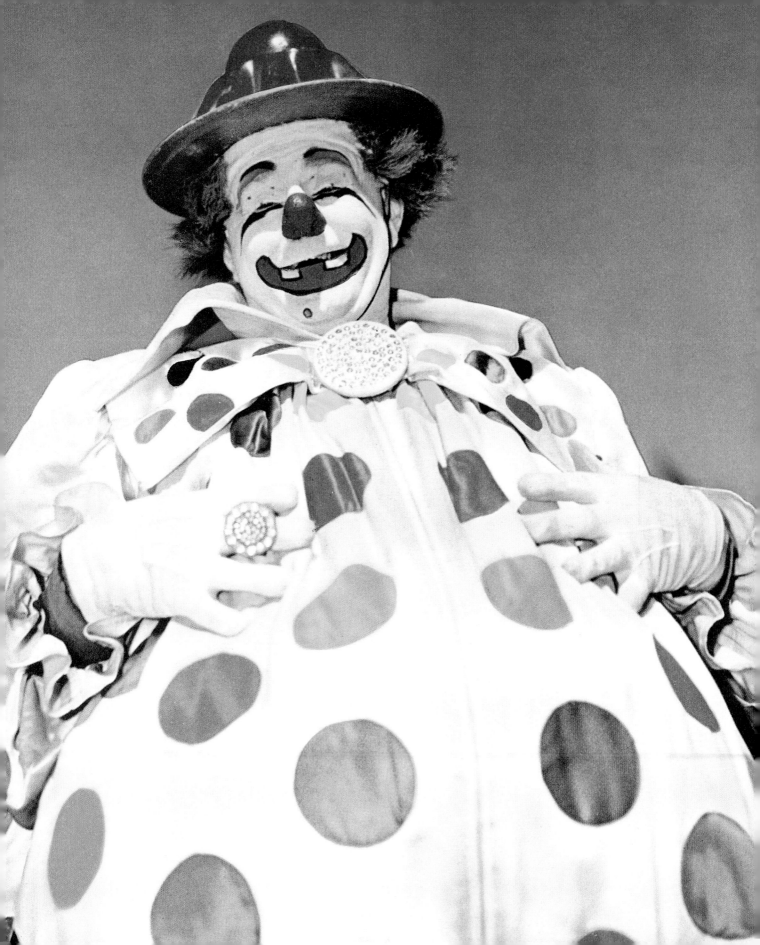

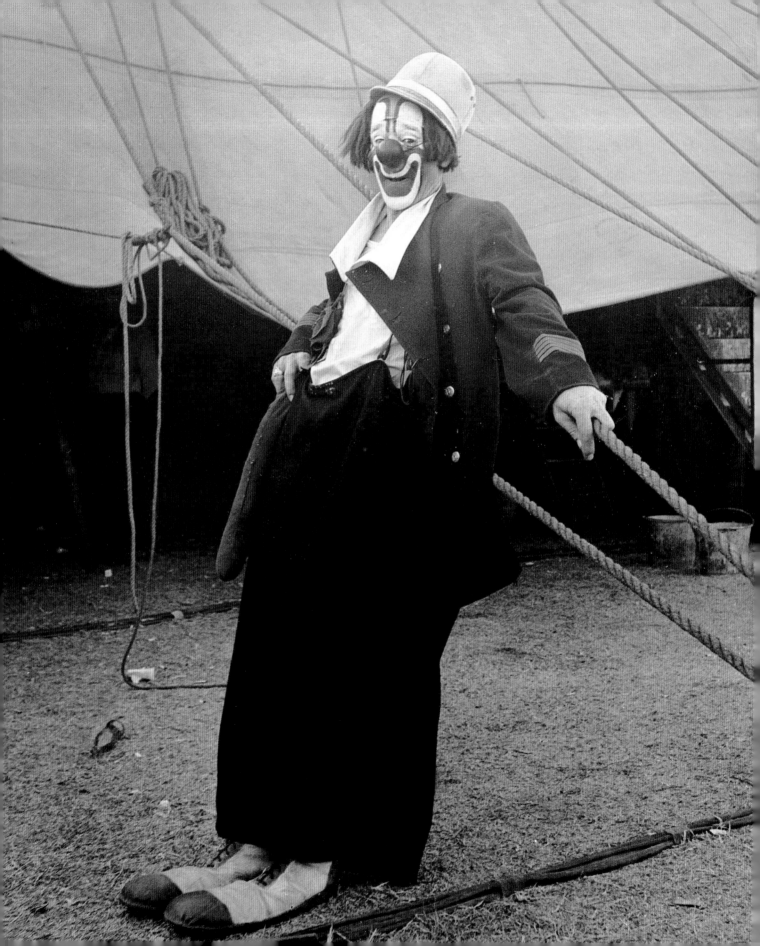

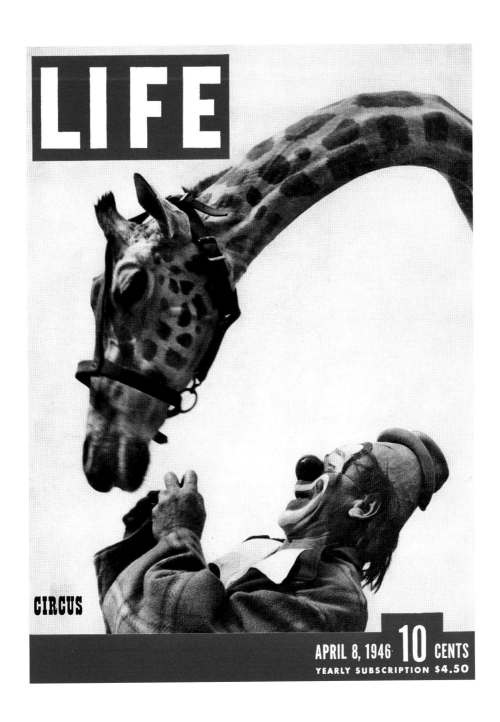

LIFE

CIRCUS

APRIL 8, 1946 **10** CENTS
YEARLY SUBSCRIPTION $4.50

◄ Lou Jacobs in clown alley, photograph, 1940s
Lou Jacobs in der „Clownsgasse", Fotografie, 1940er Jahre
Lou Jacobs dans l'allée des clowns, photographie, années 40

Ringling Bros. giraffe Soudana and Lou Jacobs, magazine cover, photograph by Loomis Dean, 1946
Ringling Bros. Circus, Giraffe Soudana und Lou Jacobs, Zeitschriftentitel, Fotografie von Loomis Dean, 1946
Lou Jacobs et la girafe Soudana du cirque Ringling, couverture de magazine, photographie de Loomis Dean, 1946

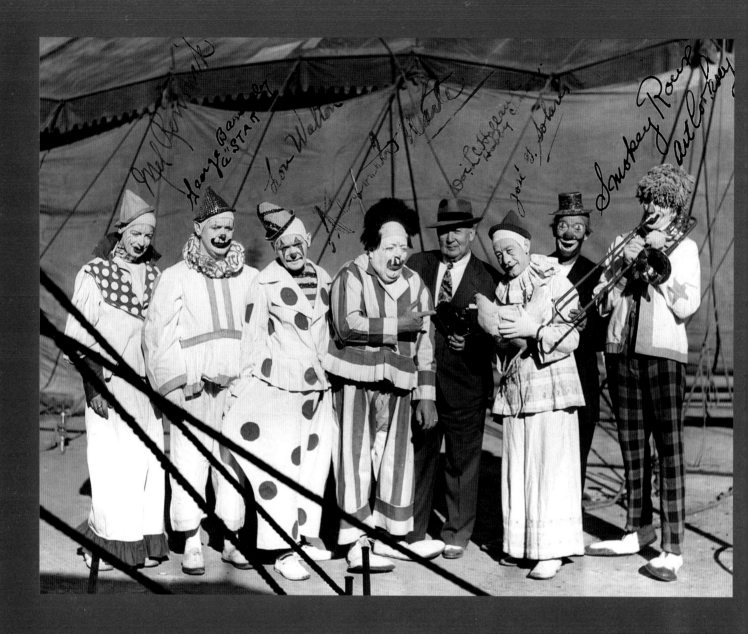

Clyde Beatty Circus clowns, from left to right: Mel Rennick, George Barnaby, Lou
Walton, Alfonato Naite, Doc Holland, Jose G. Solares, Smokey Rouse, and Art
Cooksey, photograph, 1946
Clowns des Clyde Beatty Circus, v. l. n. r.: Mel Rennick, George Barnaby, Lou Walton,
Alfonato Naite, Doc Holland, Jose G. Solares, Smokey Rouse und Art Cooksey,
Fotografie, 1946
Clowns du cirque Clyde Beatty, de gauche à droite: Mel Rennick, George Barnaby,
Lou Walton, Alfonato Naite, Doc Holland, Jose G. Solares, Smokey Rouse et Art
Cooksey, photographie, 1946

▶ Cross-dressing clown Ernie Burch, photograph, 1950s
Der Clown Ernie Burch in Frauenkleidern, Fotografie, 1950er Jahre
Le clown travesti Ernie Burch, photographie, années 50

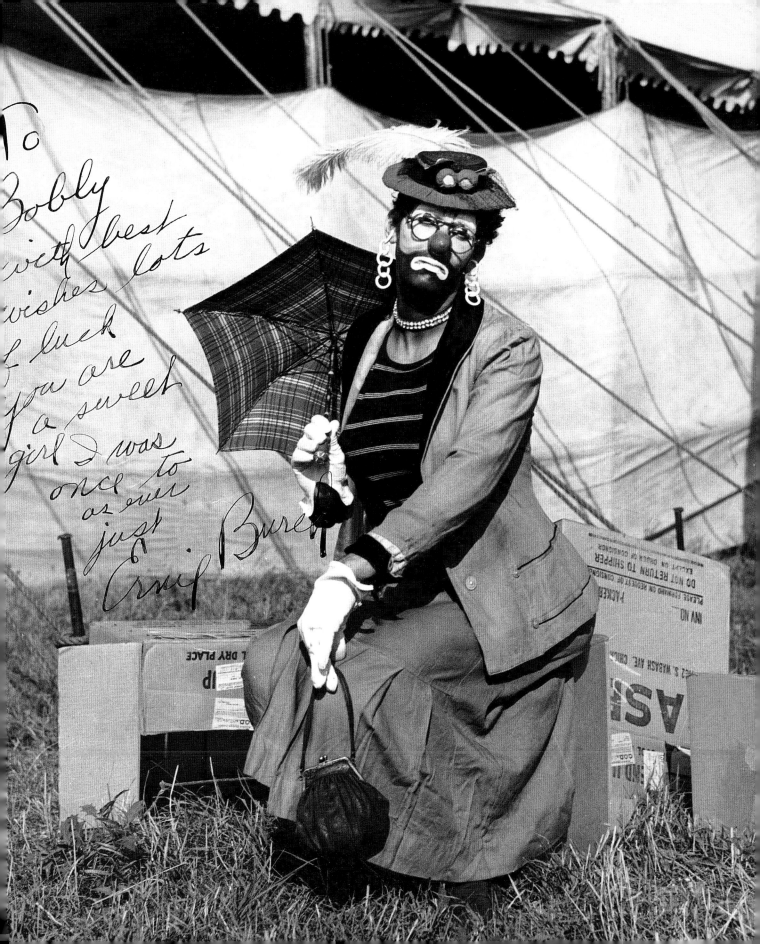

To
Bobby
with best
wishes lots
of luck
you are
a sweet
girl I was
once to
as ever
just
Emif Buret

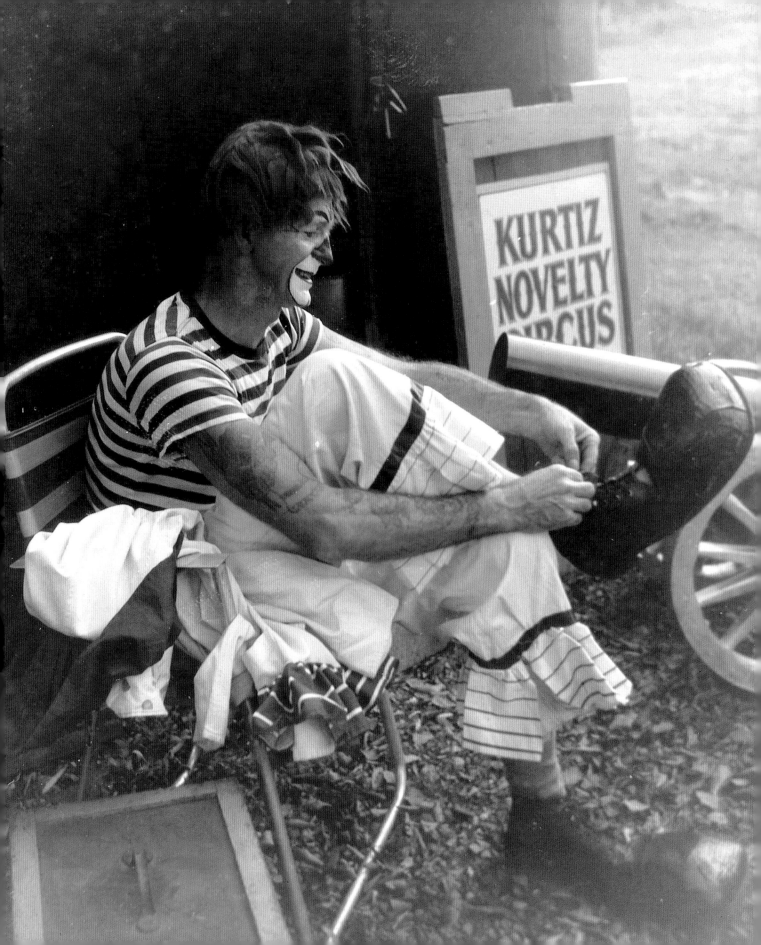

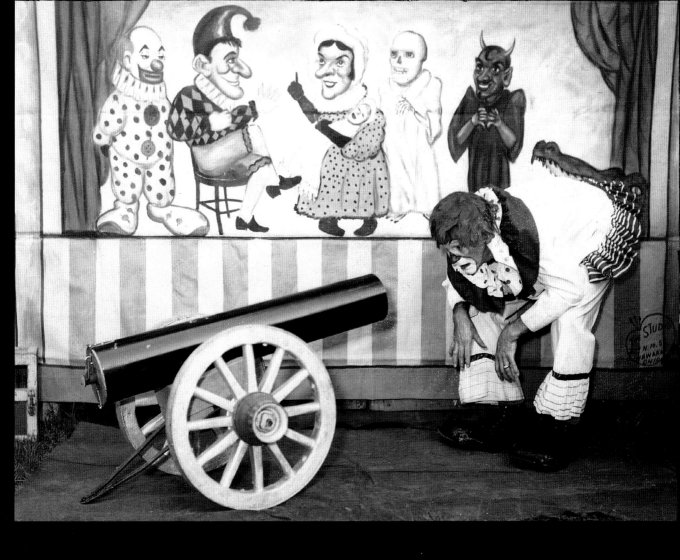

◄ Clown getting dressed for Kurtiz Novelty Circus, 1940s
Clown beim Umziehen, Kurtiz Novelty Circus, 1940er Jahre
Clown enfilant son costume, cirque Kurtiz Novelty, années 40

Clown and cannon, photograph by Gene Glen, 1950s
Clown mit Kanone, Fotografie von Gene Glen, 1950er Jahre
Clown et canon, photographie de Gene Glen, années 1950

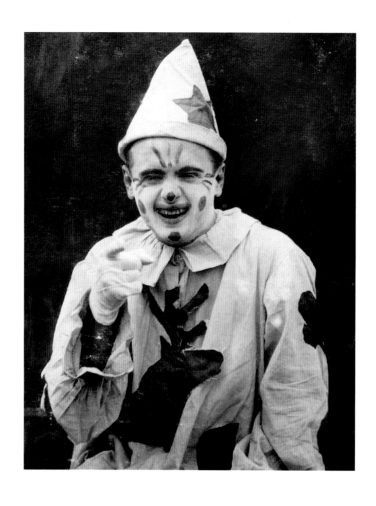

Photo postcard, 1922
Postkarte, 1922
Photo carte postale, 1922

▶ Goo Goo the Clown sporting props, photograph, 1950s
Goo Goo der Clown mit Requisiten, Fotografie, 1950er Jahre
Goo Goo the Clown présentant ses accessoires, photographie, années 50

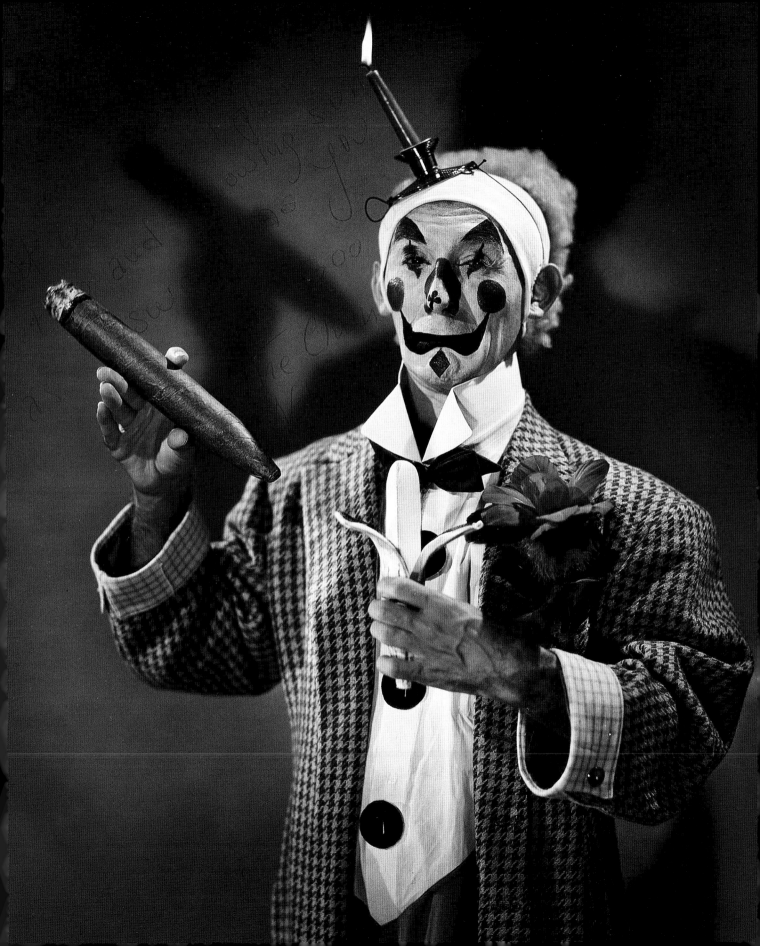

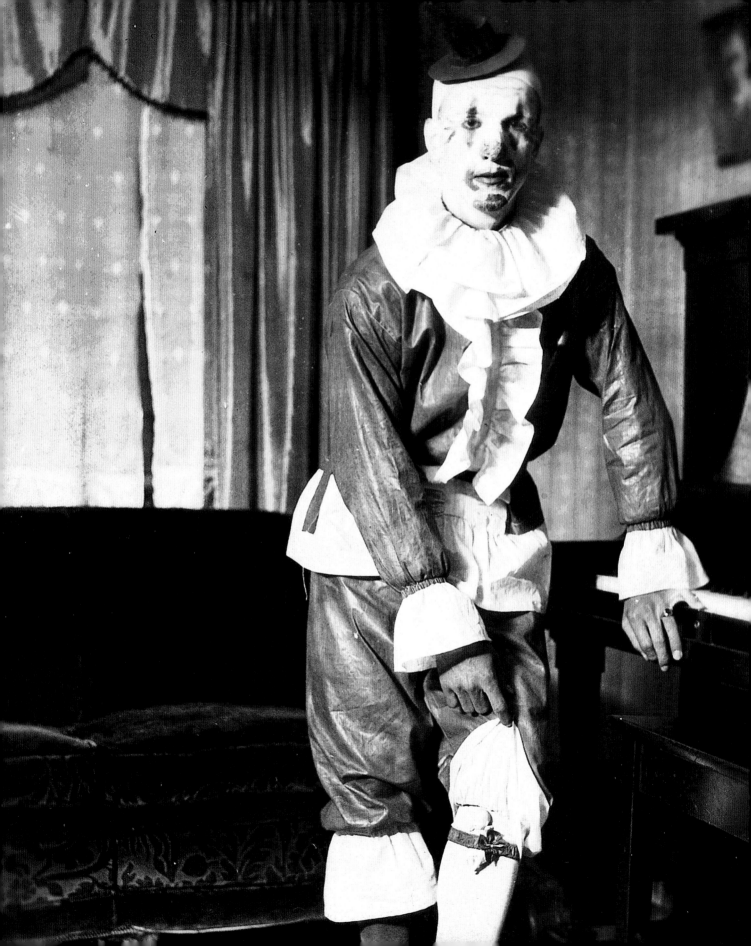

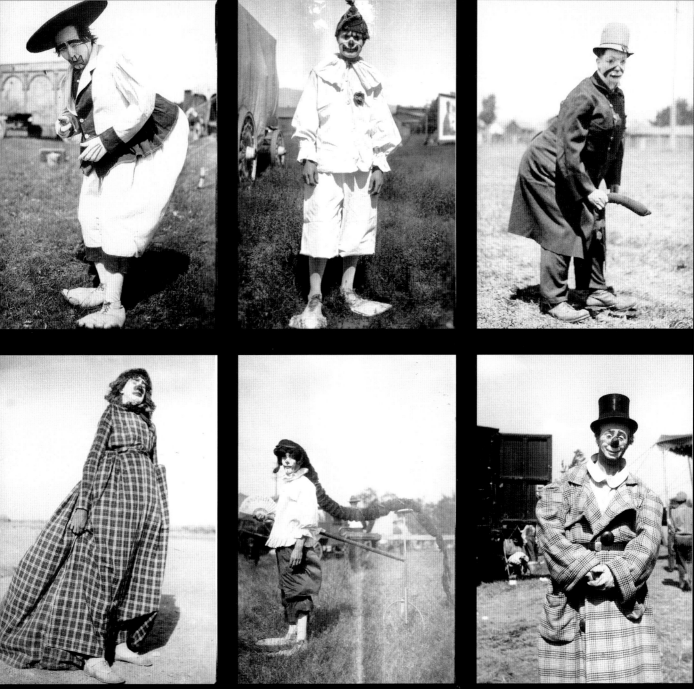

◄ Clown with garter, snapshot, 1930s
Clown mit Strumpfhalter, Schnappschuss, 1930er Jahre
Clown à la jarretière, instantané, années 30

Assorted informal snapshots, 1940s
Diverse Schnappschüsse, 1940er Jahre
Divers instantanés informels dans le même style, années 40

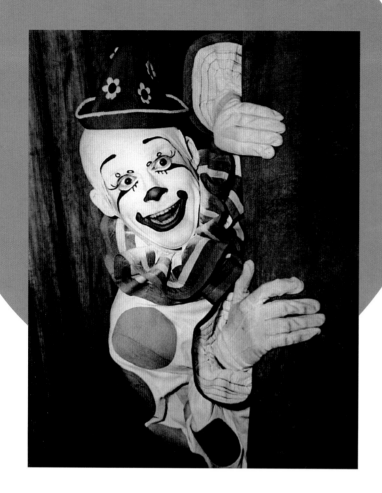

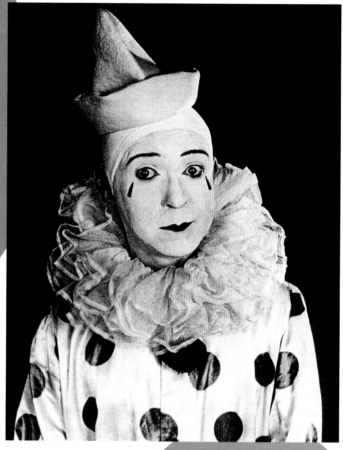

Clown Harry Dann, photograph, 1930s
Clown Harry Dann, Fotografie, 1930er Jahre
Clown Harry Dann, photographie, années 30

Silent film star Harry Langdon, photograph, 1920s
Stummfilmstar Harry Langdon, Fotografie, 1920er Jahre
Star du muet Harry Langdon, photographie, années 1920

▶ Paul "Chesty" Mortier, photograph, 1940s
Paul „Chesty" Mortier, Fotografie, 1940er Jahre
Paul Mortier dit « La poitrine », photographie, années 40

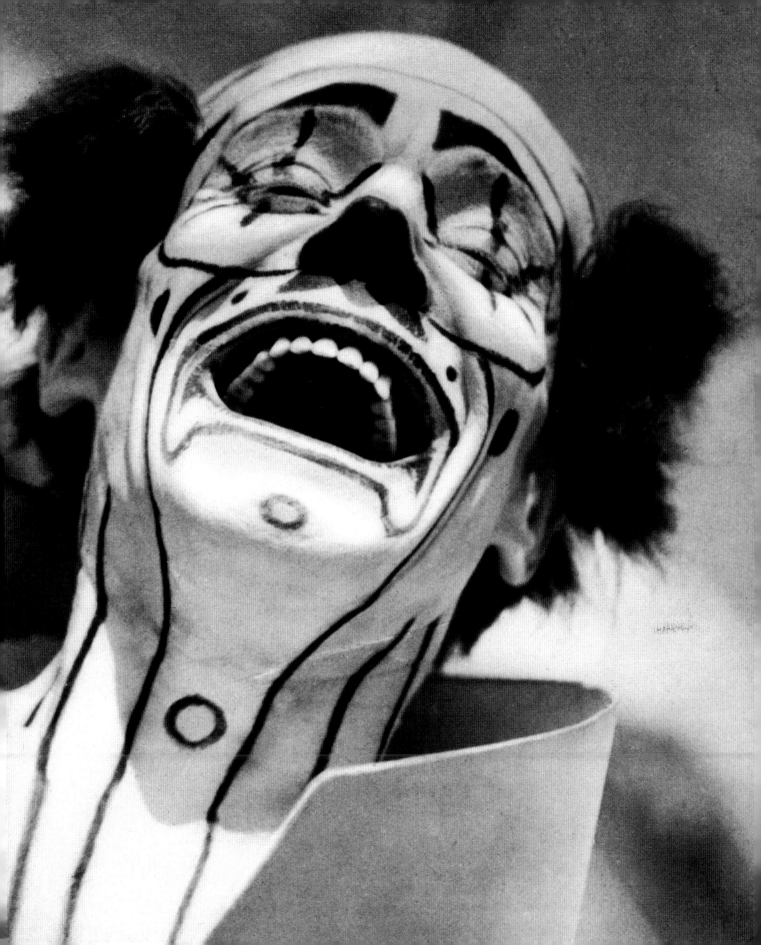

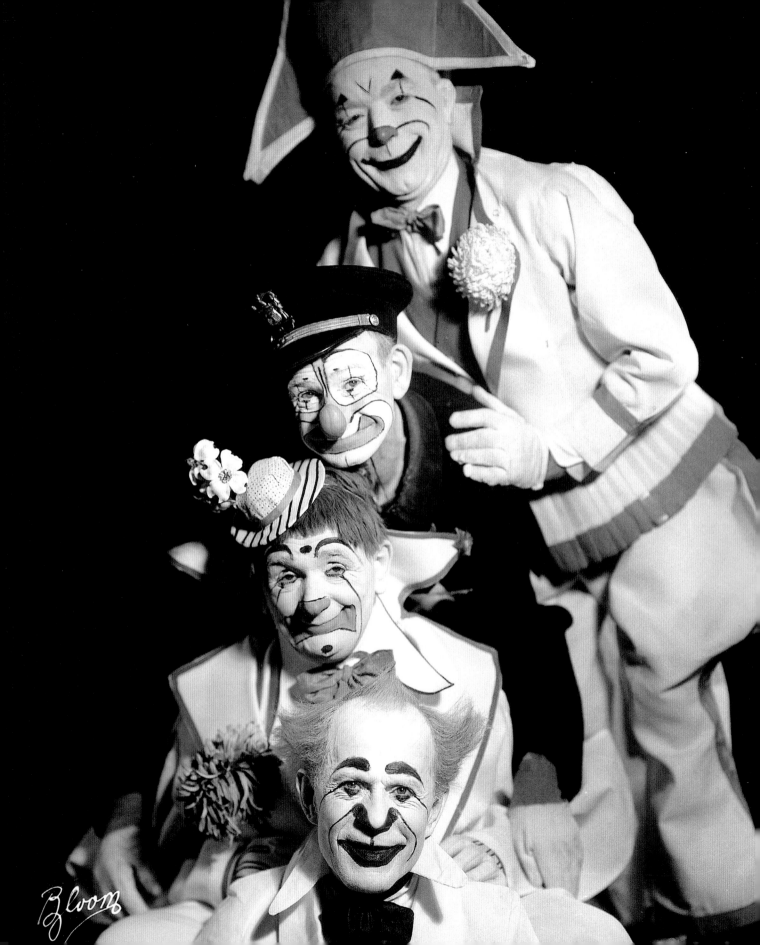

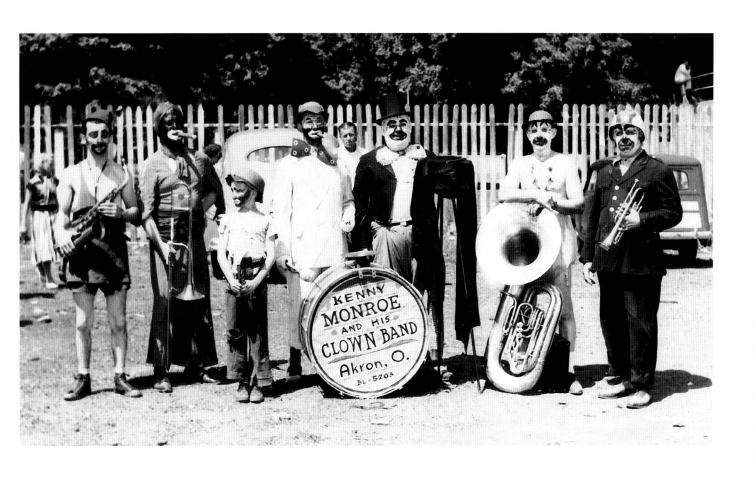

◄ Portrait of four clowns, publicity photograph by Bloom, Chicago, 1940s
Gruppenporträt mit vier Clowns, Werbefoto von Bloom, Chicago, 1940er Jahre
Portrait de quatre clowns, photographie publicitaire par Bloom, Chicago, années 40

Kenny Monroe and his Clown Band, Akron, Ohio, snapshot, 1940s
Kenny Monroe und seine Clown Band, Akron, Ohio, Schnappschuss, 1940er Jahre
Kenny Monroe et son orchestre de clowns, Akron, Ohio, instantané, années 40

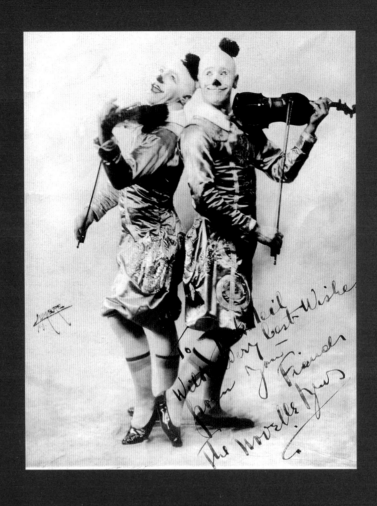

Novelle Bros., vaudeville actors, photograph, ca. 1900
Novelle Bros., Vaudeville-Darsteller, Fotografie, um 1900
Les frères Novelle, comiques de vaudeville, photographie, vers 1900

▶ Pagano, the one-man band, photograph, 1920s
Pagano, die Ein-Mann-Band, Fotografie, 1920er Jahre
Pagano, un orchestre à lui tout seul, photographie, années 20

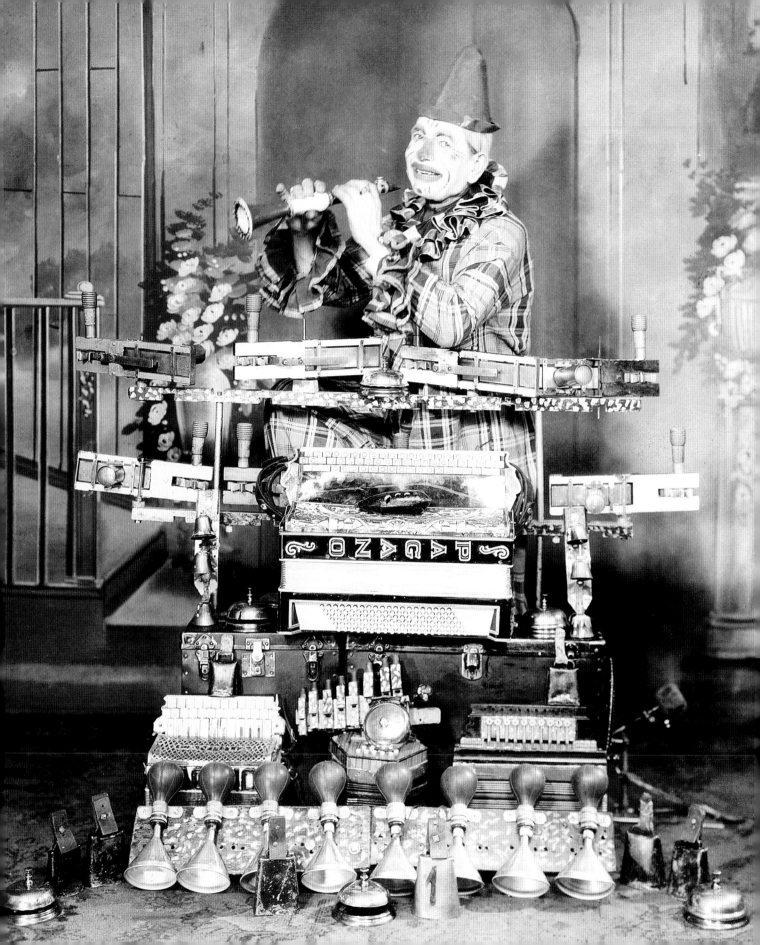

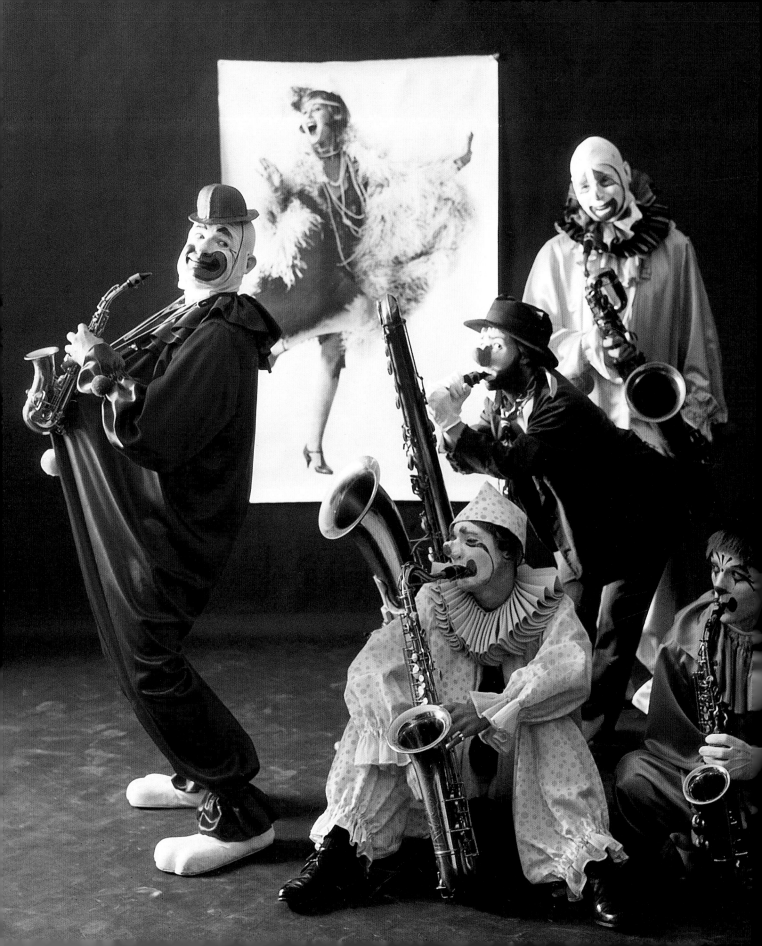

Musical novelty act Jack Green, photograph, 1950s
Musikalische Nummer von Jack Green, Fotografie, 1950er Jahre
Jack Green et ses parodies musicales, photographie, années 50

◄ Session outtake for Clancy's Clowns' album cover, *Saxophobia*, Capitol Records, 1959
Unveröffentlichtes Sessionfoto der Clancy's Clowns für die Plattenhülle von *Saxophobia*, Capitol Records, 1959
Une photo prise pendant l'enregistrement, couverture de l'album *Saxophobia* des Clancy Clowns, Capitol Records, 1959

► The Shappis and Their Crazy Piano, publicity photograph, 1950s
The Shappis and Their Crazy Piano, Werbefoto, 1950er Jahre
Les Shappis et leur piano fou, photographie publicitaire, années 50

►► Skull the Clown, publicity photograph, 1950s
Skull the Clown, Werbefoto, 1950er Jahre
Skull the Clown, photographie publicitaire, années 1950

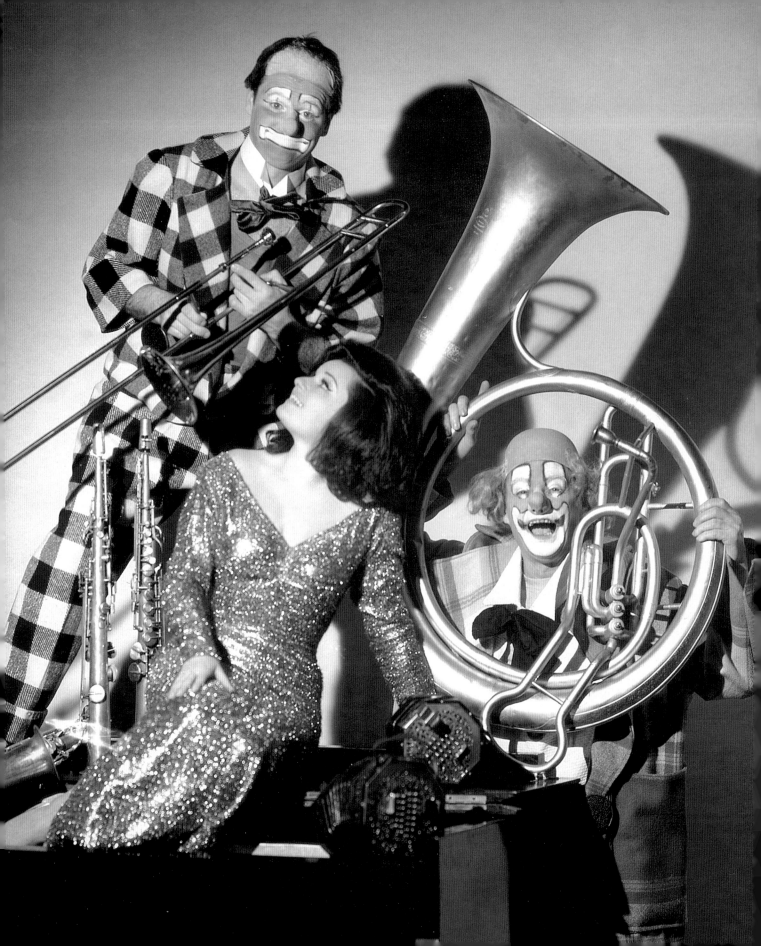

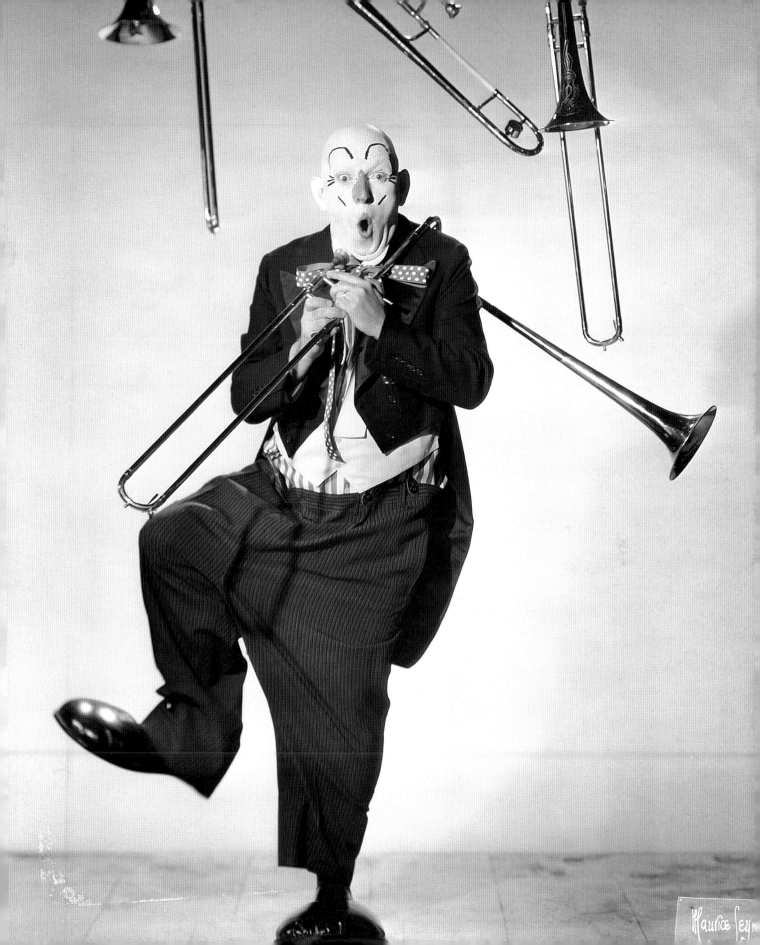

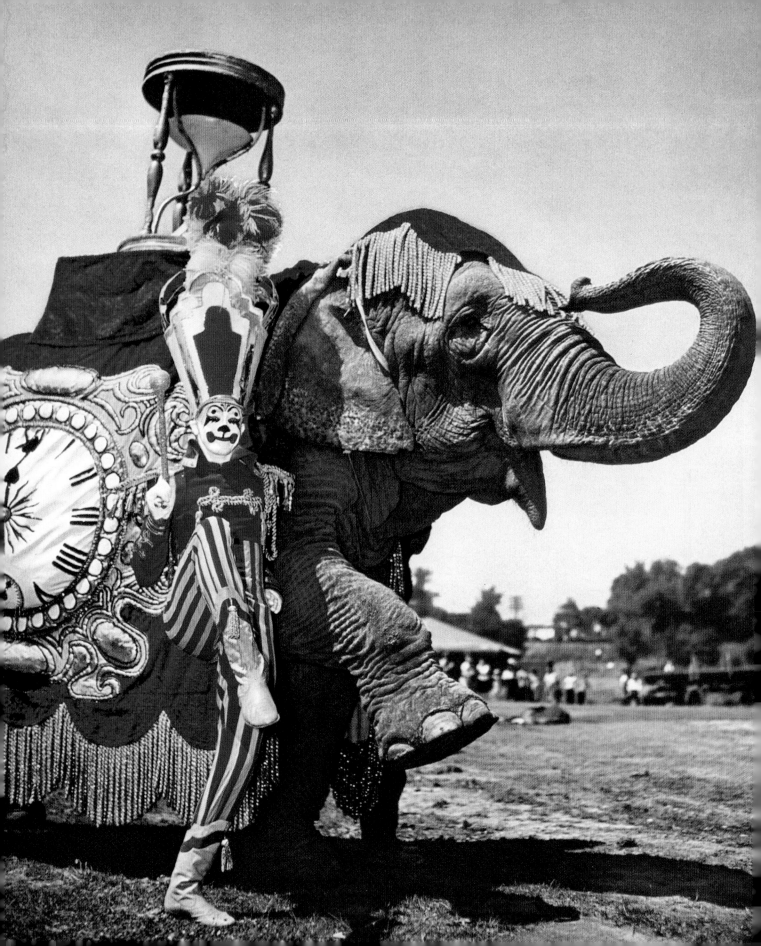

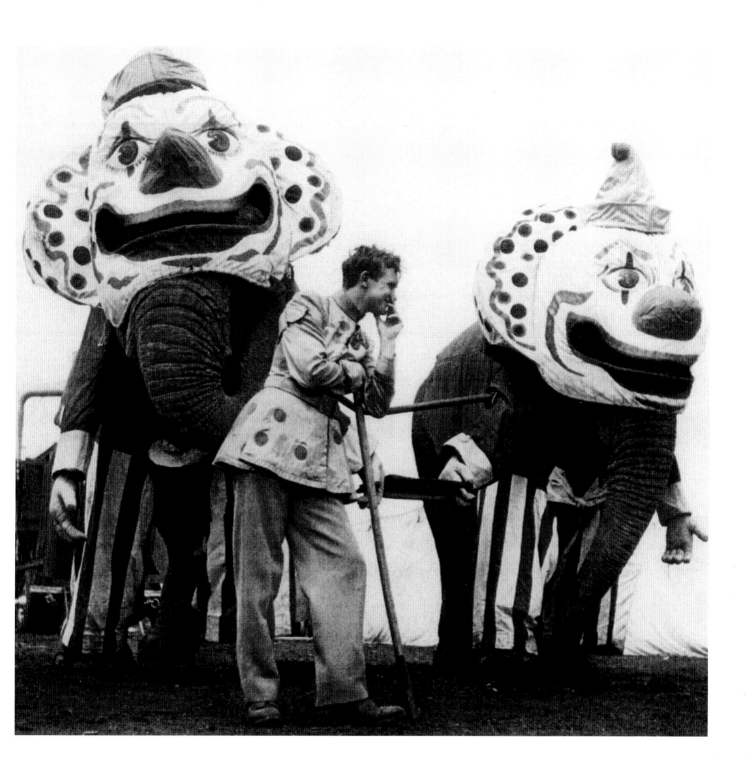

Elephants on parade, photographs, 1958 (left), 1940s (above)
Elefantenparaden, Fotografien, 1958 (links), 1940er Jahre (oben)
Eléphants pendant la parade, photographies, 1958 (à gauche), 1940 (ci-dessus)

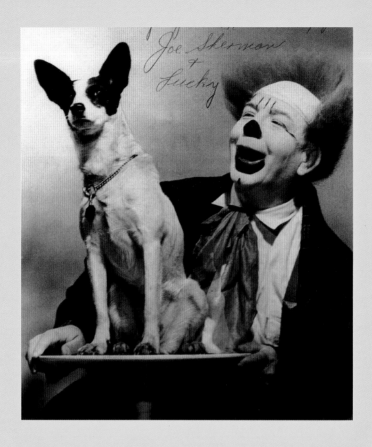

Hall of Fame clown Joe Sherman with his dog, Lucky, publicity photograph, 1940s
Clown Joe Sherman, Mitglied der Hall of Fame, mit seinem Hund Lucky, Werbefoto, 1940er Jahre
Le célèbre clown vedette Joe Sherman, avec son chien Lucky, photographie publicitaire, années 40

▶ The "King of Clowns" Felix Adler with his piglet, Honey, photograph, 1940s
Der „King of Clowns" Felix Adler mit seinem Ferkel Honey, Fotografie, 1940er Jahre
Le «Roi des clowns» Felix Adler avec son porcelet Honey, photographie, années 40

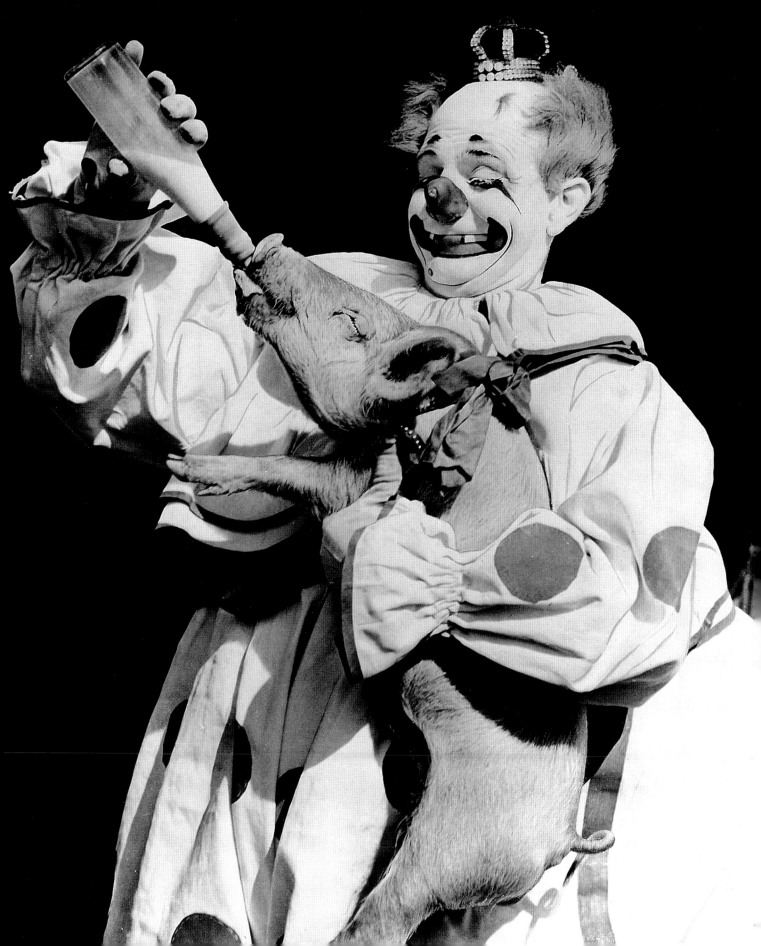

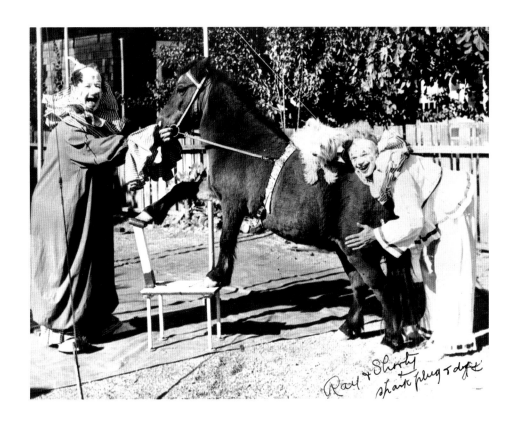

Ray & Shorty + sparkplug + dogs

◄ Ernest Torrence as the clown in the film *The Sideshow of Life*, publicity still, 1924
Ernest Torrence als Clown in dem Film *The Sideshow of Life*, Werbefoto, 1924
Ernest Torrence, le clown du film *The Sideshow of Life*, photographie du film, publicité, 1924

Clowns Ray and Shorty with their donkey Sparkplug and dogs, snapshot, 1940s
Die Clowns Ray und Shorty mit ihrem Esel Sparkplug und Hunden, Schnappschuss, 1940er Jahre
Les clowns Ray et Shorty, leur âne Sparkplug et leurs chiens, instantané, années 40

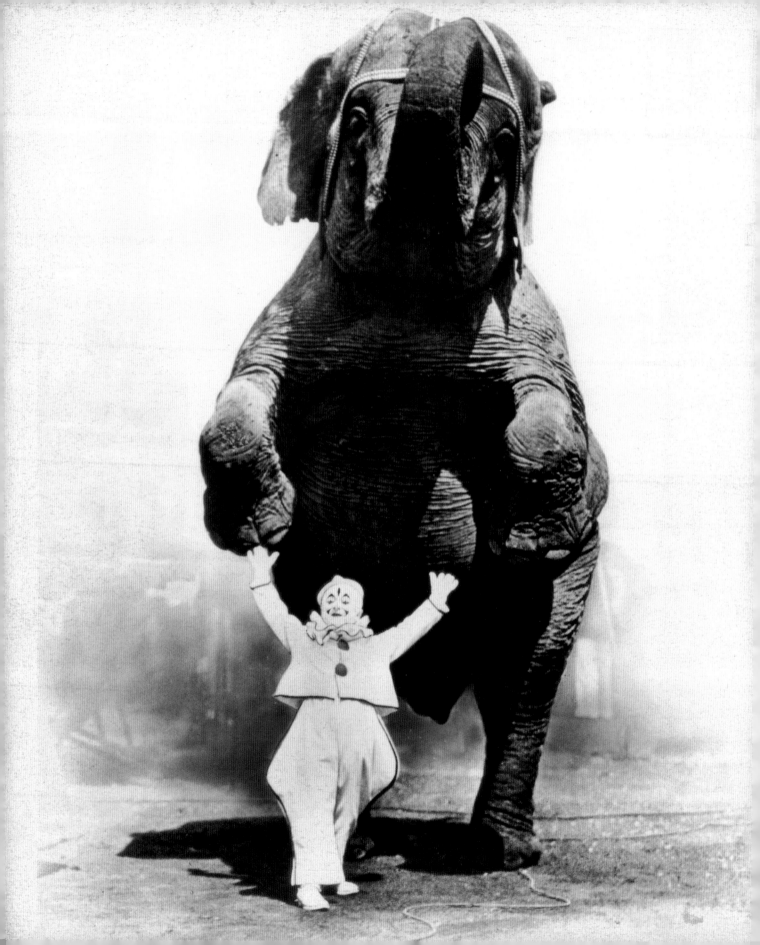

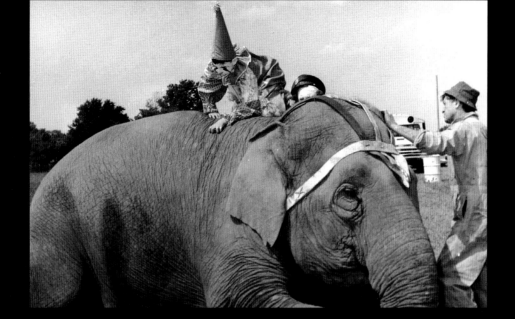

◀ Midget clown with circus elephant, publicity photograph, 1930s
Zwergwüchsiger Clown mit Zirkuselefant, Werbefoto, 1930er Jahre
Clown nain et éléphant de cirque, photographie, années 30

Clown climbing aboard elephant for circus parade, snapshot, 1950s
Ein Clown besteigt einen Elefanten bei einer Zirkusparade, Schnappschuss, 1950er Jahre
Clown grimpant sur un éléphant pour la parade, instantané, années 50

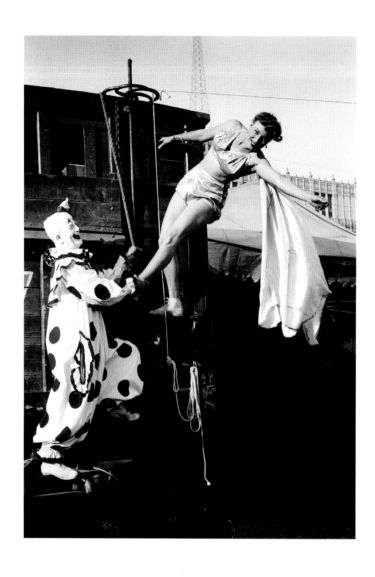

Clown with female circus acrobat, photograph, 1940s
Clown mit Zirkusakrobatin, Fotografie, 1940er Jahre
Clown avec une acrobate de cirque, photographie, années 40

▶ Screwy the Clown getting his earlobe tweaked, photograph by Carl H. Haussman, 1940s
Screwy der Clown bekommt die Ohren lang gezogen, Fotografie von Carl H. Haussman, 1940er Jahre
Le clown Screwy se faisant tirer l'oreille, photographie de Carl H. Haussman, années 40

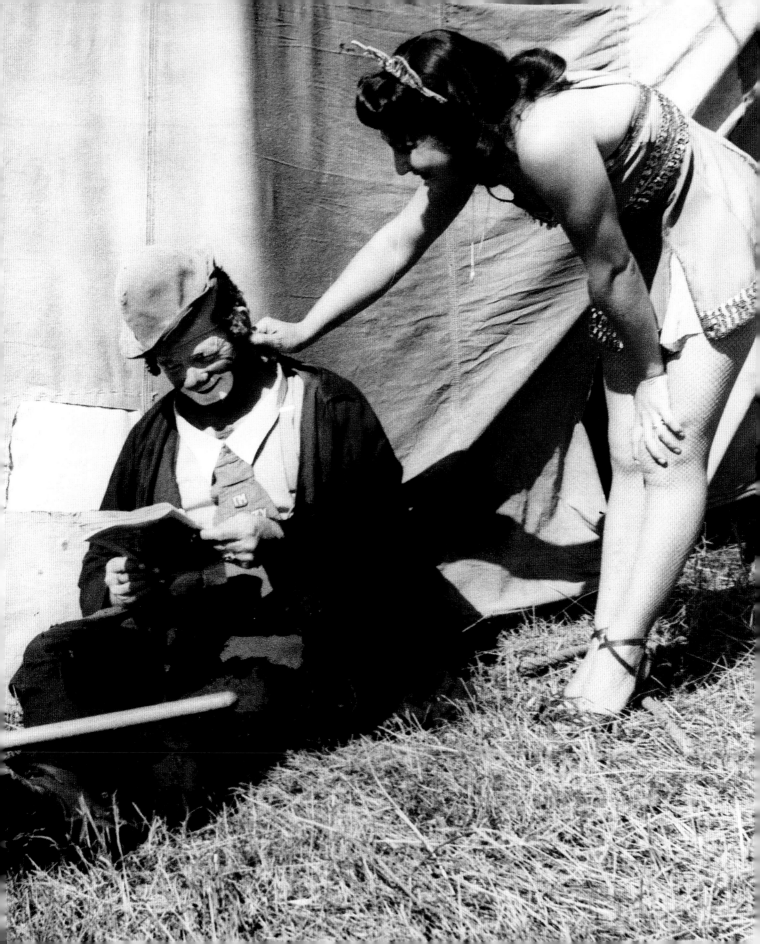

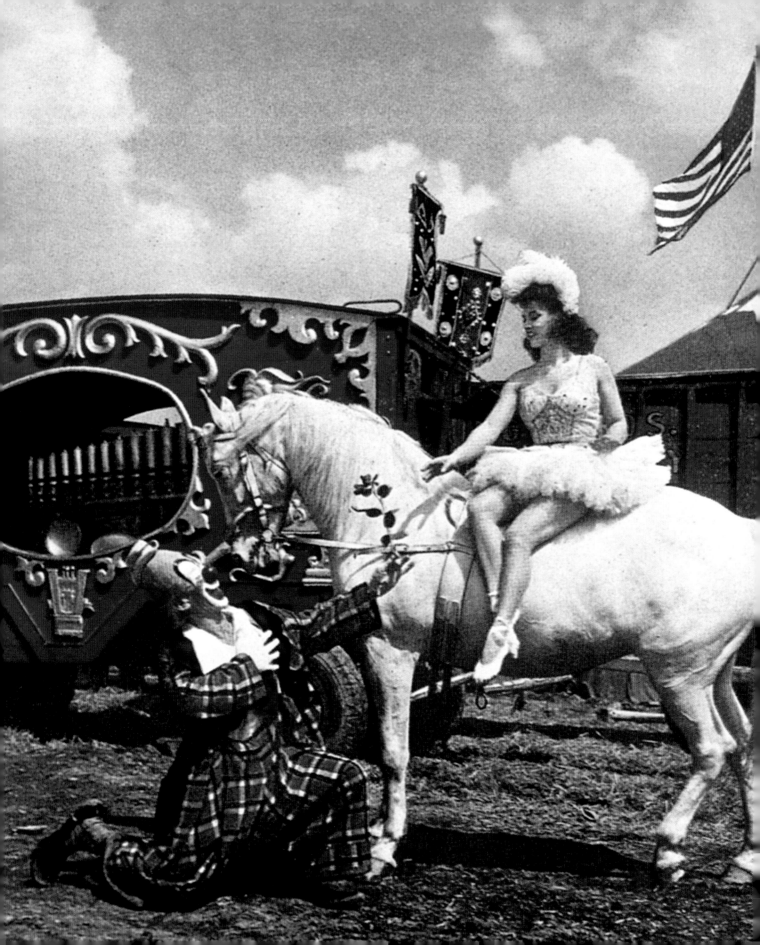

◀ Lou Jacobs proposing to showgirl, photograph, 1958
Lou Jacobs macht einer Kunstreiterin den Hof, Fotografie, 1958
Lou Jacobs faisant sa demande en mariage à une écuyère, photographie, 1958

Snapshot, 1920s
Schnappschuss, 1920er Jahre
Instantané, années 20

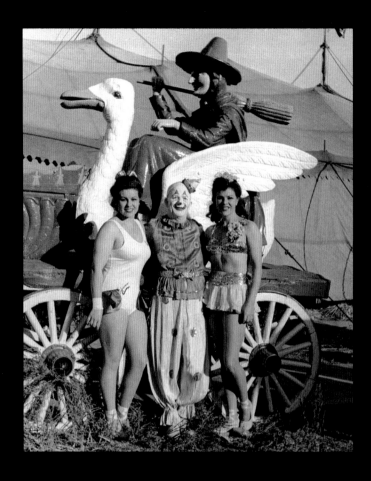

Backstage, in front of a circus float, snapshot, ca. 1940
Hinter dem Zelt vor einem Zirkuswagen, Schnappschuss, um 1940
Derrière la scène, devant un char de parade, instantané, vers 1940

▶ Clown and showgirl, snapshot, ca. 1961
Clown und Revuegirl, Schnappschuss, um 1961
Clown et showgirl, instantané, vers 1961

▶ ▶ Betty Page posing with doll, photograph by Irving Klaw, 1950s
Betty Page posiert mit Puppe, Fotografie von Irving Klaw, 1950er Jahre
Betty Page et une poupée, photographie d'Irving Klaz, années 50

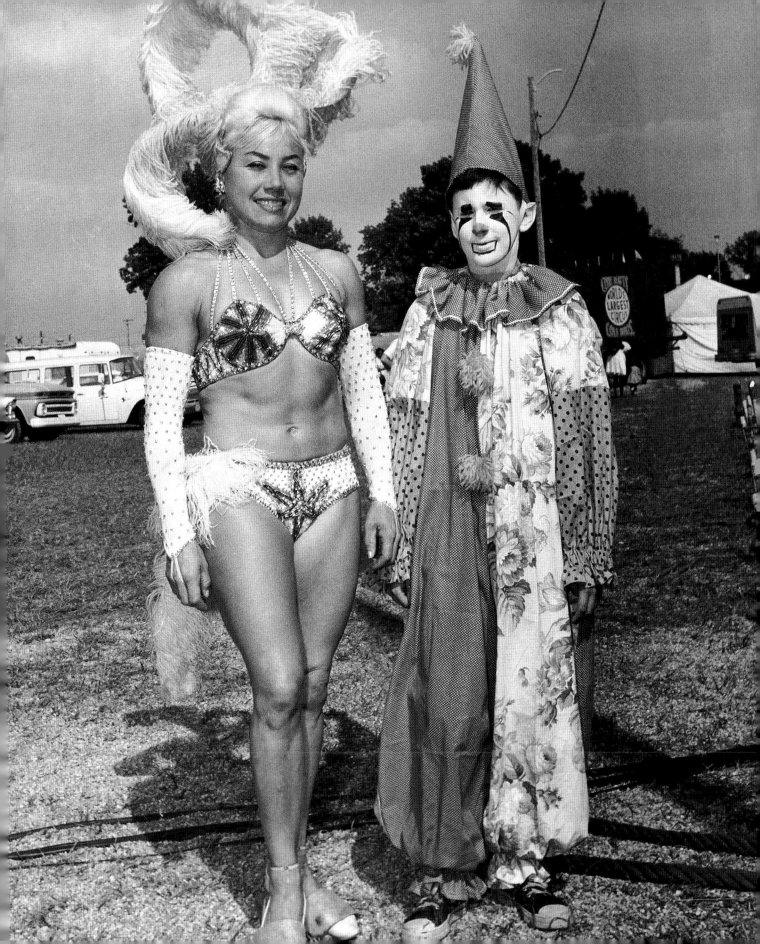

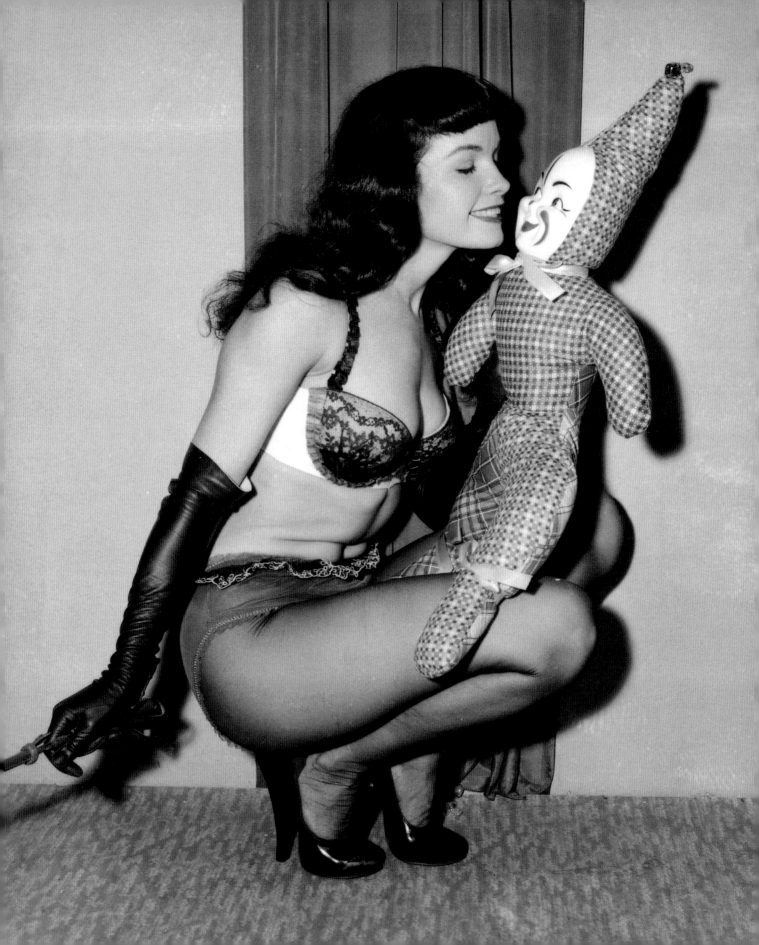

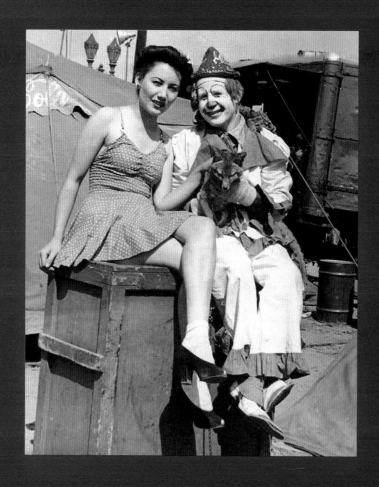

Snapshot, ca. 1949
Schnappschuss, um 1949
Instantané, vers 1949

◀◀ Clown doll, ca. 1938
Clownpuppe, um 1938
Poupée clown, vers 1938

▶ Snapshot, ca. 1930
Schnappschuss, um 1930
Instantané, vers 1930

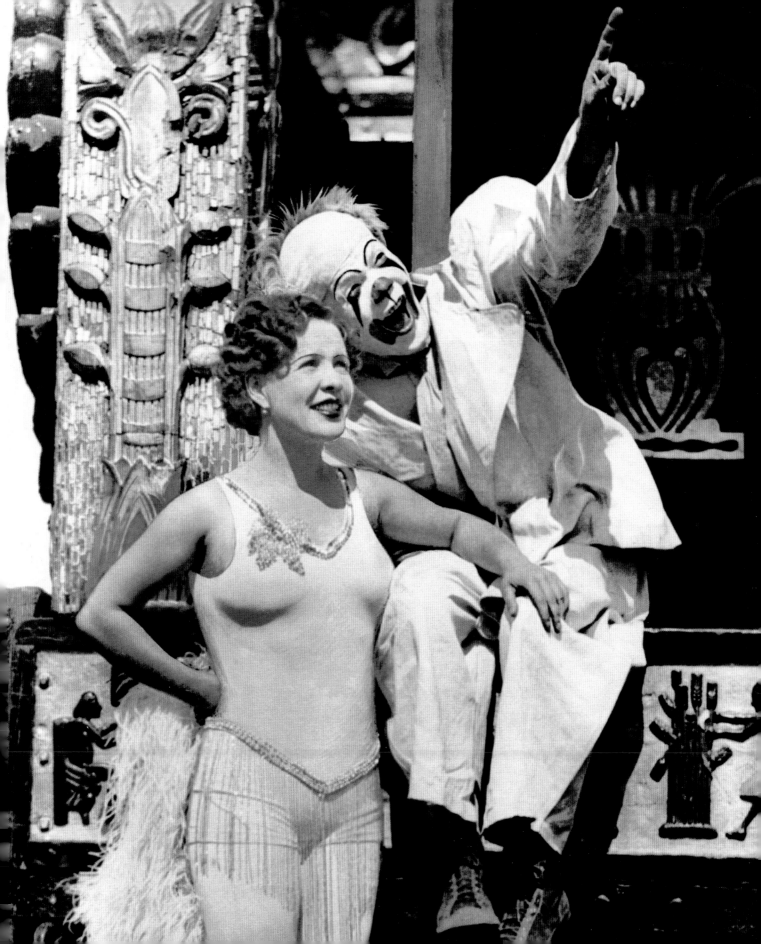

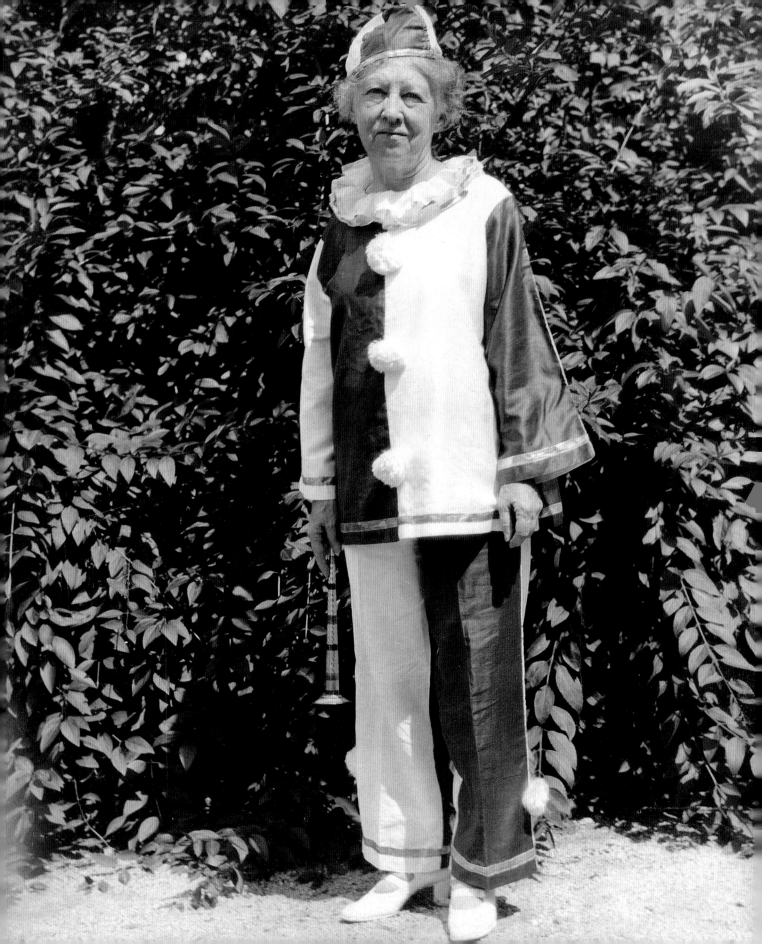

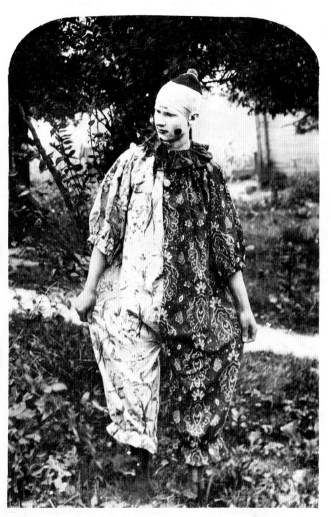

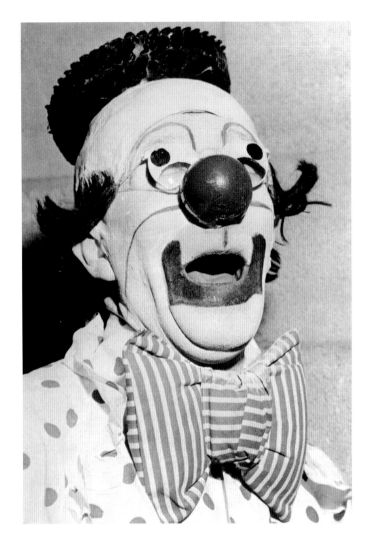

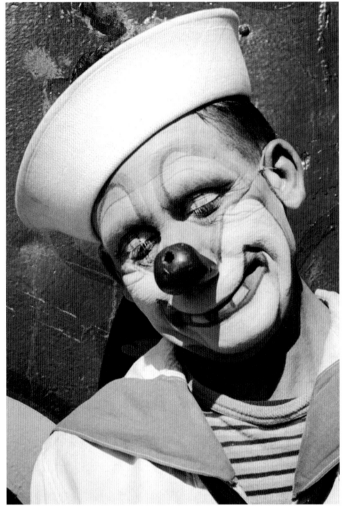

Sailor clown, photograph, 1950s
Matrosenclown, Fotografie, 1950er Jahre
Clown marin, photographie, années 50

▶ The crustier side of clowns, 1950s–60s
Ein eher barscher Clown, 1950er bis 1960er Jahre
Le côté revêche des clowns, années 50–60

Ed Raymond from Polack Bros. Shrine Circus, publicity photograph, 1950s
Ed Raymond aus dem Polack Bros. Shrine Circus, Werbefoto, 1950er Jahre
Ed Raymond du Polack Bros. Shrine Circus, photographie publicitaire, années 50

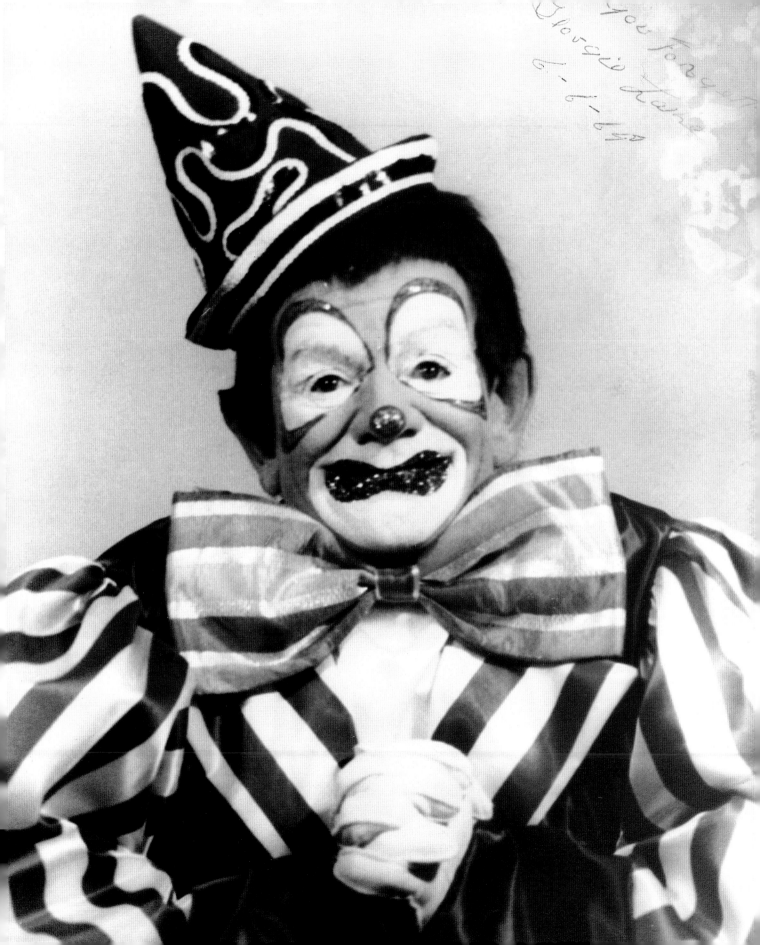

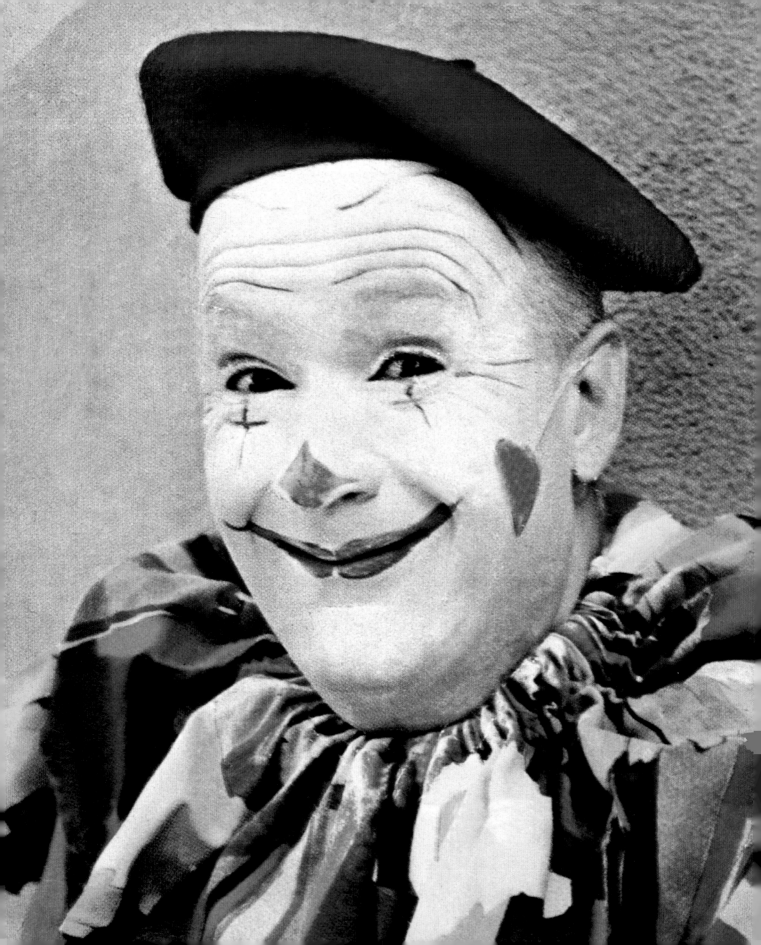

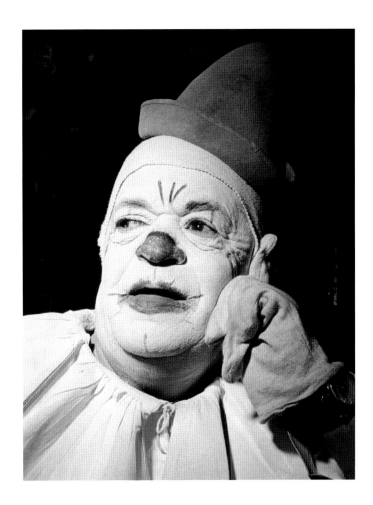

"THE FOOL DOTH THINK HE IS WISE, BUT THE WISE MAN KNOWS HIMSELF TO BE A FOOL."
– WILLIAM SHAKESPEARE, "AS YOU LIKE IT", ACT V, SCENE 1

„DER NARR HALT SICH FÜR WEISE, ABER DER WEISE WEISS, DASS ER EIN NARR IST."
– WILLIAM SHAKESPEARE, *WIE ES EUCH GEFÄLLT*, 5. AUFZUG. 1. SZENE, ÜBERSETZT VON AUGUST WILHELM VON SCHLEGEL

« LE FOU CROIT QU'IL EST SAGE, MAIS LE SAGE SAIT BIEN QU'IL N'EST QU'UN FOU. »
– WILLIAM SHAKESPEARE, *COMME IL VOUS PLAIRA*, ACTE I, SCÈNE 1 (*TRAD. JULES SUPERVIELLE*)

◄ Mister Mumbles the Magic Clown, promotional postcard, 1973
Mister Mumbles the Magic Clown, Werbepostkarte, 1973
Mister Mumbles the Magic Clown, carte postale publicitaire, 1973

Joe Short, "Captain Bob-Lo," photograph, 1958
Joe Short, „Captain Bob-Lo", Fotografie, 1958
Joe Short, «Captain Bob-Lo», photographie, 1958

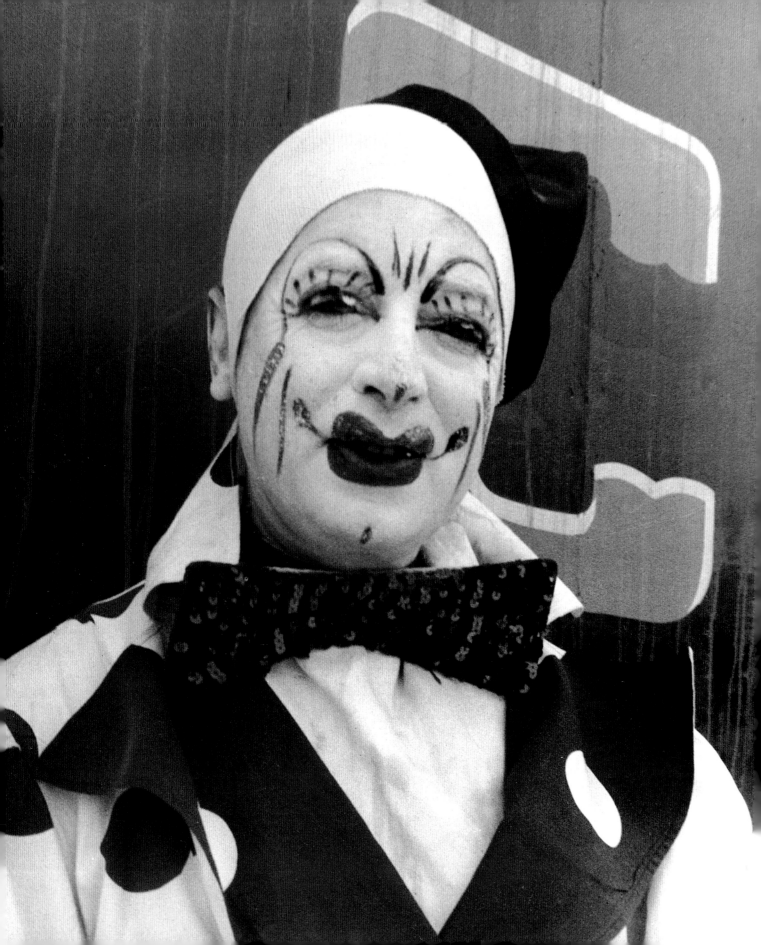

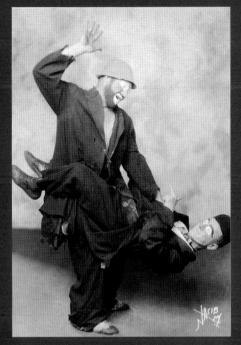
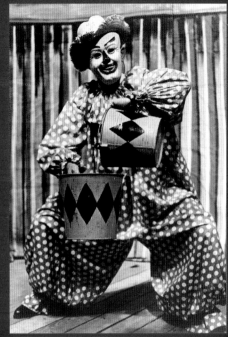
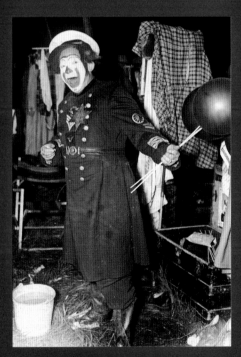
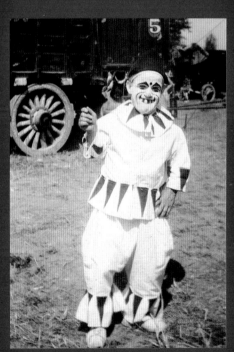

◄ Mel Rennick in front of a Clyde Beatty Circus wagon, photograph, 1946
Mel Rennick vor einem Wagen des Clyde Beatty Circus, Fotografie, 1946
Mel Rennick devant une roulotte du cirque Clyde Beatty, photographie, 1946

Anonymous clowns, photographs, 1930s
Unbekannte Clowns, Fotografien, 1930er Jahre
Clowns anonymes, photographies, années 30

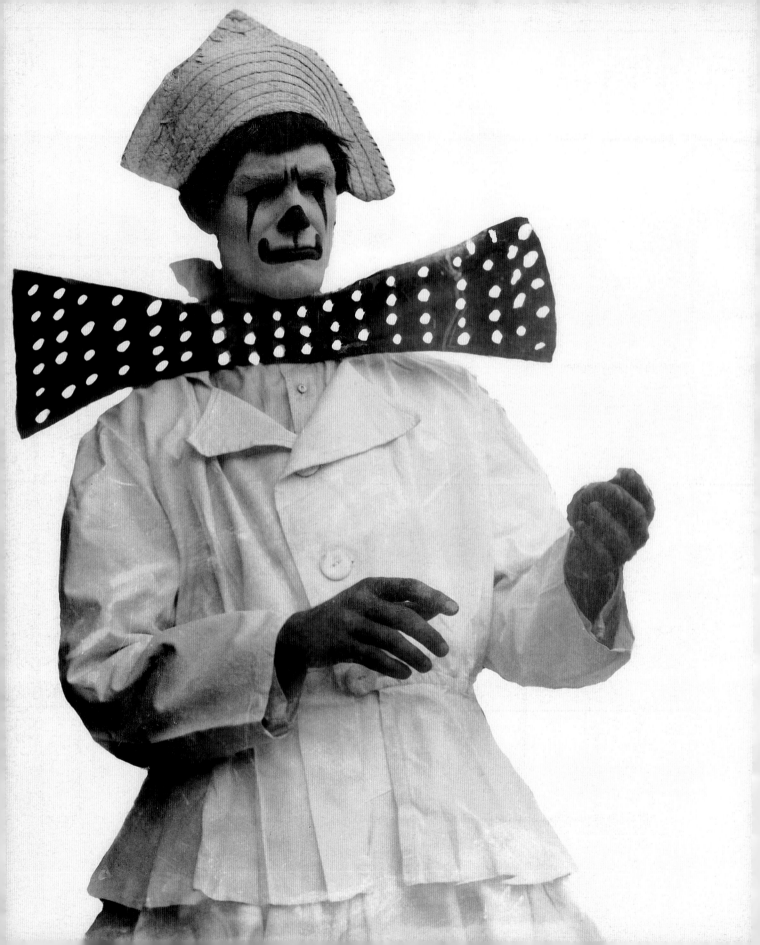

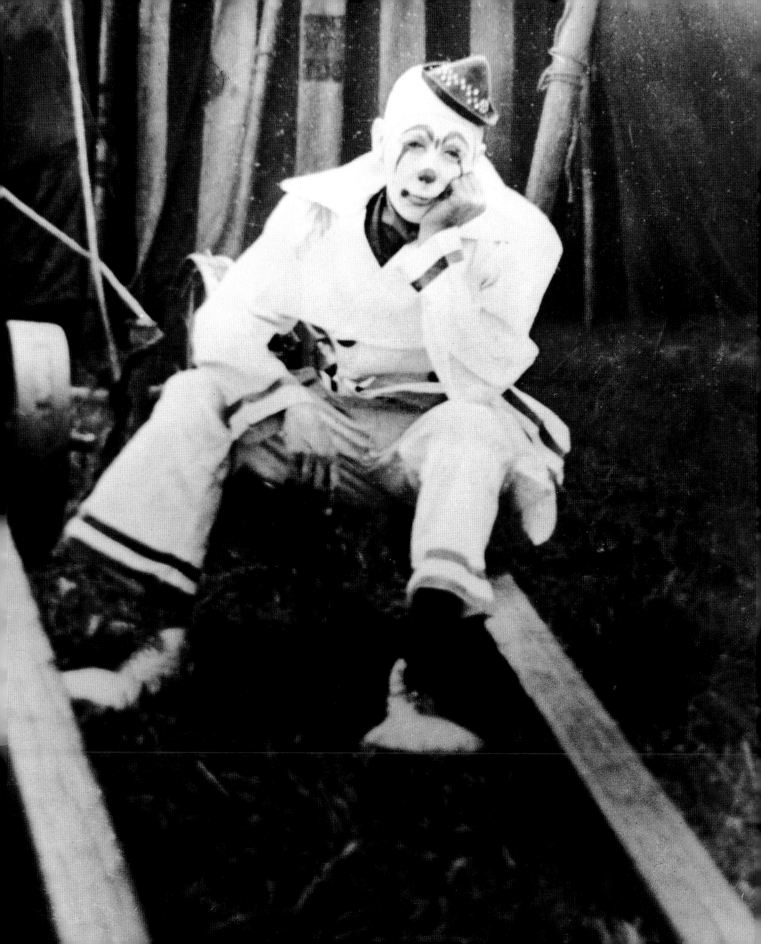

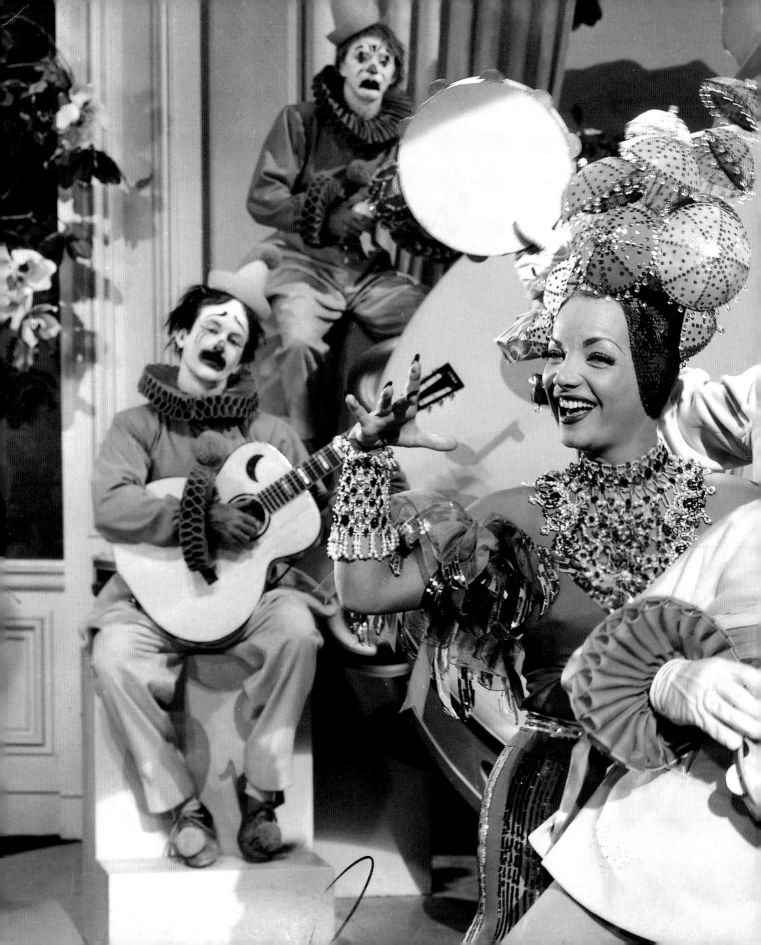

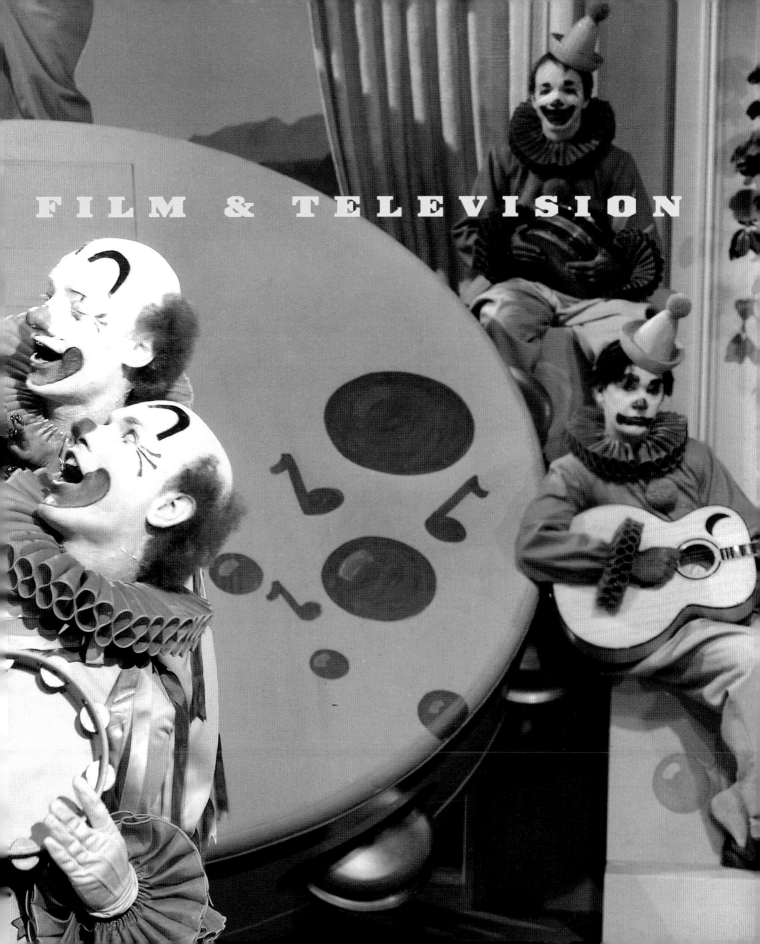

FILM & TELEVISION

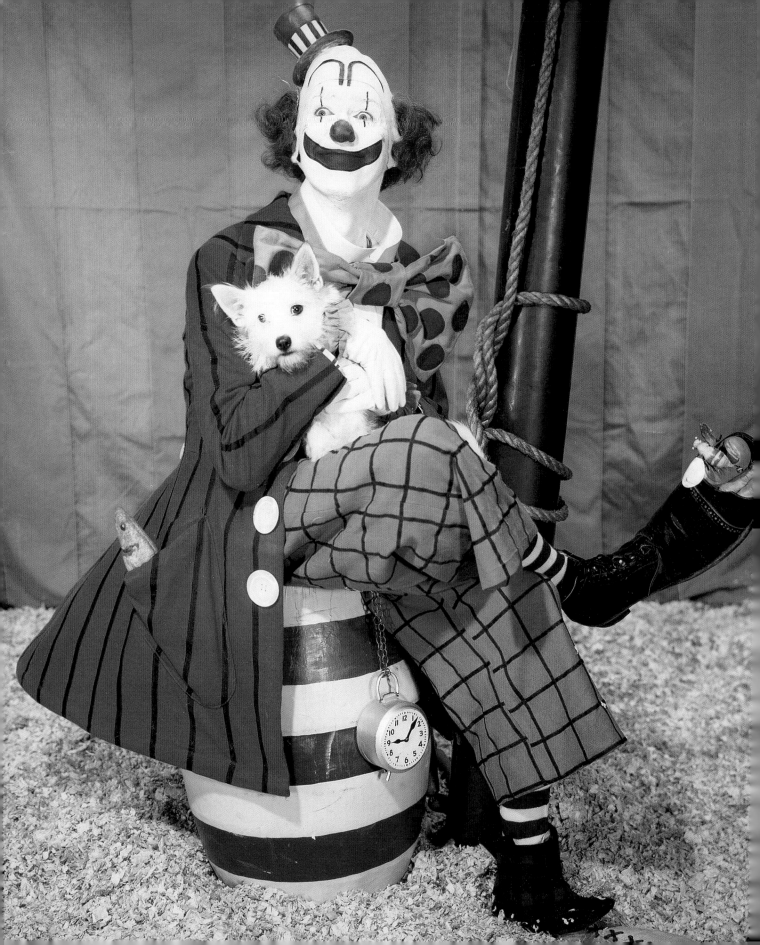

FILM & TELEVISION

The big screen of the movies and the small screen of television transported the circus first into theaters and later into private homes. Waiting for the circus to come to town during the summer was no longer necessary. In film, the intrigue and rich subject matter of a traveling show delivered strong scripts in all genres – comedy, drama, the musical, and even the horror film. Silent movie impresario Mack Sennett brought many celebrated clowns to the silver screen (several of them from the vaudeville circuit), including Charlie Chaplin, Fatty Arbuckle, Buster Keaton, Ben Turpin, Harry Langdon, and W. C. Fields. Prominent actresses and actors from Ginger Rogers to Tony Curtis tried their hand at clowning, and a few clowns even discovered acting.

Being more visual than verbal, clown acts transcended language and cultural barriers, becoming popular both on celluloid and through the tube. By the 1950s, TVs were affordable and widespread, with one in most households; television became the afternoon babysitter for American school children of the nuclear age. A motley-painted clown was accepted as a comfortable friend who introduced cartoons and held birthday parties broadcast from this modern piece of electronics. Once the kids were home from school and before homework beckoned, a golden time, a surreal moment, arrived when children could lose themselves in fantasy through the novelty of television.

Clowns became the ambassadors of televised children's entertainment. With their roots in live theater, they relied upon slapstick and vaudeville to generate chuckles from a studio audience before the advent of canned laughter and computer-generated special effects. Popular programs were broadcast at a time when a pie in the face was still funny and cartoons were shown that appealed to both eager boys and girls. "A cartoonist is just a clown with a pencil!" noted Pinto Colvig, the voice of Disney's Goofy and Capitol Records' original Bozo the Clown. Toys and prizes enticed young viewers to watch and participate. While some clowns were entertaining and harmless, others were quite nightmarish and may have led to some real phobias, the fodder for generations of psychotherapists to come.

◄◄ Carmen Miranda and friends in the musical *Nancy Goes to Rio*, film still, 1950
Carmen Miranda und Freunde in dem Musical *Nancy Goes to Rio*, Standfoto, 1950
Carmen Miranda et ses amis dans la comédie musicale *Voyage à Rio*, photographie du film, 1950

◄ Jimmy Stewart in *The Greatest Show on Earth*, publicity photograph, 1952
James Stewart in *Die größte Schau der Welt* (*The Greatest Show on Earth*), Werbefoto, 1952
Jimmy Stewart dans *Sous le plus grand chapiteau du monde*, photographie publicitaire, 1952

FILM & FERNSEHEN

Mit der Leinwand kam der Zirkus ins Kino, mit dem Fernsehen dann sogar zu den Zuschauern nach Hause. Es war nicht mehr nötig, darauf zu warten, dass er im Sommer in die Stadt kam. Die Intrigen und das bunte Leben einer fahrenden Schaustellertruppe wurden zu starken Drehbüchern in allen möglichen Filmgenres verarbeitet – Komödie, Drama, Musical, sogar Horrorfilm. Der große Impresario des Stummfilms, Mack Sennett, brachte viele gefeierte Clowns ins Kintopp, darunter Charlie Chaplin, Fatty Arbuckle, Buster Keaton, Ben Turpin, Harry Langdon und W. C. Fields. Namhafte Schauspieler von Ginger Rogers bis Tony Curtis versuchten sich als Clowns, und einige Clowns machten später sogar als Schauspieler Karriere.

Clownsnummern stützten sich stärker auf das Visuelle als aufs Verbale und waren dadurch in der Lage, Kultur- und Sprachbarrieren zu überwinden und sowohl auf Zelluloid als auch auf der Mattscheibe erfolgreich zu sein. In den Fünfzigern waren Fernsehgeräte so erschwinglich, dass sie bereits in den meisten amerikanischen Haushalten standen und zum nachmittäglichen Babysitter avancierten. Ein bunt angemalter Clown, der Zeichentrickserien ansagte und Kindergeburtstage veranstaltete, wurde als Freund und Beschützer akzeptiert. Wenn die Kinder von der Schule nach Hause kamen, lockte eine herrliche Zeit, in der sie sich in der Welt der Fantasie verlieren konnten, bevor sie Hausaufgaben machen mussten.

Clowns wurden die Botschafter des Kinderfernsehens. Von ihrer Bühnenerfahrung ausgehend, verließen sie sich auch im Studio auf Slapstick und Vaudevilleburlesken, um das Publikum zu Heiterkeitsausbrüchen anzuregen, als es noch kein Hintergrundlachen vom Band gab. Das war zu einer Zeit, in der eine Torte im Gesicht noch lustig war und die Zeichentrickserien sich an wissbegierige Jungen und Mädchen richteten. „Ein Zeichentrickfilmer ist ein Clown mit einem Bleistift!", erklärte Pinto Colvig, die Stimme von Goofy und von Bozo the Clown bei Capitol Records. Gewinne stachelten die Kleinen dazu an, regelmäßig zuzuschauen und mitzumachen. Während einige Clowns ganz harmlos waren, hatten andere alptraumhafte Qualitäten und verursachten Phobien, die zukünftige Generationen von Psychotherapeuten beschäftigen sollten.

Frank Sinatra in *The Joker is Wild*, film still, 1957
Frank Sinatra in *Schicksalsmelodie (The Joker is Wild)*, Standfoto, 1957
Frank Sinatra dans *Le Pantin brisé*, photographie du film, 1957

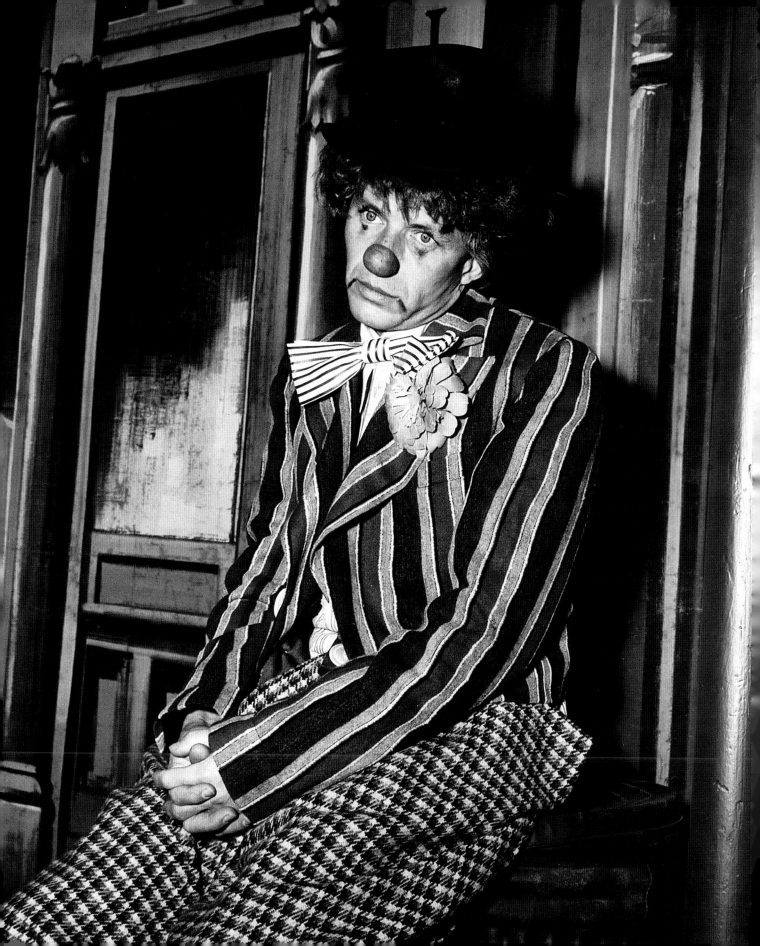

FILM & TÉLÉVISION

Grâce au grand écran du cinéma et au petit écran de la télévision le cirque est entré d'abord dans les salles et plus tard dans les foyers ; il n'était plus nécessaire d'attendre l'été et la venue du cirque en ville. Au cinéma, les péripéties du spectacle ambulant et un sujet si riche de contenu inspirèrent de solides scripts en tous genres – la comédie, le drame, les variétés et même les films d'horreur. Mack Sennet, imprésario de films muets, amena de nombreux clowns célèbres au grand écran (plusieurs d'entre eux venaient du vaudeville) comme Charlie Chaplin, Fatty Arbuckle, Buster Keaton, Ben Turpin, Harry Langdon et W. C. Fields. D'éminents acteurs et actrices, de Ginger Rogers à Tony Curtis, se sont essayé à la clownerie et quelques clowns sont même devenus acteurs.

Le numéro de clown, plus visuel que verbal, dépassait les limites du langage et les barrières culturelles, étant à la fois populaire sur le petit et sur le grand écran. Dans les années 50, les appareils devenant de plus en plus abordables pour la plupart des ménages, la télévision devint la baby-sitter des après-midi des écoliers américains de l'ère du nucléaire. Le clown bigarré était un ami familier qui présentait les dessins animés et organisait les fêtes d'anniversaire. Quand les enfants rentraient de l'école et avant qu'ils ne fassent leurs devoirs, ils retrouvaient un moment privilégié, un moment irréel, où ils pouvaient se perdre dans un monde imaginaire grâce à ce nouveau gadget, la télévision.

Les clowns devinrent les ambassadeurs des spectacles télévisés pour enfants. Venant de la scène du théâtre, ils comptaient sur la farce et les variétés pour déclencher les rires du public des studios, avant la venue du rire en boîte et des effets spéciaux par ordinateurs. Les programmes populaires étaient diffusés à l'époque où le gag de la tarte à la crème amusait encore et où l'on montrait des dessins animés qui plaisaient à la fois aux garçons et aux filles. « Un dessinateur de dessins animés est juste un clown muni d'un crayon ! » remarquait Pinto Colvig, la voix de Dingo dans les films de Walt Disney et du Bozo le Clown originel de Capitol Record. On encourageait les jeunes téléspectateurs à regarder et à participer en leur proposant des jouets et des prix à gagner. Bien que les clowns fussent amusants et inoffensifs, certains d'entre eux étaient de véritables figures de cauchemars et peut-être à l'origine de réelles phobies, une manne pour les légions de futurs psychothérapeutes.

Milton Berle guest stars as a burlesque comic implicated in a murder on television's *Trials of O'Brien*, on-set photograph, 1965
Milton Berle als Gaststar während der Dreharbeiten zu der Fernsehserie *Trials of O'Brien*, wo er einen in einen Mord verwickelten Komiker spielt, 1965
Milton Berle, invité spécial de la série télévisée *Trials of O'Brien* dans le rôle d'un comique burlesque impliqué dans un crime, photographie de plateau, 1965

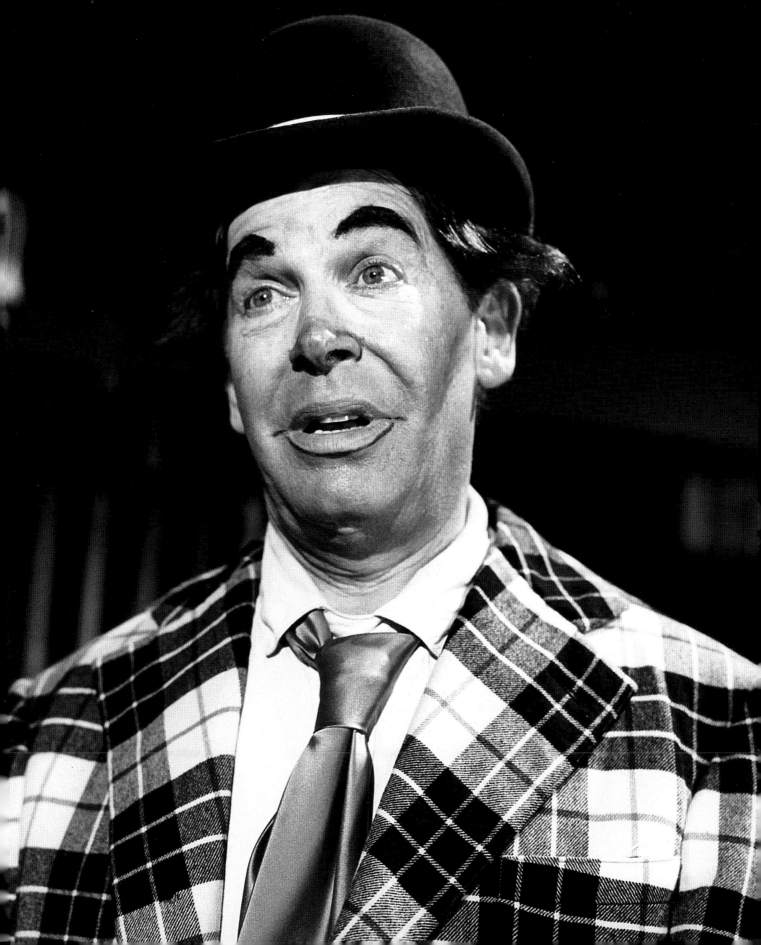

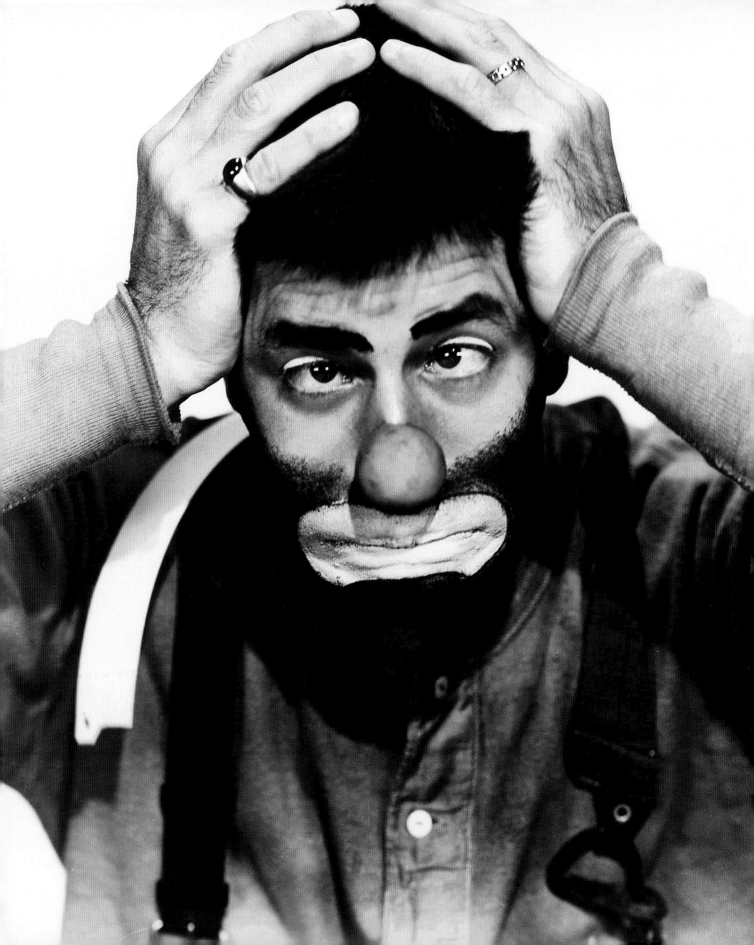

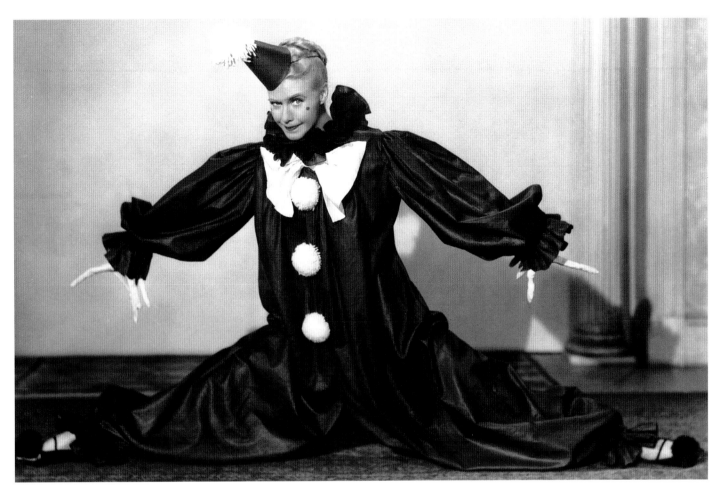

"Clowns work as well as aspirin, but twice as fast."
– Groucho Marx

„Lachen ist wie ein Aspirin, es wirkt nur doppelt so schnell."
– Groucho Marx

« Les clowns font autant d'effet que l'aspirine, mais deux fois plus vite. »
– Groucho Marx

◄ Jerry Lewis as Jerricho the Wonder Clown in *3 Ring Circus*, publicity photograph, 1954
Jerry Lewis als Jerricho the Wonder Clown in *Im Zirkus der drei Manegen (3 Ring Circus)*, Werbefoto, 1954
Jerry Lewis dans le rôle de Jerricho the Wonder Clown, dans le film *Le Clown est roi*, photographie publicitaire, 1954

Ginger Rogers in outtake from film *Lady in the Dark*, 1944
Ginger Rogers in einer nicht verwendeten Szene des Films *Lady in the Dark*, 1944
Ginger Rogers, dans une scène du film *Les Nuits ensorcelées* coupée au montage, 1944

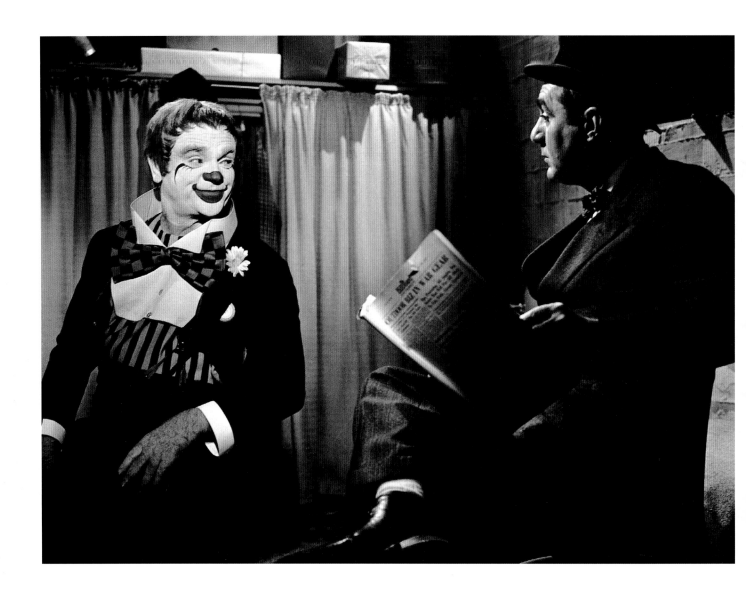

James Cagney schemes with actor Jim Backus in *Man of a Thousand Faces*, film still, 1957

James Cagney heckt etwas aus mit Schauspieler Jim Backus in *Der Mann mit den 1000 Gesichtern (Man of a Thousand Faces)*, Standfoto, 1957

James Cagney complotant avec l'acteur Jim Backus, dans le film *L'Homme aux mille visages*, photographie du film, 1957

▶ An emotional Brian Keith entertains on his eponymous television show, publicity still, 1973

Der bewegende Brian Keith in der nach ihm benannten Fernsehserie, Werbefoto, 1973

Un Brian Keith plein d'émotion pendant son show télévisé du même nom, photographie du show, 1973

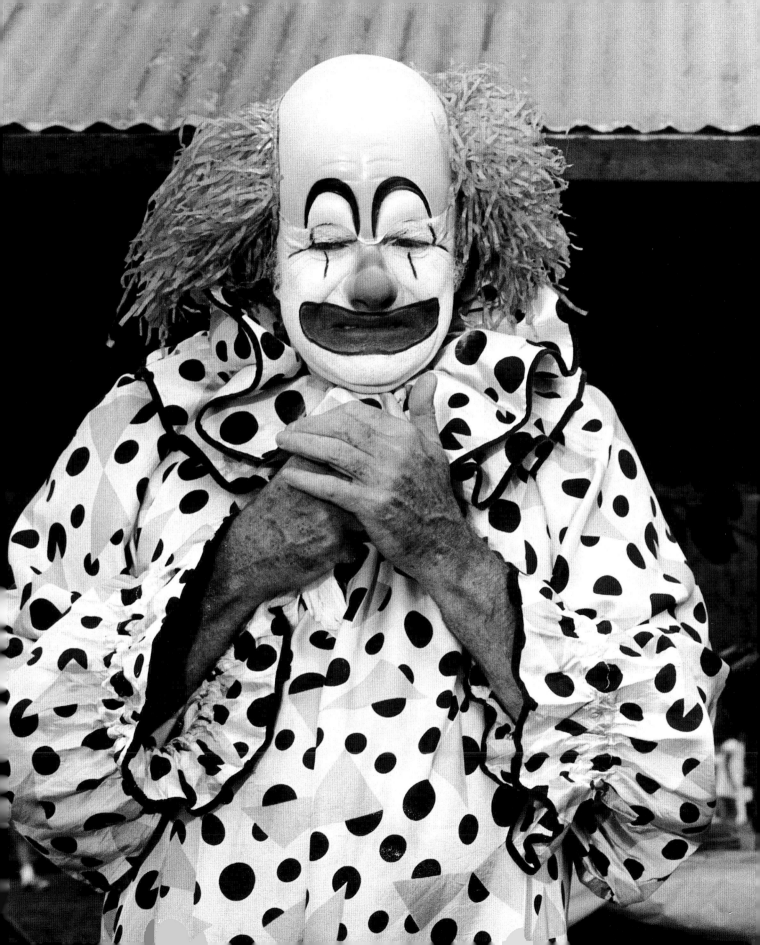

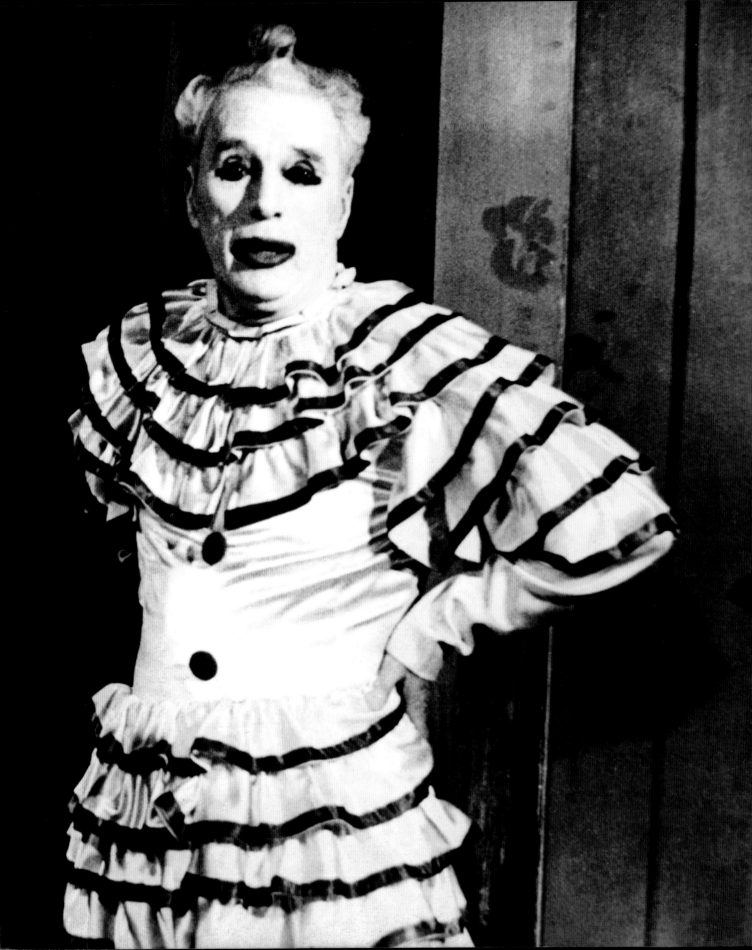

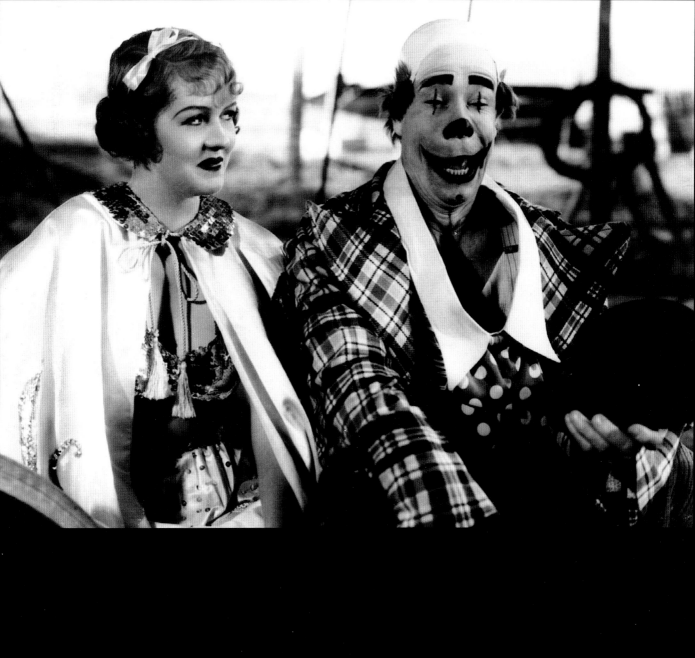

◄ Charlie Chaplin in his last American film, *Limelight*, on-set photograph, 1952
Charlie Chaplin während der Dreharbeiten zu seinem letzten amerikanischen Film
Rampenlicht (Limelight), 1952
Charlie Chaplin dans son dernier film américain, *Les Feux de la rampe*, photographie
de plateau, 1952

Wide-mouthed Joe E. Brown in *The Circus Clown*, film still, 1934
Joe E. Brown mit dem großen Mund in *The Circus Clown*, Standfoto, 1934
Joe E. Brown et sa grande bouche dans *The Circus Clown*, photographie du film, 1934

Tony Curtis in the musical film, *So This Is Paris*, on-set photograph, 1955
Tony Curtis während der Dreharbeiten zu dem Musicalfilm *Drei Matrosen in Paris (So This Is Paris)*, 1955
Tony Curtis dans la comédie musicale *So This Is Paris*, photographie de plateau, 1955

▶ Judy Garland escorted by two handsome clowns in *Till the Clouds Roll By*, film still, 1946
Judy Garland in Begleitung zwei gut aussehender Clowns in *Bis die Wolken vorüber zieh'n (Till the Clouds Roll By)*, Standfoto, 1946
Judy Garland entourée par deux magnifiques clowns dans *La Pluie qui chante*, photographie du film, 1946

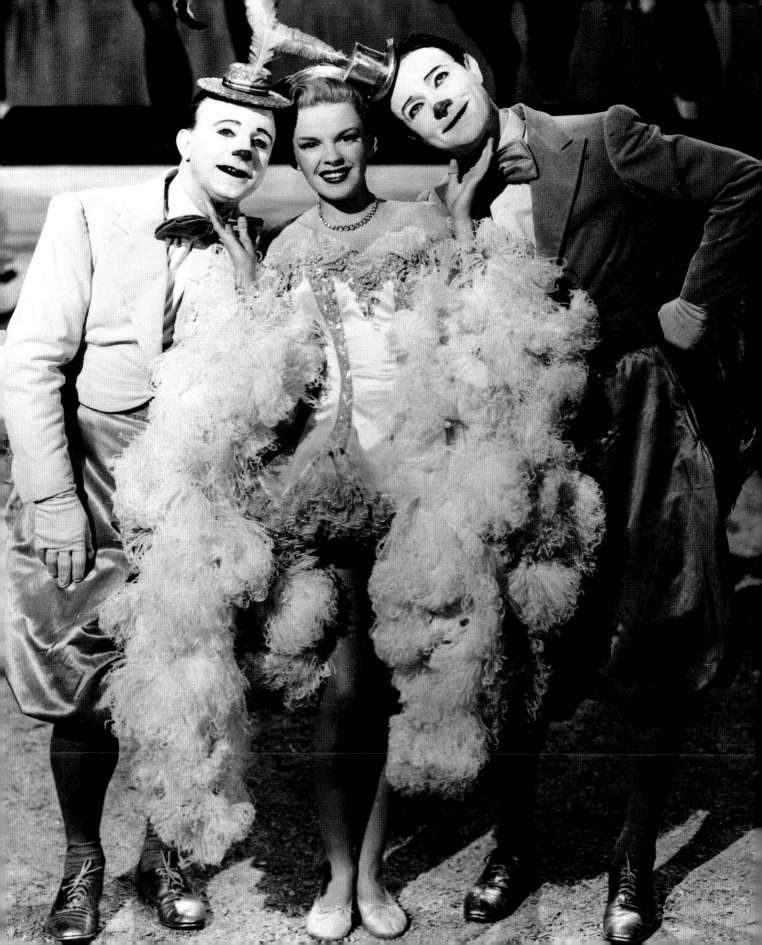

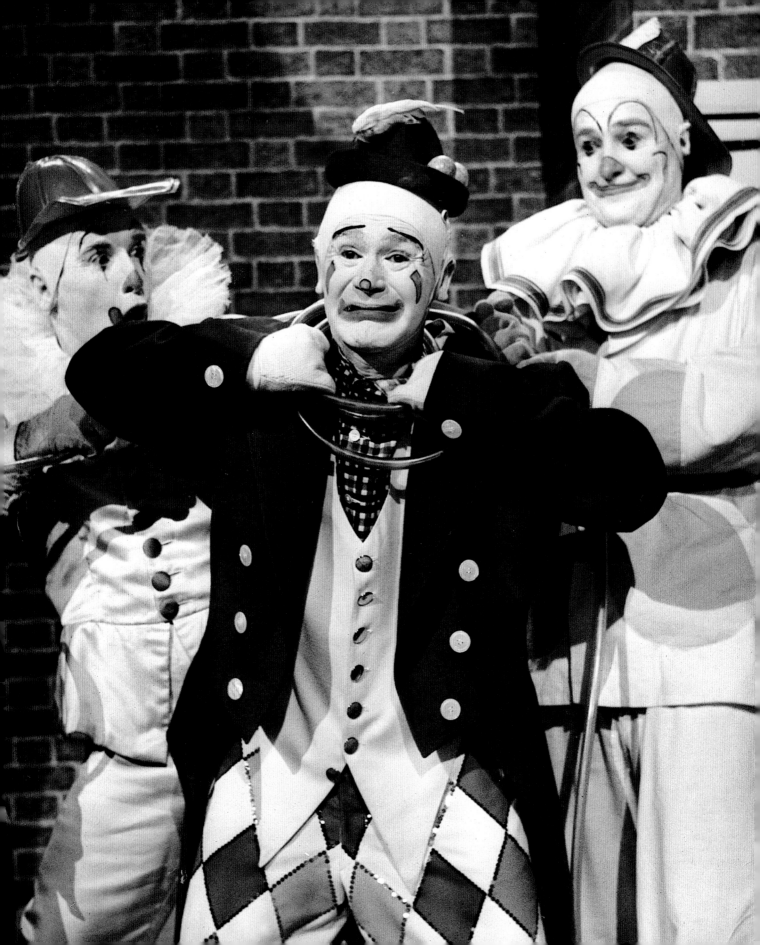

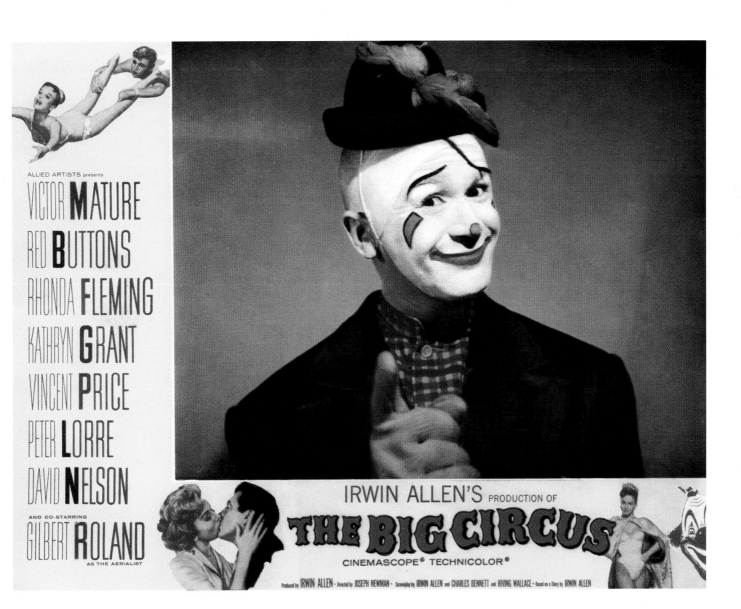

Lobby card, 1959
Eintrittskarte, 1959
Carte publicitaire, 1959

◀ Red Buttons in *The Big Circus*, film still, 1959
Red Buttons in *Die Welt der Sensationen (The Big Circus)*, Standfoto, 1959
Red Buttons dans *Le Cirque fantastique*, photographie du film, 1959

▶ Comedian and television celebrity Red Skelton, who called himself "The Pauper's Botticelli," paints a canvas for charity, photograph, 1940s
Der Komiker und Fernsehstar Red Skelton, der sich „Der Botticelli der Armen" nannte, malt ein Bild für einen guten Zweck, Fotografie, 1940er Jahre
Le comique et vedette de télévision Red Skelton, qui se nommait lui-même «Le Botticelli du pauvre», peignant un tableau pour une vente de charité, photographie, années 40.

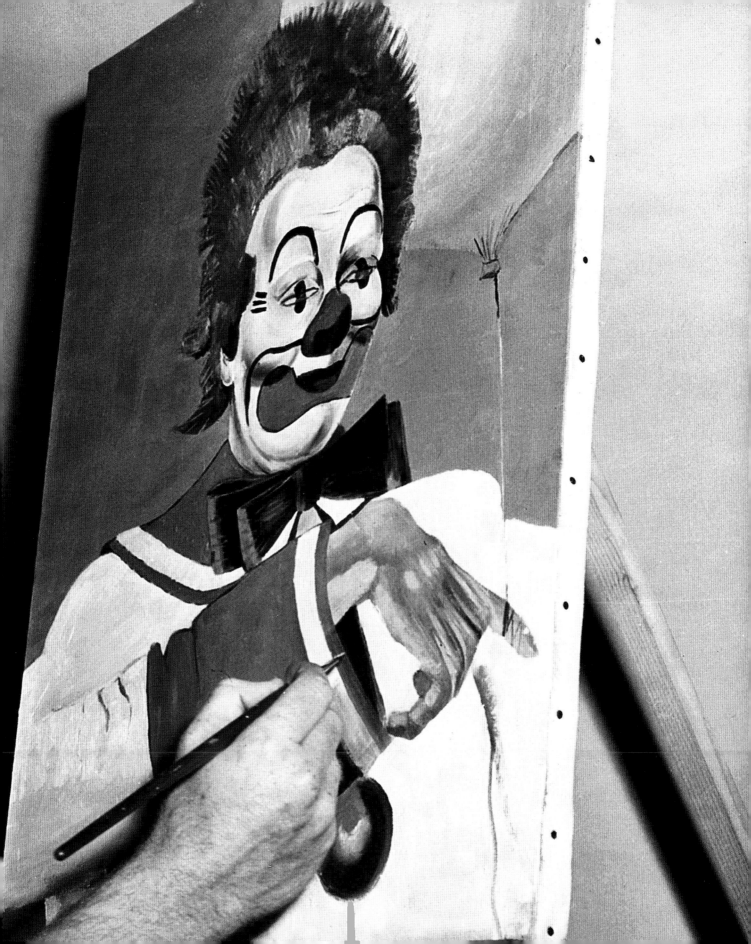

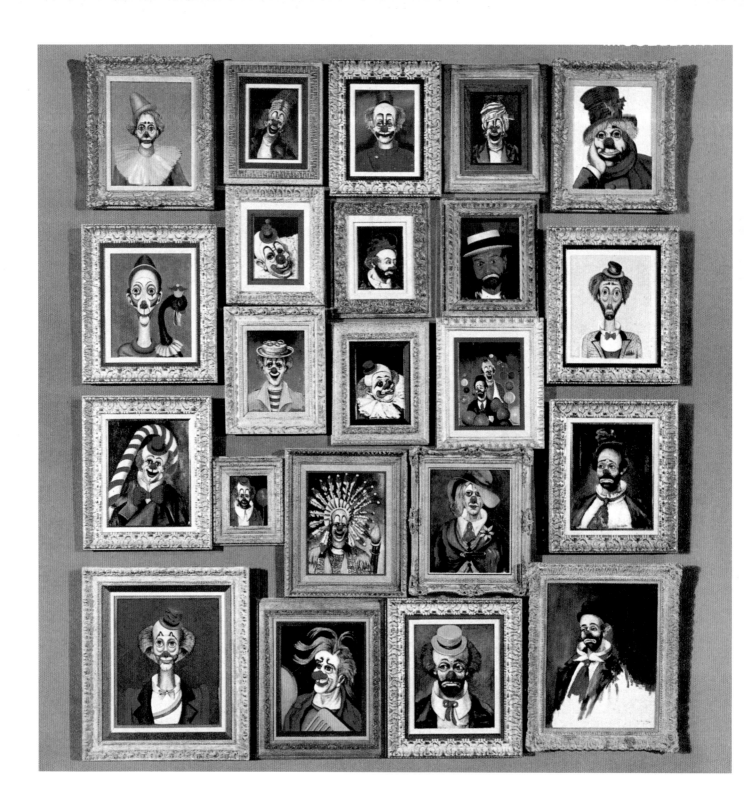

Gallery of clown portraits by Red Skelton, photograph, 1950s
Galerie mit Clownporträts von Red Skelton, Fotografie, 1950er Jahre
Collection de portraits de clowns par Red Skelton, photographie, années 50

▶ Cowboy actor Chill Wills in *Bronco Buster*, film still, 1952
Cowboydarsteller Chill Wills in dem Film *Bronco Buster*, auch bekannt unter dem Titel *Rivalen im Sattel*, Standfoto, 1952
Cowboy de cinéma Chill Wills dans *Bronco Buster*, photographie du film, 1952

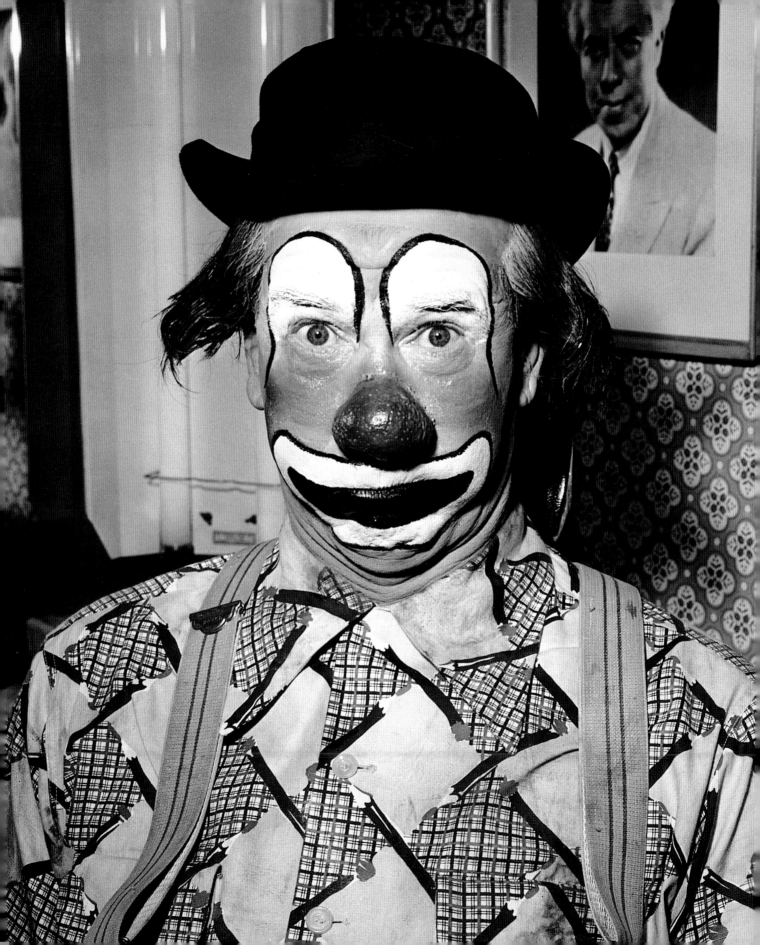

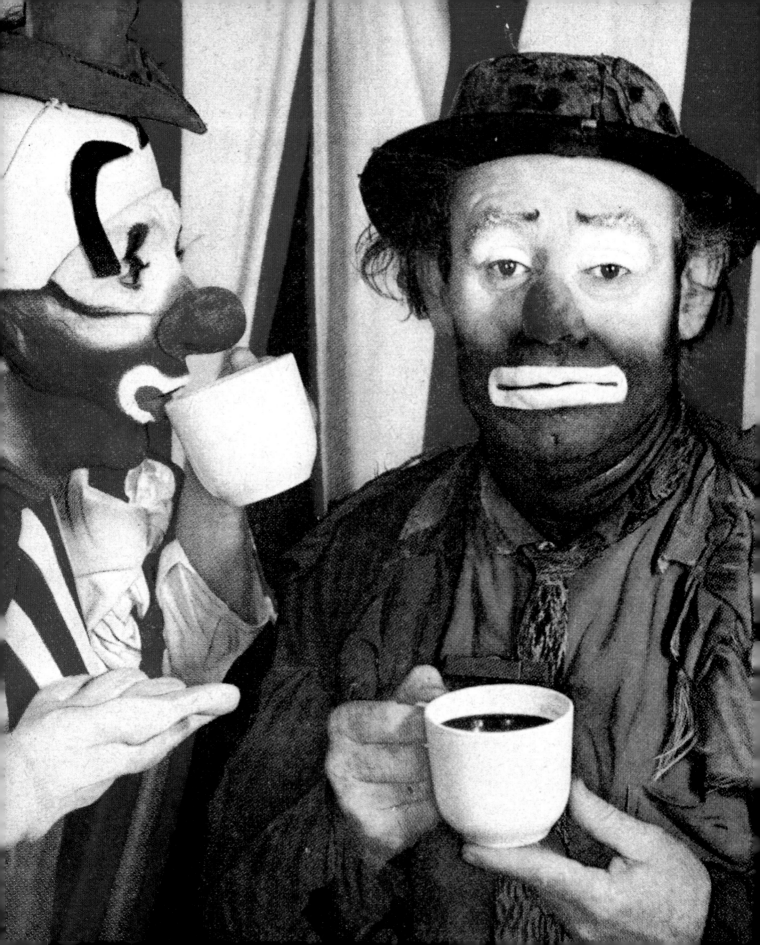

◄ Emmett Kelly and comrade share a cup of coffee, advertising photograph, 1953
Emmett Kelly und Kamerad trinken zusammen eine Tasse Kaffee, Werbefoto, 1953
Emmett Kelly et un camarade prenant le café, photographie publicitaire, 1953

Emmett Kelly, without greasepaint, checking into Universal Pictures' makeup department for *The Fat Man*, photograph, 1951
Emmett Kelly, ohne Schminke, bei der Ankunft in der Maskenbildnerei von Universal Pictures für *The Fat Man*, Fotografie, 1951
Emmett Kelly, sans fard, au studio de maquillage d'Universal Pictures pour *The Fat Man*, photographie, 1951

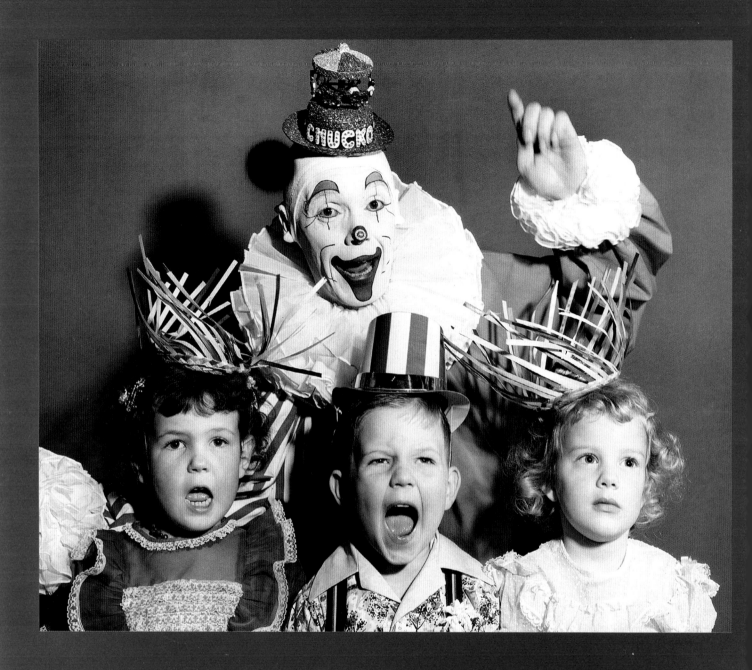

Television star Chucko the Birthday Clown, Los Angeles, California, publicity photograph, 1950s
Fernsehstar Chucko the Birthday Clown, Los Angeles, Kalifornien, Werbefoto, 1950er Jahre
Star de télévision Chucko the Birthday Clown, Los Angeles, Californie, photographie publicitaire, années 50

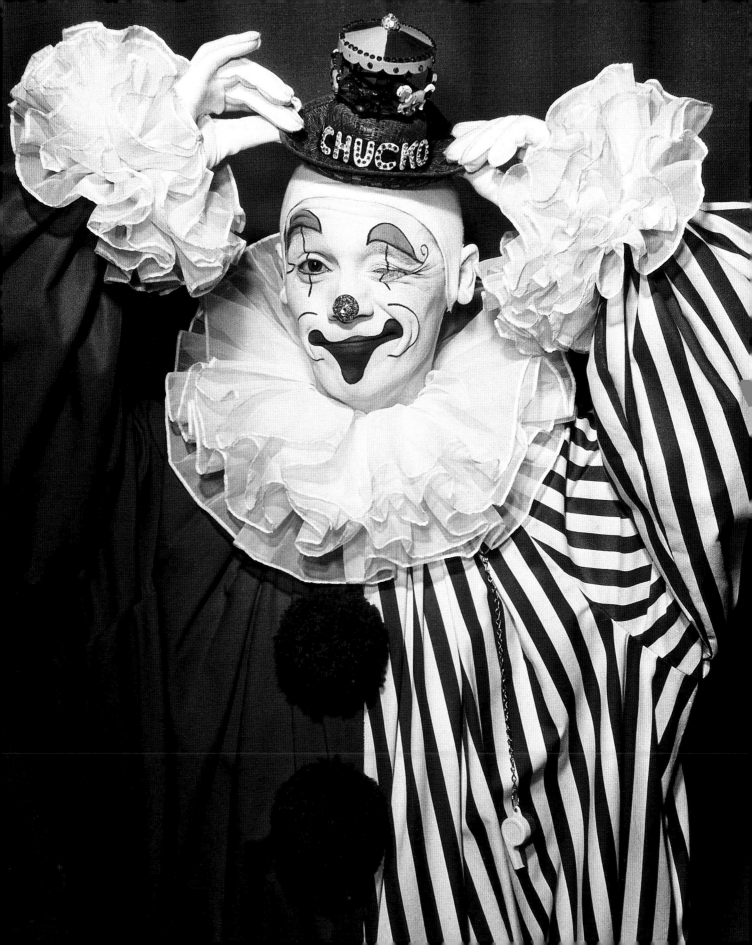

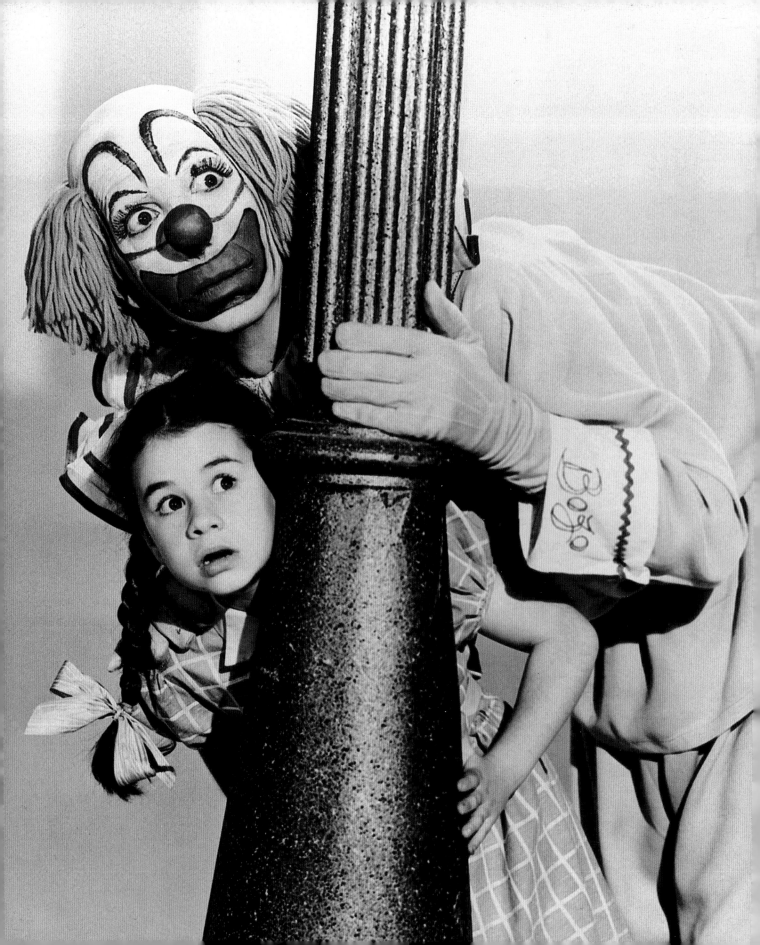

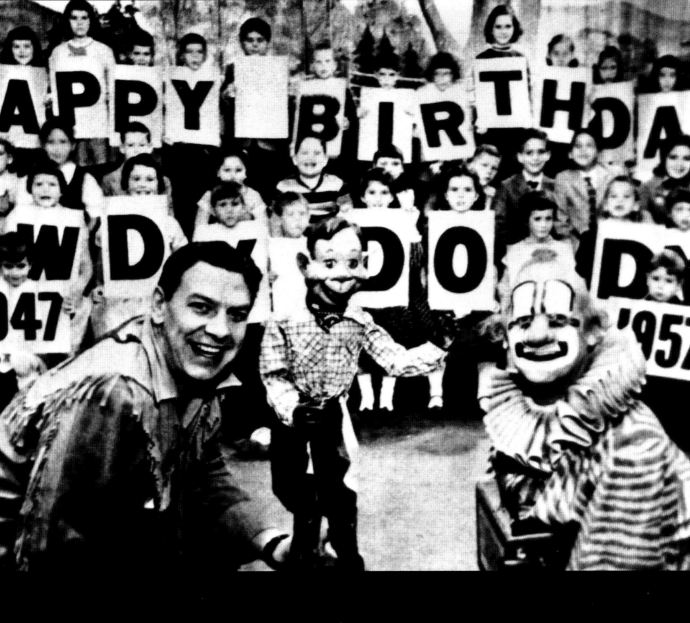

◄ Television's Bozo the Clown (here with child singing star Margaret O'Brien) was the creation of Capitol Records' president Alan Livingston; publicity photograph, 1948

Bozo the Clown aus dem Fernsehen (hier mit Kinderstar Margaret O'Brien) war eine Erfindung des Capitol-Records-Präsidenten Alan Livingston; Werbefoto, 1948

Bozo le Clown, de la télévision, (ici avec la petite chanteuse et enfant star Margaret O'Brien) a été créé par Alan Livingston, le président de Capitol Records; photographie publicitaire, 1948.

Children's afternoon TV program *The Howdy Doody Show* (from left: Buffalo Bob Smith, Howdy Doody, and Bob Keeshan, who went on to play Captain Kangaroo, as Clarabell the Clown), television still, 1957

Kinderserie im Nachmittagsprogramm *The Howdy Doody Show* (v. l. n. r.: Buffalo Bob Smith, Howdy Doody und Bob Keeshan, der später Captain Kangaroo spielte, als Clarabell the Clown), Standfoto, 1957

The Howdy Doody Show, un programme de télévision de l'après-midi pour les enfants (de gauche à droite : Buffalo Bob Smith, Howdy Doody et Bob Keeshan, qui continua à jouer Captain Kangaroo, comme Clarabell the Clown), photographie de télévision, 1957.

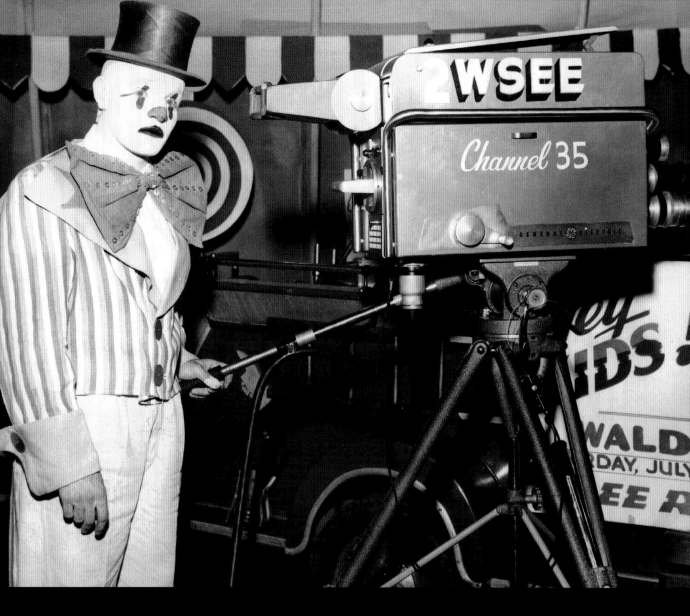

Dick Johnson, a popular children's television clown, on-set photograph in Erie, Pennsylvania, 1950s

Dick Johnson, ein beliebter Clown aus dem Kinderfernsehen, Erie, Pennsylvania, 1950er Jahre

Dick Johnson, un clown de télévision très populaire auprès des enfants, photographie de plateau, Erie, Pennsylvanie, années 50.

▶ Clown with imitation mike, photograph, 1950s

Clown mit nachgemachtem Mikrofon, Fotografie, 1950er Jahre

Clown avec faux micro, photographie, années 50

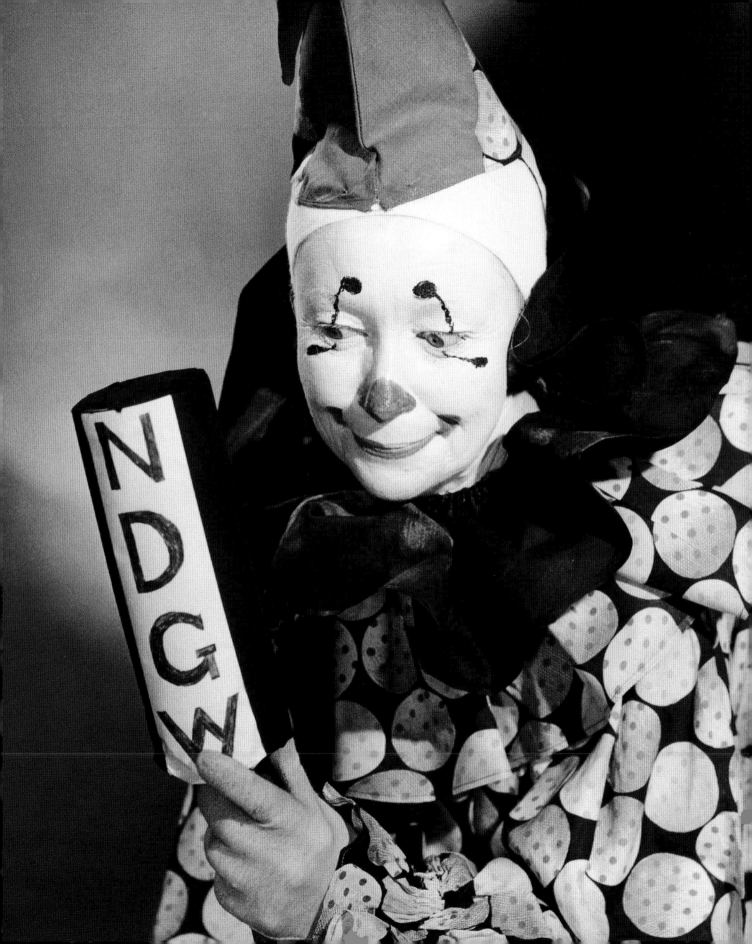

PAINTINGS

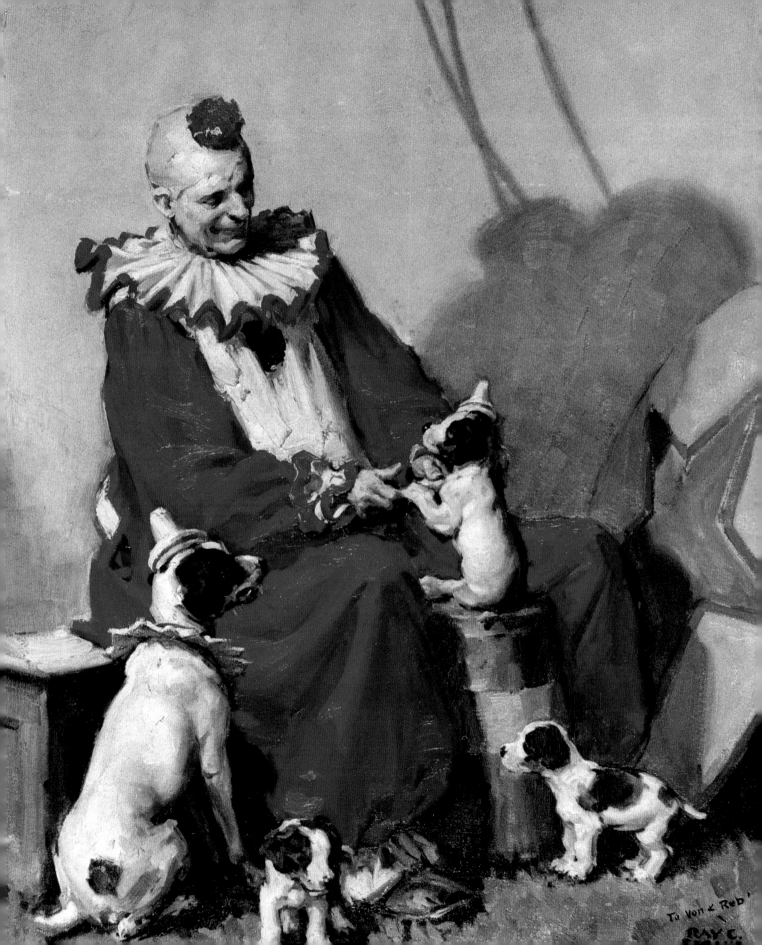

PAINTINGS

Art, like beauty, is in the eye of the beholder. Instead of capturing real life through a camera, artists picked up their oil paints and brushes to freeze the moment on canvas. Around the early 1900s, the lush life of the circus was a ripe subject to explore. Fine artists such as Pablo Picasso, Toulouse-Lautrec, Alexander Calder, and Edward Hopper first engaged viewers with their observations of circus life as metaphors for society, emotion, and the imagination. This first wave of modern artists opened the door for less established portrait artists, amateur and professional alike, who sought to capture the true character behind a clown's own painted face – in paint.

That said, much of the art with the clown as subject was probably painted using existing photographs as reference, rather than from life studies. In the postwar years, hobbies became increasingly popular for an American population with more leisure time on its hands, and the 1950s was the era of the amateur craft seeker. Publications like Walter Foster's art instruction manual *Clowns and Characters*, featuring paintings from the gifted hand of Leon Franks, spawned a rising tide of students who wanted a shortcut to mastery. Creating a piece of art in one easy lesson, however, proved harder than it looked, resulting in an endless variety of fascinatingly naïve studies. For anyone who has never been tempted by a thrift-store clown painting, the lure is nearly impossible to describe. For would-be artists truly lacking talent, paint-by-numbers kits, popularized in the 1960s, required only the ability to color within lines, and voila! – an instant masterpiece, complete with oak frame. A wide range of emotions – somber, sad, enigmatic, ecstatic, or mischievous – could be portrayed in this way by untrained artists, sometimes even elevating them to the rarefied spotlights of museums and galleries. Countless other such works are gathering dust in garages across the country. In a continued blurring of the boundaries between hi- and low-brow, many contemporary fine artists are themselves now looking to the garage for inspiration.

◀◀ Thrift-store painting, oil, ca. 1960
Gemälde aus einem Trödelladen, Öl, um 1960
Peinture trouvée à la brocante, huile, vers 1960

◀ *Country Gentleman* magazine cover detail, illustration by Ray Strang, 1930s
Country Gentleman, Ausschnitt aus dem Titelbild der Zeitschrift, Illustration von Ray Strang, 1930er Jahre
Couverture du magazine *Country Gentleman*, détail, illustration de Ray Strang, années 30

GEMÄLDE

Kunst ist genau wie Schönheit Geschmackssache. Kunstmaler erfassen keinen realistischen Eindruck mit der Kamera, sondern greifen zu Ölfarben und Pinsel. Um 1900 war das Zirkusleben ein verlockendes Motiv, das es zu erforschen galt. Große Maler und Bildhauer wie Pablo Picasso, Henri de Toulouse-Lautrec, Alexander Calder und Edward Hopper schufen mit ihren Beobachtungen des Zirkuslebens als Metaphern für Gesellschaft, Gefühle und Fantasie faszinierende Werke. Diese modernen Künstler bereiteten den Weg für weniger bekannte Porträtmaler, Laien und Profis, die den wahren Charakter des Clowns hinter seiner dicken Schminke darzustellen versuchten.

Zu diesen gemalten Clownbildern muss jedoch gesagt werden, dass sie vermutlich zumeist nach Fotos und nicht nach dem lebenden Modell entstanden. In der Nachkriegszeit und in den fünfziger Jahren versuchten sich viele Menschen am künstlerischen Ausdruck, weil Hobbys an Beliebtheit zunahmen, als die Amerikaner allmählich über mehr Freizeit verfügten. Bücher wie Walter Fosters Malanleitung *Clowns and Characters*, in der Bilder des begabten Malers Leon Franks zu sehen waren, mobilisierten ein wahres Heer von Lernwilligen, die die Malerei im Schnellkurs meistern wollten. Dies erwies sich jedoch als schwieriger als es aussah, was zu einer endlosen Reihe faszinierend naiver Porträtstudien führte. Wer niemals in einem Trödelladen den Drang verspürt hat, ein handgemaltes Clowngemälde zu kaufen, dem lässt sich ihr Reiz kaum vermitteln. Für Möchtegernkünstler, denen jedes Talent abging, gab es die Malen-nach-Zahlen-Sets, die in den Sechzigern weit verbreitet waren; hier musste man nur noch vorgezeichnete Flächen mit Farbe auszufüllen und schon besaß man ein selbst gemaltes Meisterwerk inklusive Eichenrahmen. Auf diese Weise war es Hobbymalern möglich, eine breite Palette an Emotionen zum Ausdruck zu bringen – ob nachdenklich, traurig, rätselhaft, überglücklich oder verschmitzt – und es bisweilen sogar an die geheiligten Wände von Museen und Galerien zu schaffen. Unzählige andere Werke dieser Art stauben in den Garagen ein. Je mehr die Grenze zwischen hoher Kunst und Trivialkultur verschwimmt, desto häufiger suchen anerkannte Künstler ihre Inspiration heute in Garagen und Trödelläden.

Vintage clown painting by Fred Fredden Goldberg, oil, ca. 1940
Clowngemälde von Fred Fredden Goldberg, Öl, um 1940
Peinture classique de clown, de Fred Fredden Goldberg, huile, vers 1940

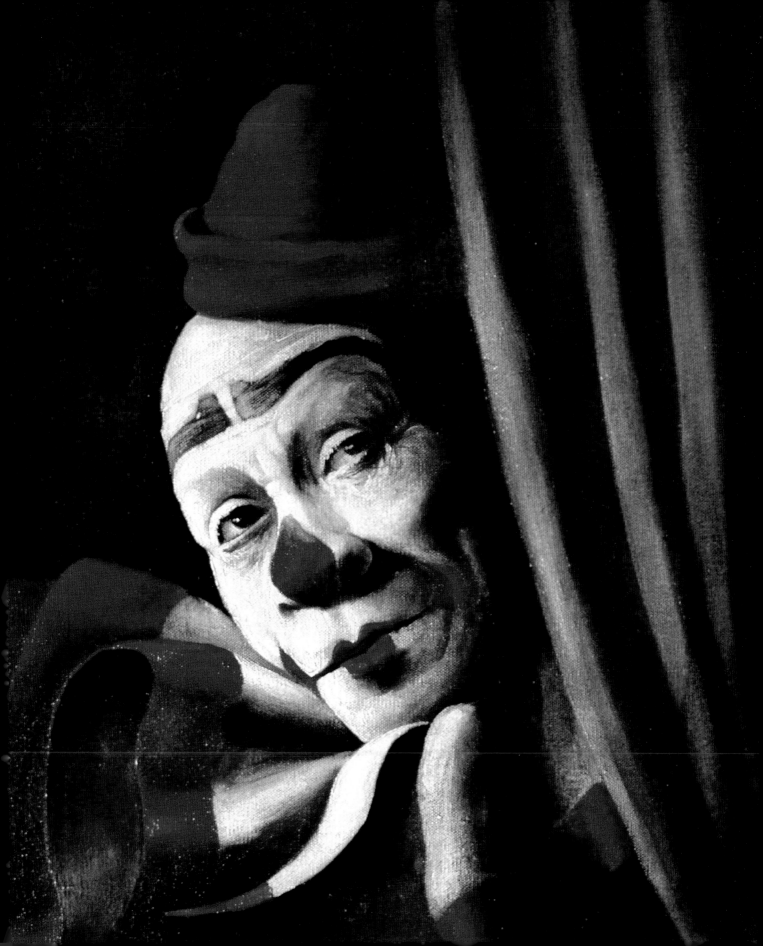

PEINTURES

L'Art, comme la beauté, est dans l'œil de celui qui regarde. Au lieu de saisir la réalité avec un appareil, les artistes utilisaient leur palette et leurs pinceaux pour fixer l'instant sur la toile. Aux environs de 1900, la richesse exubérante de la vie du cirque était prête pour l'exploration. De grands artistes tels que Pablo Picasso, Toulouse-Lautrec, Alexander Calder et Edward Hopper furent les premiers à éveiller l'attention du public par leur peinture de la vie du cirque, peinture qui se voulait aussi métaphore de la société, des émotions et de l'imagination. La première vague d'artistes modernes a ouvert la porte aux portraitistes amateurs et professionnels moins connus cherchant à saisir la personne derrière le visage peint du clown – par la peinture.

Ceci dit, beaucoup de portraits de clowns étaient probablement peints d'après des photographies déjà existantes plutôt que d'après nature. Après la guerre, les années 50 furent l'époque des amateurs cherchant leur voie, due à la popularité grandissante du hobby dans une société américaine disposant de plus de loisirs. Une foule d'étudiants de plus en plus nombreux recherchaient le plus court chemin vers la maîtrise de leur art dans des publications comme le manuel d'instructions de Walter Foster « Clowns and Characters » reproduisant des peintures du talentueux Leon Franks. Mais créer une œuvre d'art en une seule leçon était plus difficile qu'ils ne l'imaginaient, ce qui nous a valu une infinie variété de fascinants petits tableaux naïfs. Pour quelqu'un qui n'a jamais été tenté par un portrait de clown dans une brocante, la tentation est presque impossible à décrire. Pour les artistes en herbe vraiment sans talent, les panoplies de peinture par numéros, très répandues dans les années 60, ne demandaient que de savoir peindre sans dépasser la ligne et voilà ! – un tableau de maître en un tour de main, cadre en chêne inclus. Un large éventail d'émotions – tristesse, mélancolie, mystère, extase ou malice – pouvaient être ainsi reproduites par des artistes sans aucune formation, leur permettant même parfois de se retrouver sous les projecteurs des musées ou des galeries. D'innombrables œuvres du même genre amassent la poussière dans tous les garages du pays. La frontière entre le kitsch et le sophistiqué étant de plus en plus vague, beaucoup d'excellents artistes contemporains se tournent maintenant vers les garages pour trouver l'inspiration.

Walter Foster instructional art book, cover painting by Leon Franks, 1951
Handbuch von Walter Forster zum Erlernen der Malerei, Einbandillustration von
Leon Franks, 1951
Manuel d'art de Walter Foster, peinture de Leon Franks, 1951

CLOWNS
AND
CHARACTERS

by

Leon Franks

Thrift-store painting by T. Cruz, oil, ca. 1960
Gemälde von T. Cruz aus einem Trödelladen, Öl, um 1960
Trouvée à la brocante, peinture de T. Cruz, huile, vers 1960

► Amateur painting, oil, ca. 1940
Gemälde eines Amateurs, Öl, um 1940
Peinture d'amateur, huile, vers 1940

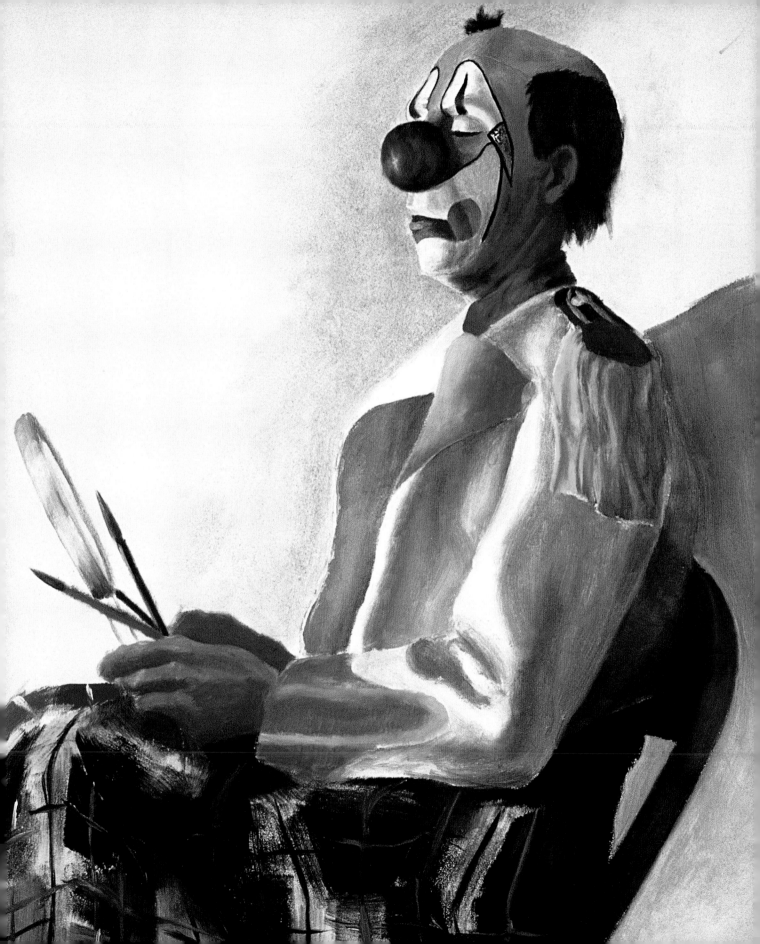

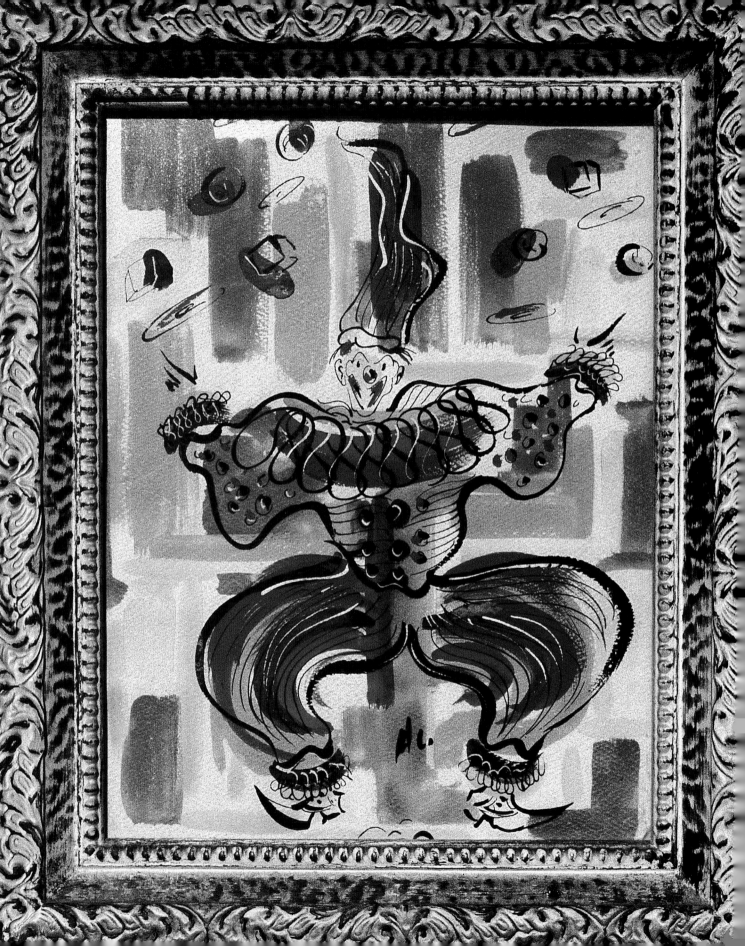

"A COMEDIAN MAKES FUN OF THE AUDIENCE. A CLOWN MAKES FUN OF HIMSELF."
– RED SKELTON

„EIN KOMIKER MACHT WITZE AUF KOSTEN DES PUBLIKUMS. EIN CLOWN MACHT WITZE ÜBER SICH SELBST."
– RED SKELTON

« UN COMIQUE SE MOQUE DU PUBLIC. UN CLOWN SE MOQUE DE LUI-MÊME. »
– RED SKELTON

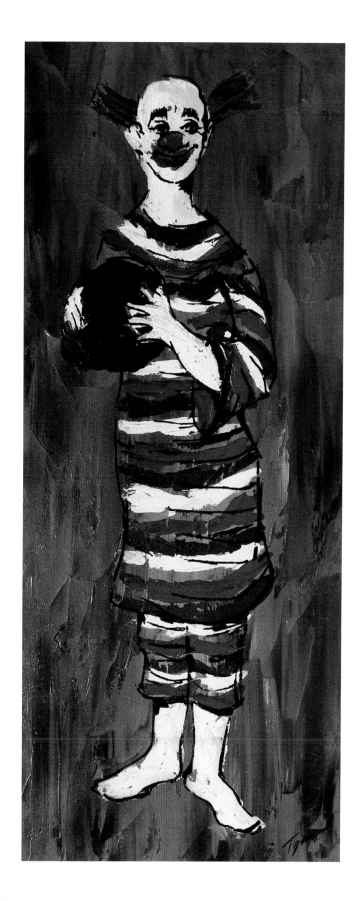

Palette knife painting, oil, 1960s
Gemälde, Öl, gespachtelt, 1960er Jahre
Peinture au couteau, huile, années 60

◄ Anonymous painting, oil, 1950s
Gemälde eines unbekannten Künstlers, Öl, 1950er Jahre
Peinture anonyme, huile, années 50

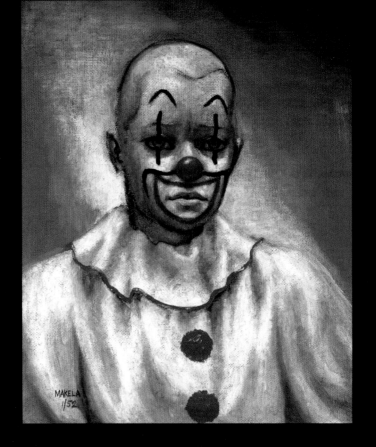

Thrift-store painting by Makela, oil, 1952
Gemälde von Makela aus einem Trödelladen, Öl, 1952
Trouvée à la brocante, peinture de Makela, huile, 1952

▶ Anonymous painting, oil, 1950s
Gemälde eines unbekannten Künstlers, Öl, 1950er
Peinture anonyme, huile, années 50

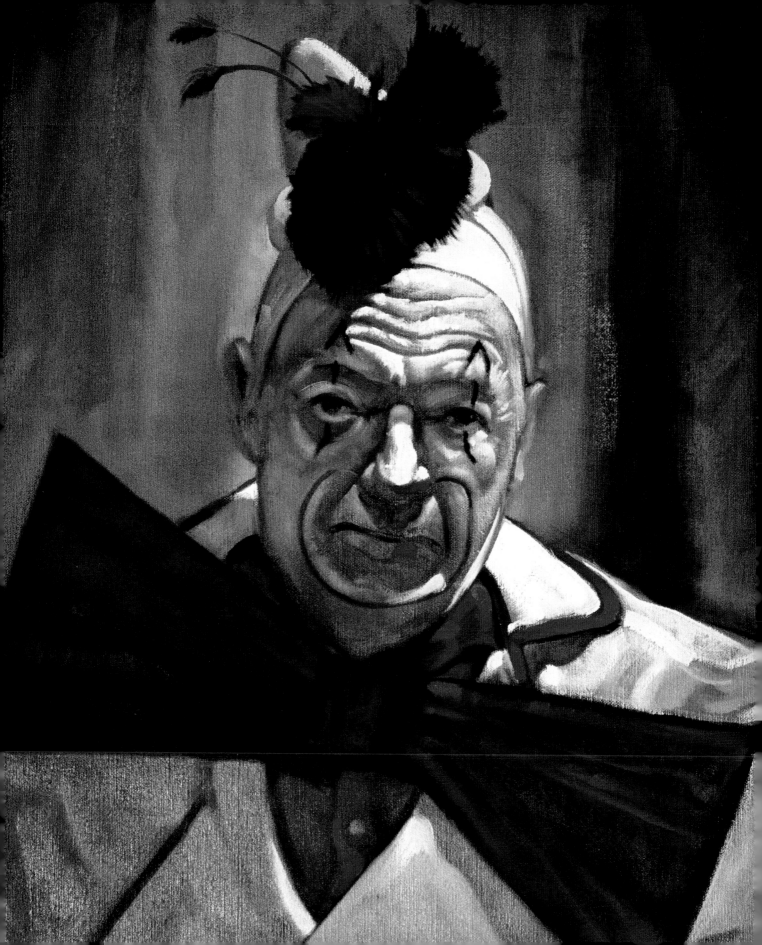

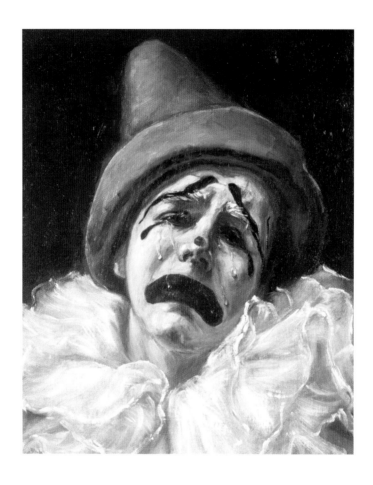

Painting by Galley, oil, ca. 1930
Gemälde von Galley, Öl, um 1930
Peinture de Galley, huile, vers 1930

▶ Painting by Paul W. Tucker, oil, ca. 1920
Gemälde von Paul W. Tucker, Öl, um 1920
Peinture de Paul W. Tucker, huile, vers 1920

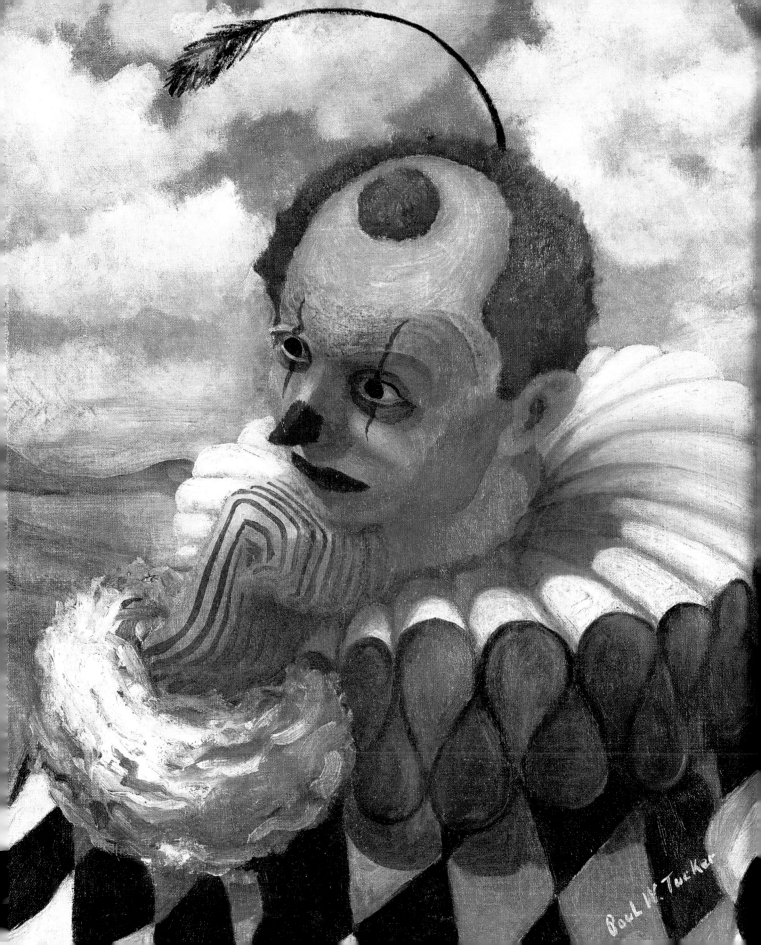

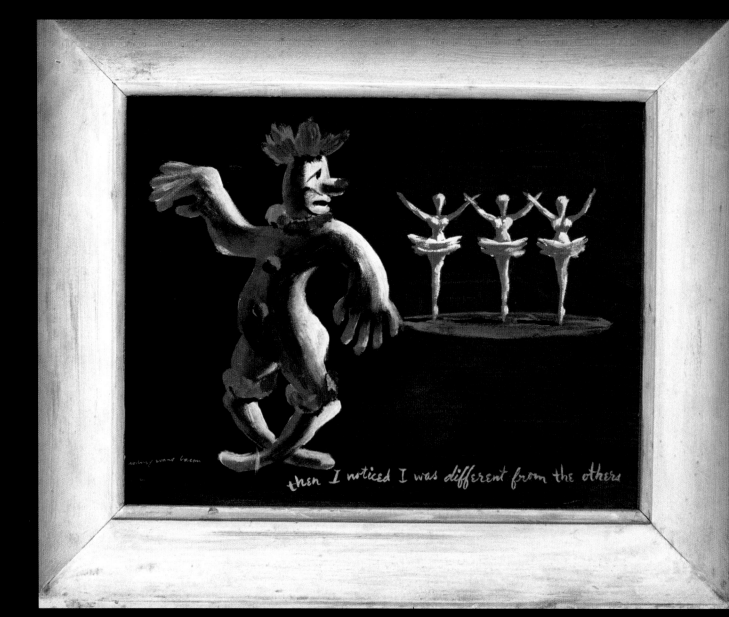

then I noticed I was different from the others

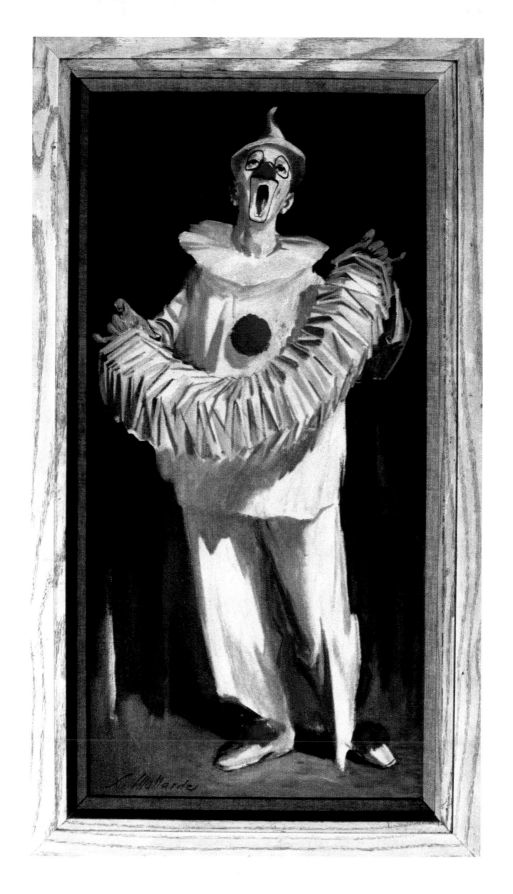

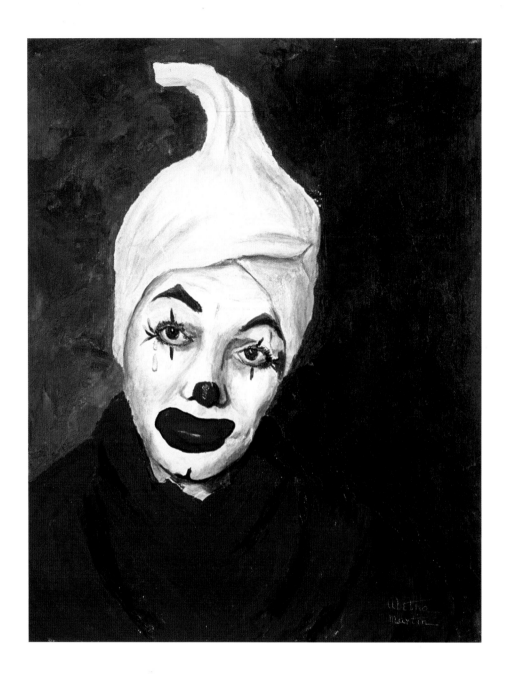

Thrift store painting by Aletha Martin, oil, ca. 1950

Gemälde von Aletha Martin aus einem Trödelladen, Öl, um 1950

Trouvée à la brocante, peinture d'Aletha Martin, huile, 1950

► Amateur painting by Deno Snider, oil, ca. 1950

Amateurgemälde von Deno Snider, Öl, um 1950

Peinture d'amateur de Deno Snider, huile, vers 1950

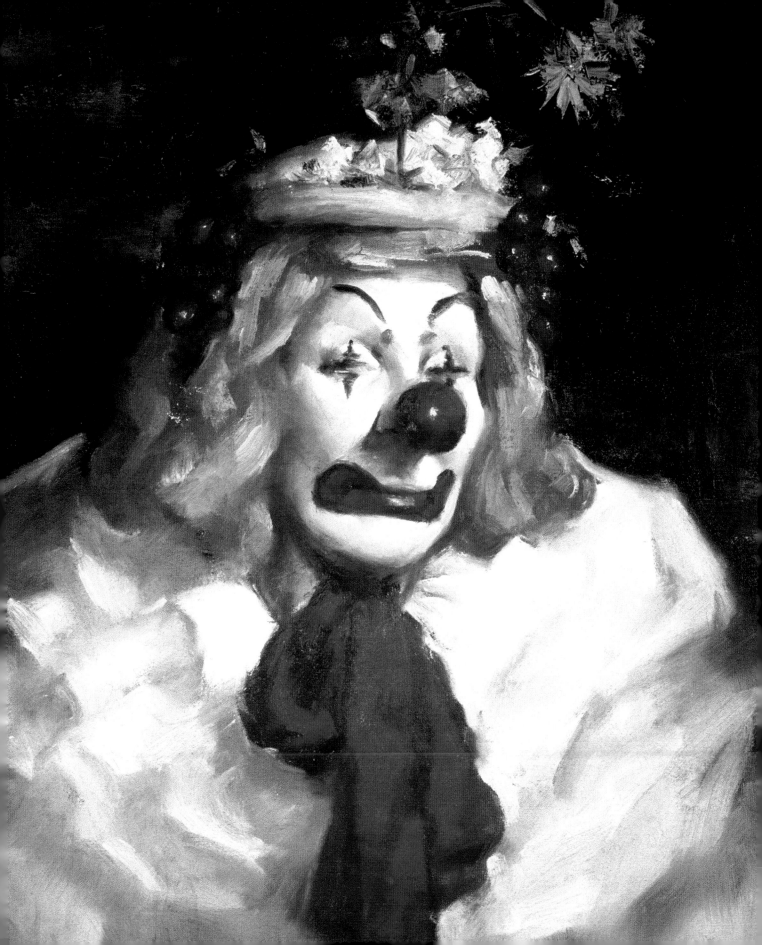

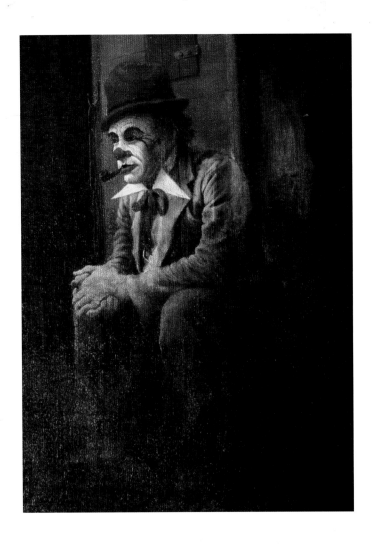

Hobo clown, oil, ca. 1930
Fahrender Clown, Öl, um 1930
Clown vagabond, huile, vers 1930

▶ Portrait of Emmett Kelly, anonymous, oil, ca. 1960
Porträt eines unbekannten Künstlers von Emmett Kelly, Öl, um 1960
Portrait d'Emmett Kelly, anonyme, huile, vers 1960

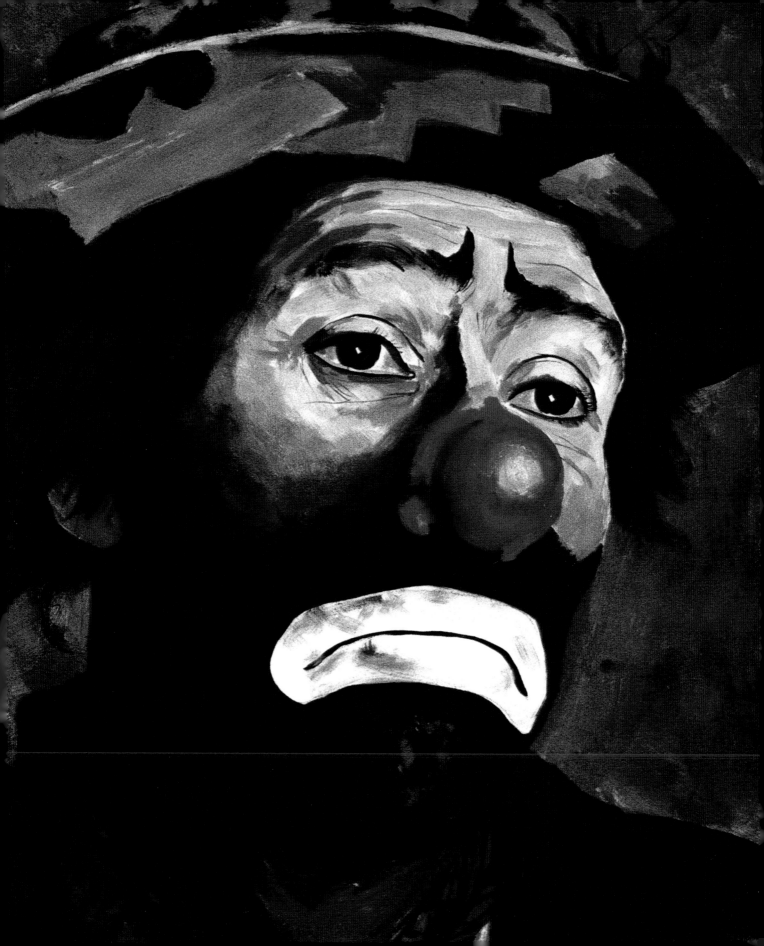

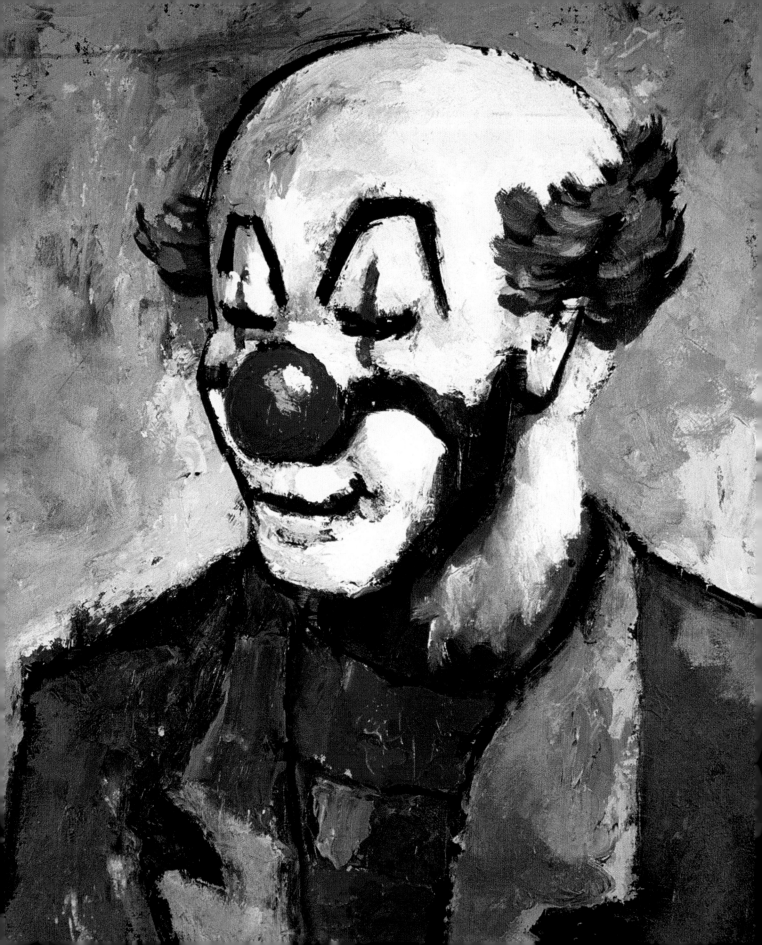

Stylized clown with duck by Nurtzell, 1960s
Stilisierter Clown mit Ente von Nurtzell, 1960er Jahre
Clown stylisé avec canard de Nurtzell, années 60

◄ Painting by Dixson, oil, 1966
Gemälde von Dixson, Öl, 1966
Peinture de Dixson, huile, 1966

►► The Testor Corporation's oil paint-by-numbers #510 blue line guide (left) and kit detail (right), 1950s
Malen nach Zahlen, links: Vorlage Nr. 510 der Testor Corporation für ein Ölgemälde; rechts: Details des Malsets (rechts), 1950er Jahre
Peinture aux numéros, nr. 510 de Testa Corporation, huile, dessin en bleu (à gauche) et détail de la panoplie (à droite), années 50.

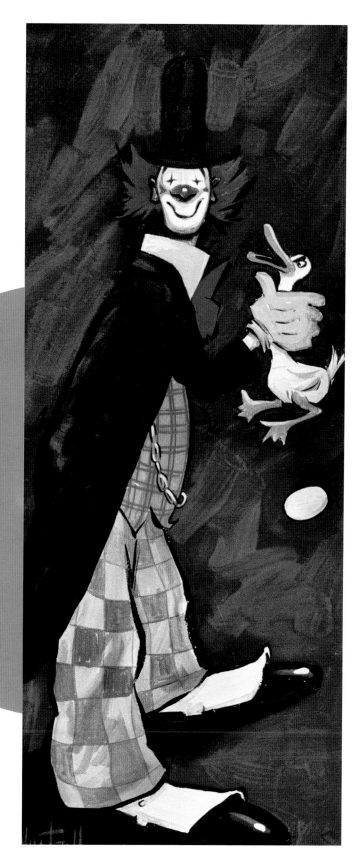

Paint areas
marked
with dotted
lines first

CLOWNS

2-8 x 10 Paintings · 2 Décor-Lite Frames

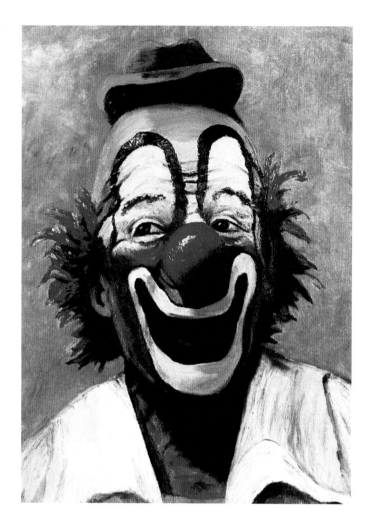

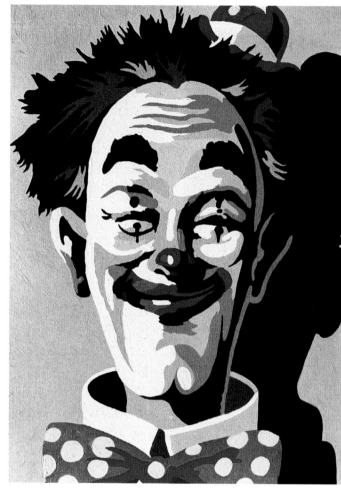

Paint-by-numbers portrait of Stan Laurel, of Laurel & Hardy comedy fame, oil, 1950s

Malen nach Zahlen, Porträt von Stan Laurel aus dem berühmten Komikerduo Dick und Doof, Öl, 1950er Jahre

Peinture par numéros, portrait de Stan Laurel, du célèbre duo comique Laurel & Hardy, huile, années 50

Portrait of Lou Jacobs, oil, 1950s

Porträt von Lou Jacobs, Öl, 1950er Jahre

Portrait de Lou Jacobs, huile, années 50

▶ Painting by F. Dressen, oil, ca. 1930

Gemälde von F. Dressen, Öl, um 1930

Peinture de F. Dressen, huile, vers 1930

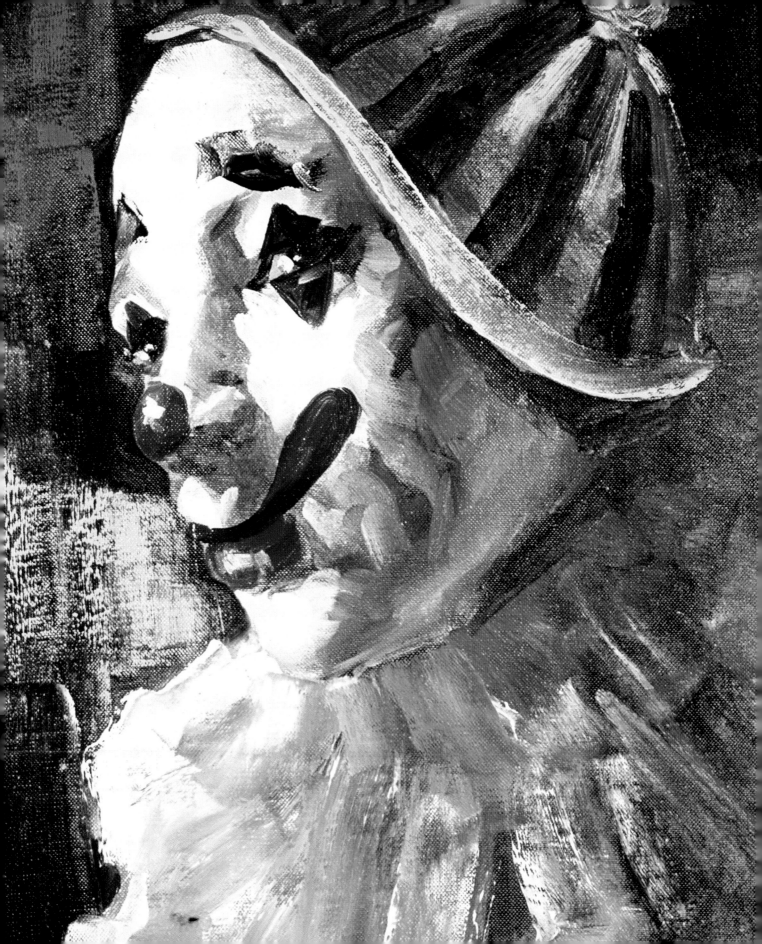

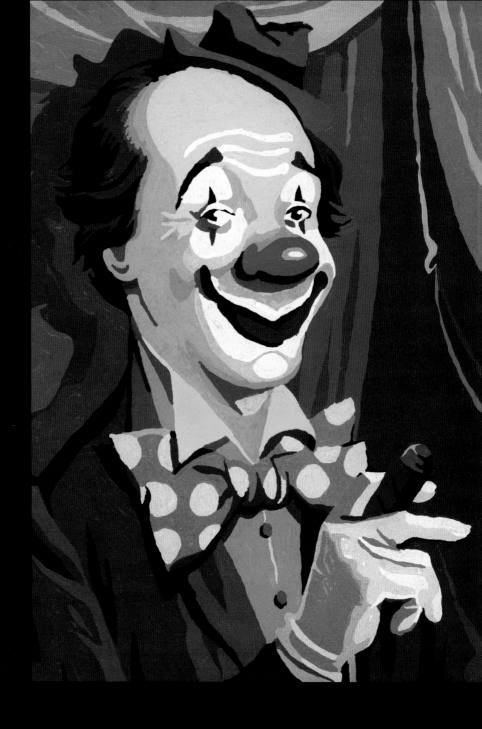

Paint-by-numbers clowns, oil, 1960s
Malen nach Zahlen, Clowns, Öl, 1960er Jahre
Peinture par numéros, clowns, années 60

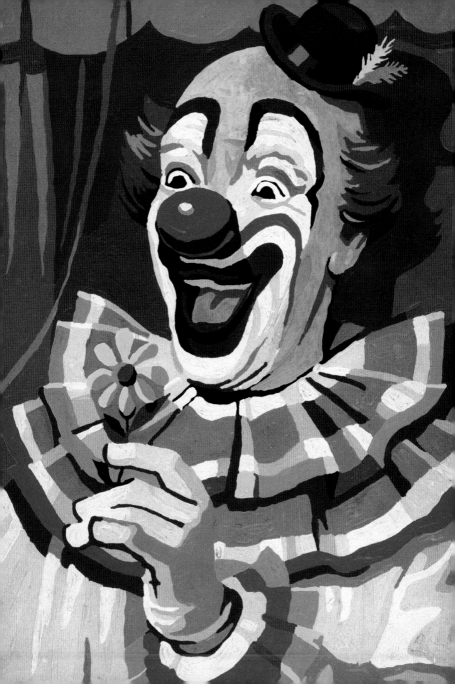

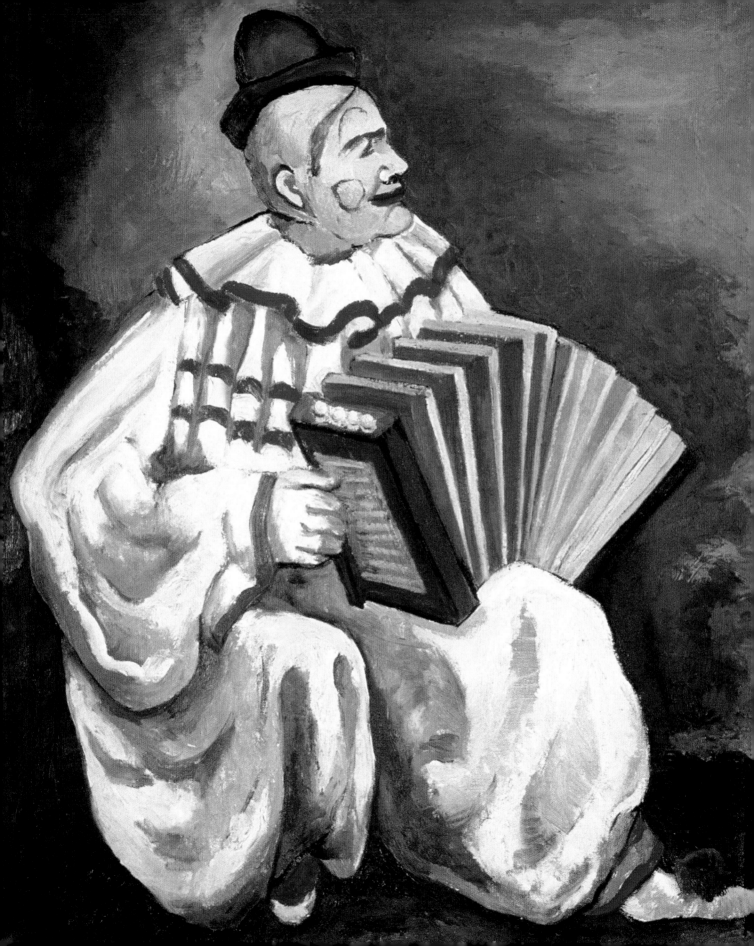

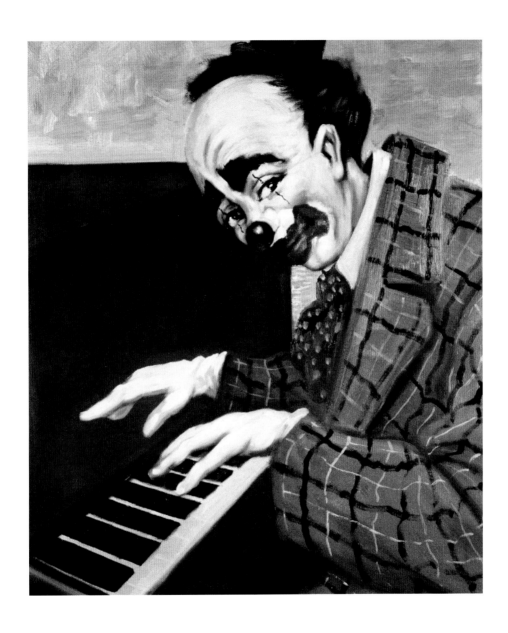

◄ Laura Loth painting, oil, ca. 1930
Laura-Loth-Gemälde, Öl, um 1930
Peinture de Laura Loth, huile, vers 1930

Albert Val painting, oil, ca. 1940
Albert-Val-Gemälde, Öl, um 1940
Peinture d'Albert Val, huile, vers 1940

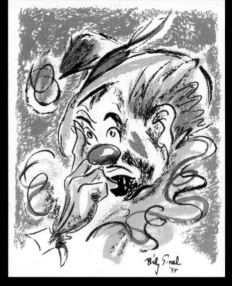
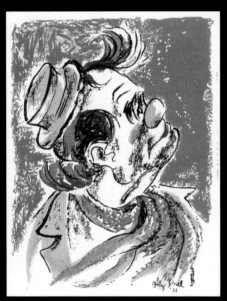
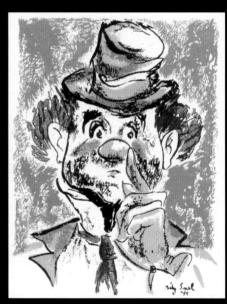

Silk screen prints, Billy Snel, 1955
Siebdrucke, Billy Snel, 1955
Impressions sur soie de Billy Snel, 1955

▶ Psychedelic thrift store clown, oil, ca. 1969
Psychedelischer Clown aus einem Trödelladen, Öl, um 1969
Peinture de clown psychédélique, huile, vers 1969

▶▶ Black velvet painting by Roberto G. Sanchez, oil, ca. 1970s
Gemälde auf schwarzem Samt von Roberto G. Sanchez, Öl, vermutlich
1970er Jahre
Peinture sur velours noir de Roberto G. Sanchez, huile, années 70

▶▶▶ Mexican black velvet painting, oil, 1970s
Mexikanisches Gemälde auf schwarzem Samt, Öl, 1970er Jahre
Peinture mexicaine sur velours noir, huile, années 70

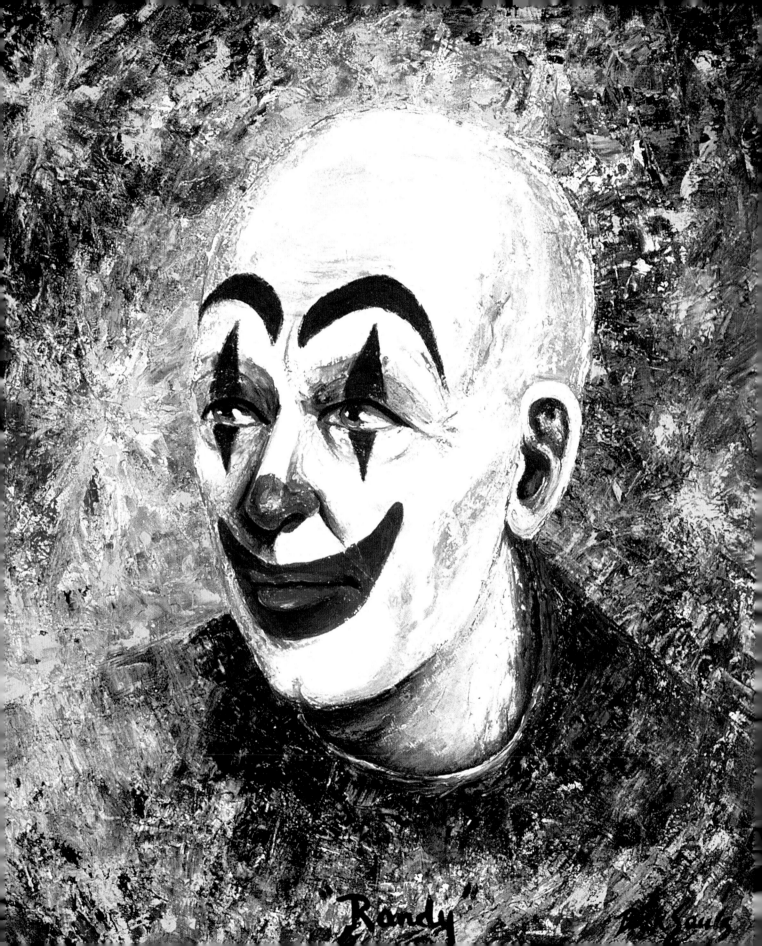

Randy

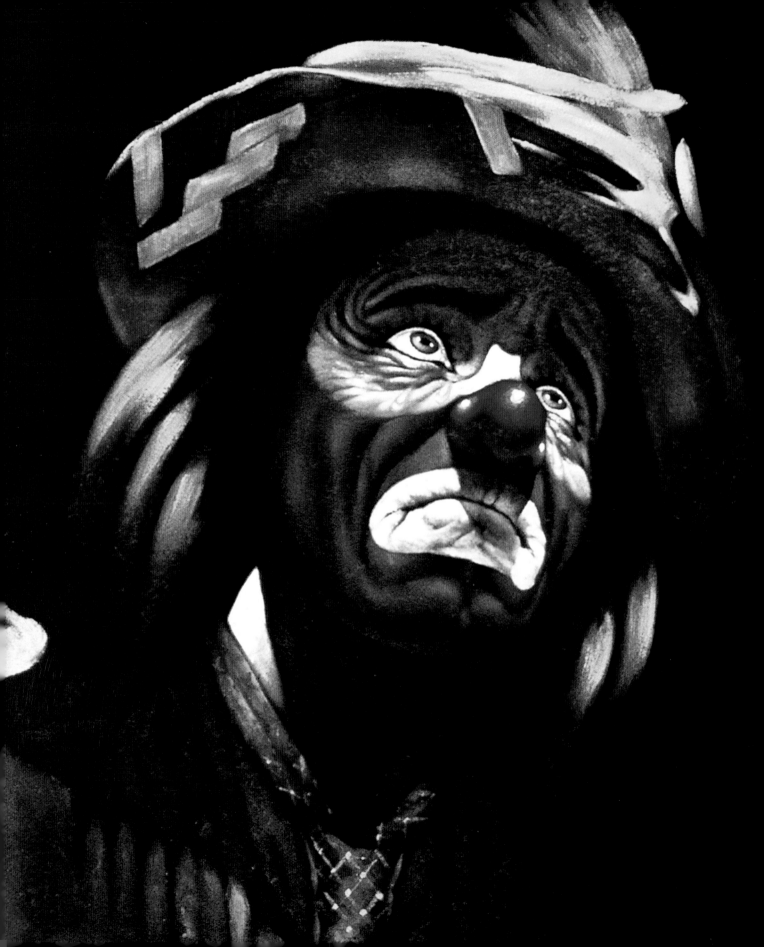

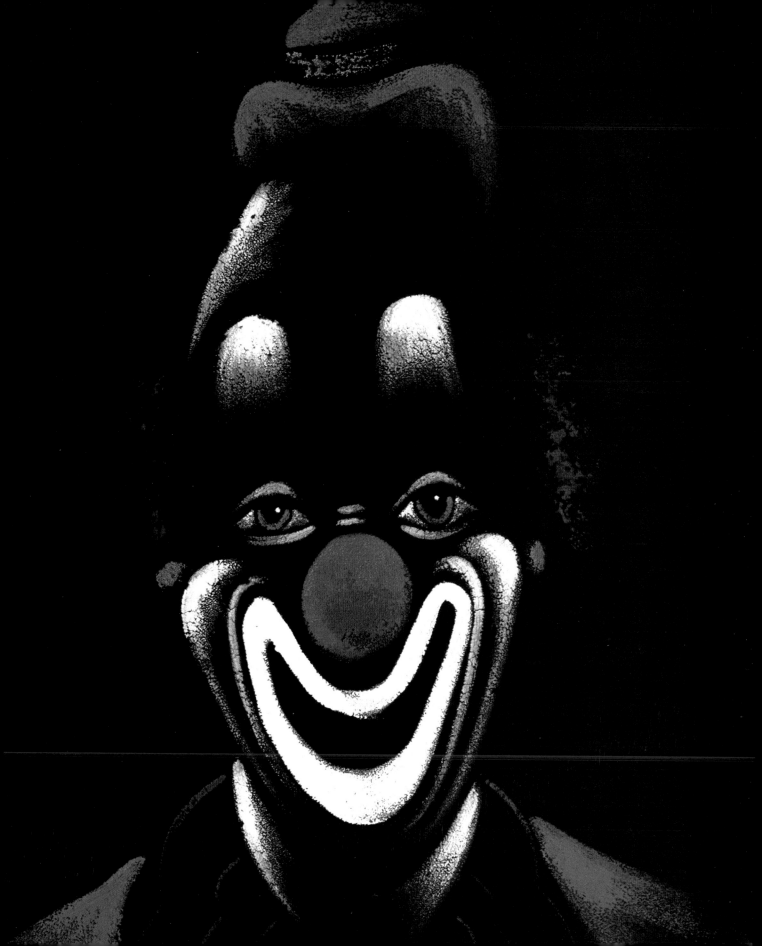

GRAPHICS

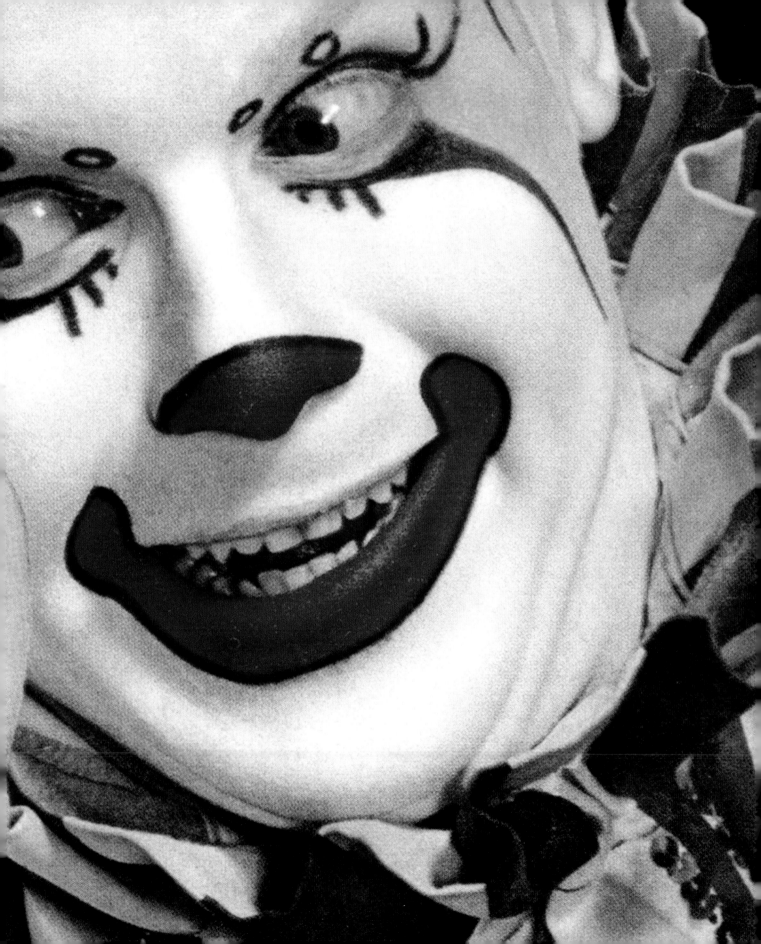

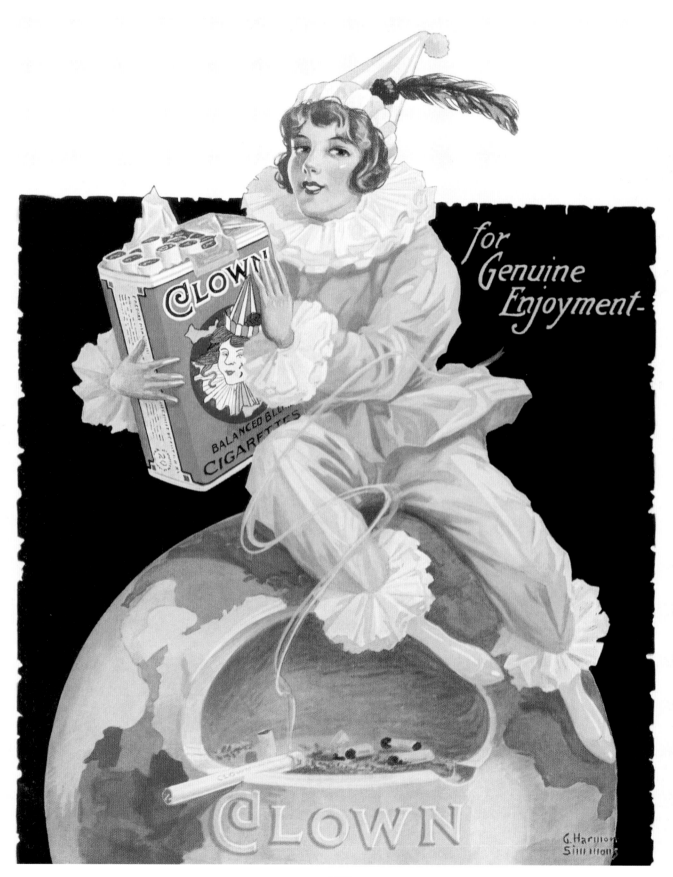

for Genuine Enjoyment-

GRAPHICS

With a bold use of primary colors, the image of the clown has been a mainstay of the commercial art world since the early 1900s, splashed across national magazine covers, emblazoned on promotional posters, printed on sheet music and album covers, and even sent through the mail as diminutive postage stamps. Clowns have been used throughout the printed media to sell everything from chewing gum to leather shoes, from cigarettes to the lighters that lit them. Even as movie stars emerged in the 1920s as popular endorsers of commercial wares, the clown image could compete, embodying all the emotions needed to sell a variety of products. Toys and games, candy and soft drinks, cookies and breakfast cereal were sold to kids with clowns as pitchmen. By the late 1930s adults, too, were being targeted. Loud ties and marbled fountain pens for Father's Day, coffee for the daily grind of caffeine addicts, and even house paint and gasoline were sold, all on the public recommendation of a grotesquely painted character.

In an age that lacked irony, a light-hearted approach to communication graphics drove the trend, but there were nevertheless some strange connections between product and clown. The American Cyanamid Company, whose motto was "molding the future through chemistry," stretched the ad concept thin using Ringling Bros.' "King of Clowns" Felix Adler to tout stearates. An ad for Texaco Oil ventured to describe a car's performance as "lively as a circus performer" for the smart consumer who came in for an oil change. The visual hook? A clown holding a daisy. The clever ad world provided a joker in every deck.

◀◀ Magazine cover, detail, 1949
Titelblatt einer Illustrierten, Ausschnitt, 1949
Couverture de magazine, détail, 1949

◀ Cigarette ad, illustration by G. Harmon Simmons, 1928
Zigarettenwerbung, Illustration von G. Harmon Simmons, 1928
Publicité pour des cigarettes, illustration de G. Harmon Simmons, 1928

ILLUSTRATIONEN

Der Clown ist seit Beginn des 20. Jahrhunderts ein zentrales Motiv von Gebrauchsgrafiken aller Art – nicht zuletzt wegen der kräftigen Primärfarben. Er prunkte auf den Titelseiten von Zeitschriften, schmückte Werbeplakate, lachte einen von Schallplattenhüllen an und kam sogar auf Briefmarken mit der Post ins Haus. Clowns wurden in den Printmedien als Werbeträger für alles Mögliche eingesetzt, vom Kaugummi bis zu Lederschuhen, von Zigaretten bis zu Feuerzeugen. Auch als ab den zwanziger Jahren Filmstars für Produkte zu werben begannen, konnten die Clowns weiterhin mithalten, weil sie

verkaufsfördernd die gewünschten Emotionen versinnbildlichten. Spielzeug und Spiele, Süßigkeiten und Limonade, Kekse und Cornflakes wurden den Kindern allesamt von Clowns angepriesen. Ende der Dreißiger gerieten auch die Erwachsenen ins Blickfeld der Werbestrategen. Schreiend bunte Krawatten und marmorierte Füllfederhalter zum Vatertag, sogar Wandfarbe und Benzin wurden auf die Empfehlung von grotesk angemalten Gestalten hin gekauft.

In einer Zeit, die nur wenig Sinn für Ironie hatte, ging der Trend hin zu einem fröhlichen Ansatz in Werbegrafik und Grafikdesign. Manchmal jedoch war die Ver-

bindung zwischen beworbenem Produkt und Clown geradezu absurd war. Die American Cyanamid Company, die das Motto hatte „Die Zukunft durch Chemie gestalten", ging etwas zu weit, als sie den „King of Clowns" Felix Adler Stearate anpreisen ließ. Eine Anzeige für Texaco Oil war sich nicht zu schade, die Leistung eines Autos als „lebhaft wie ein Zirkuskünstler" zu umschreiben, wenn der schlaue Kunde kam und das Öl wechseln ließ. Die Illustration dazu? Sie zeigte einen Clown mit einem Gänseblümchen in der Hand. Die gewitzten Werbeleute hatten immer noch einen Joker in der Hinterhand.

Magazine cover featuring Lou Jacobs, illustration by John Atherton, 1944
Zeitschrift mit Lou Jacobs auf dem Titelbild, Illustration von John Atherton, 1944
Couverture de magazine, portrait de Lou Jacobs par John Atherton, 1944

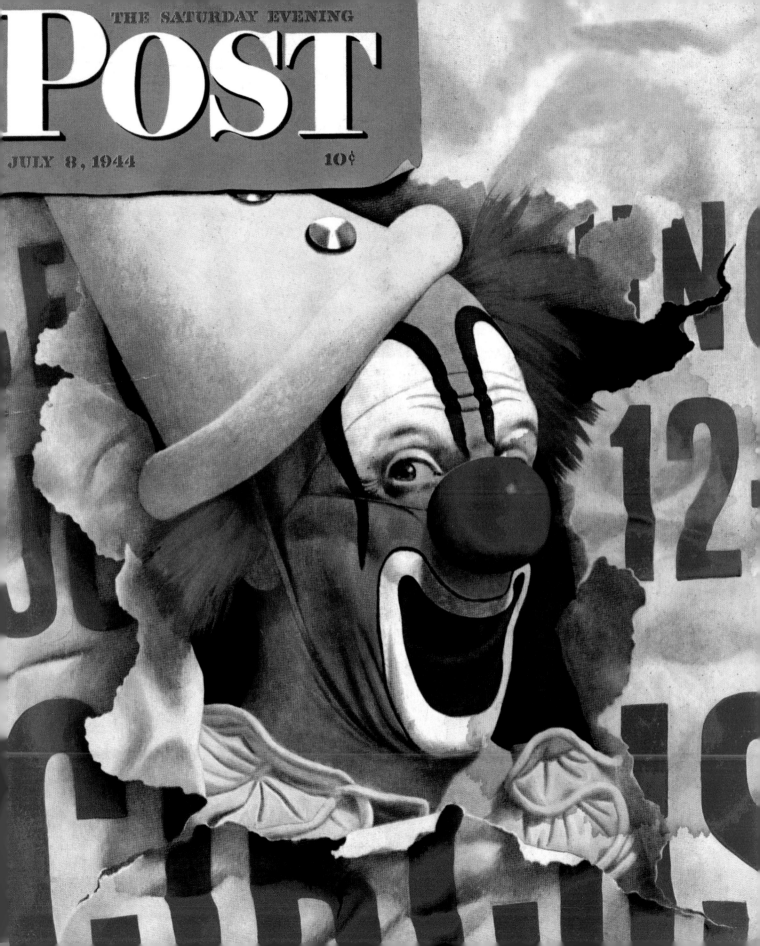

GRAPHISMES

Utilisant principalement les couleurs primaires, l'image du clown a toujours fait partie du monde de la publicité depuis le début du XXe siècle, étalée sur les couvertures de magazines, en effigie sur les affiches, imprimée sur les feuilles de musique et les pochettes de disques, et même envoyée par la poste sur les timbres-poste. Les clowns s'affichaient sur tout ce qui s'imprimait pour vendre n'importe quoi, du chewing-gum aux chaussures de cuir, des cigarettes aux briquets pour les allumer. Même lorsque dans les années 20 les stars de cinéma se sont mises à faire de la publicité, l'image du clown avait toujours sa place, personnifiant toutes les émotions nécessaires pour faire vendre une grande variété de marchandises. Les jeux et les jouets, les friandises et les boissons, les biscuits et les céréales de petit-déjeuner étaient vendus aux enfants par un clown pour vanter les mérites du produit. A la fin des années 30, ce fut au tour des adultes d'être ciblés. Des cravates criardes aux stylos plume marbrés pour la Fête des Pères, le café pour la mouture quotidienne des amateurs de caféine et même les peintures d'intérieur et l'essence étaient vendus sur la seule référence d'un personnage grotesquement peint.

A une époque sans ironie, une tentative de communication par une conception graphique plus ludique était à la mode, mais il y avait néanmoins d'étranges connexions entre le produit et le clown. La compagnie américaine Cyanamid, dont la devise était « Façonner le futur par la chimie », avait poussé l'idée de la publicité assez loin en embauchant « le roi des clowns » Felix Adler, du cirque Ringling, pour vendre des stéarates. Une réclame pour Texaco Oil se hasardait à vanter les performances d'une voiture en la décrivant comme étant « aussi trépidante qu'un artiste de cirque » au consommateur averti venu faire une vidange. Et ce qui attirait l'œil ? Un clown tenant une marguerite. Les petits malins de la publicité avaient un joker dans tous les jeux de cartes.

News magazine, illustration by Wesley Neff, 1938
Nachrichtenmagazin, Illustration von Wesley Neff, 1938
Magazine, illustration de Wesley Neff, 1938

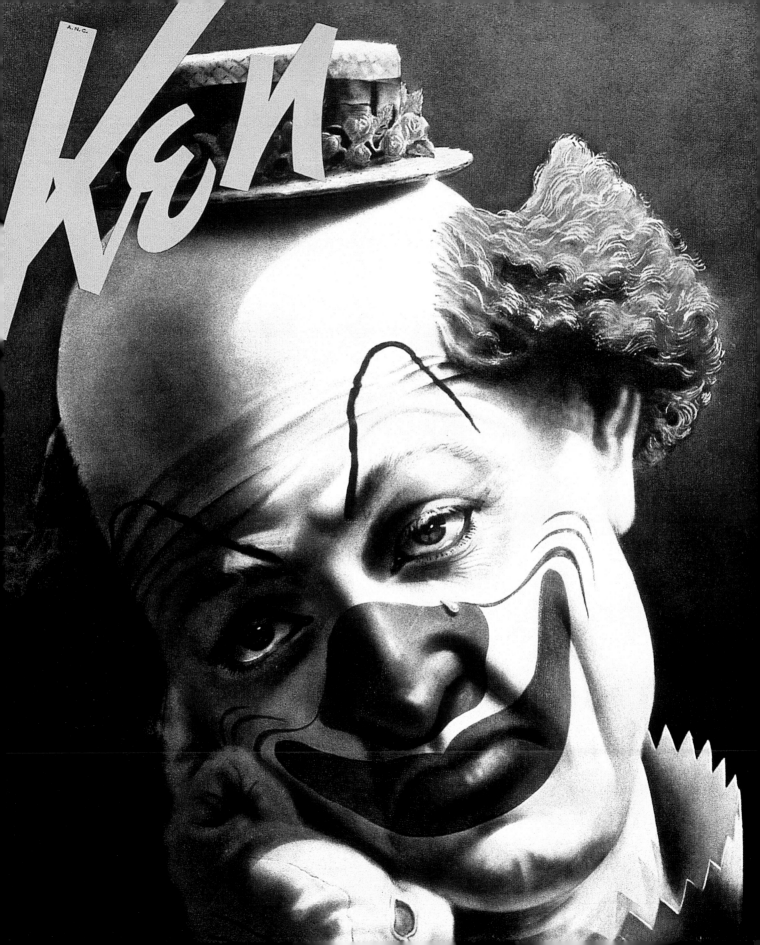

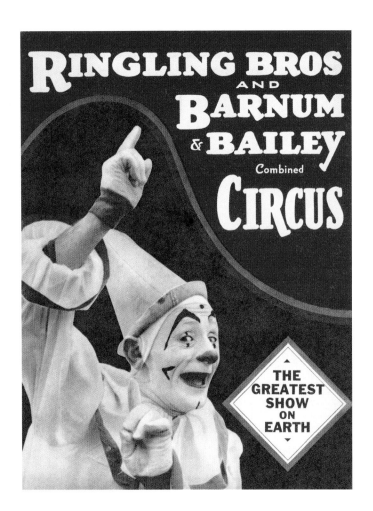

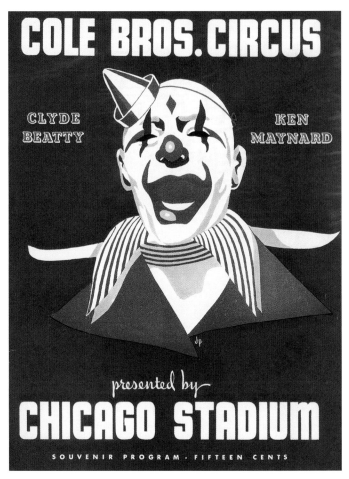

Circus programs, 1950s
Zirkusprogramme, 1950er Jahre
Programmes de cirque, années 1950

► Circus program, 1945
Zirkusprogramm, 1945
Programme de cirque, 1945

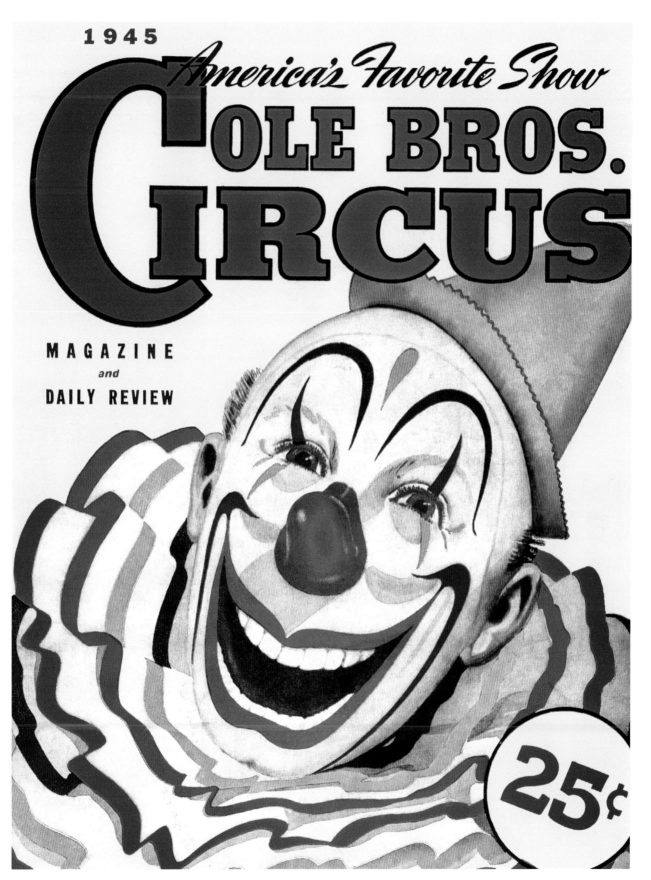

1945

America's Favorite Show

COLE BROS. CIRCUS

MAGAZINE
and
DAILY REVIEW

25¢

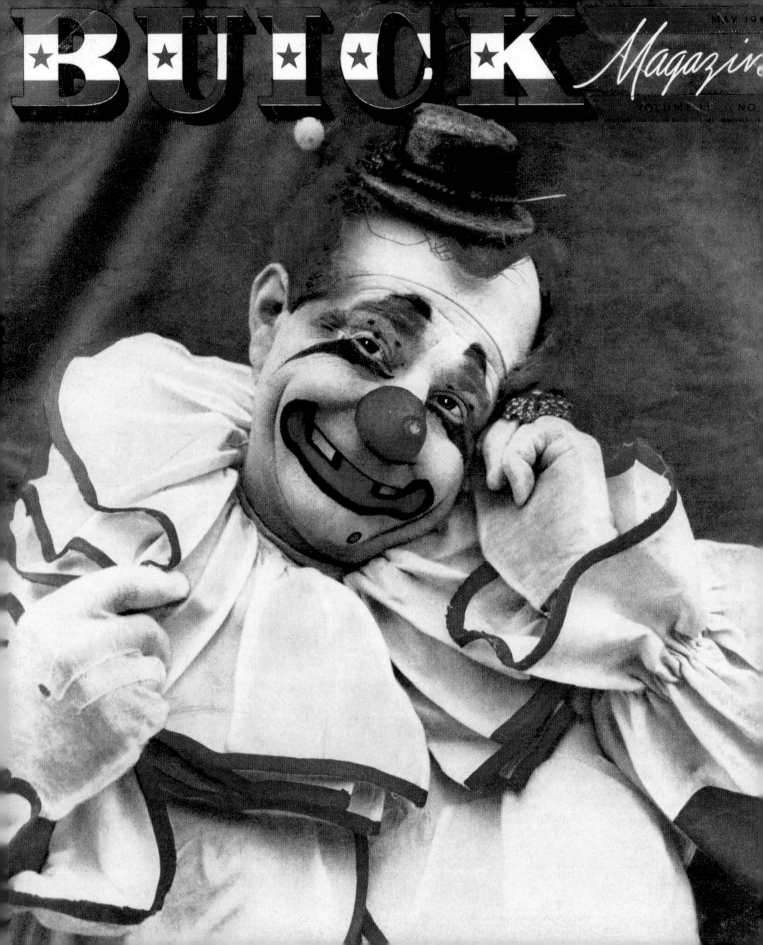

Magazine cover, illustration by Rea Irvin, 1947

April 12, 1947

THE NEW YORKER

Price 15 cents

◄ Magazine cover featuring Felix Adler, photograph by Steinmetz, 1950
Zeitschrift mit Felix Adler auf dem Titelbild, Fotografie von Steinmetz, 1950
Couverture de magazine, portrait de Felix Adler, photographie de Steinmetz, 1950

Magazine cover, illustration by Rea Irvin, 1947
Zeitschriftentitel, Illustration von Rea Irvin, 1947
Couverture de magazine, illustration de Rea Irvin, 194

Circus

MAGAZIN
and
DAILY
REVIEW

*Seaso
of 193*

10
CENT

*In Th
Issue*

*OUTSTANDIN
FEATURE ARTICL
and ILLUSTRATIO
BY
EMINENT CIRCU*

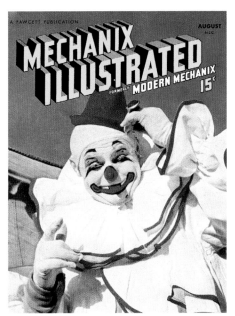

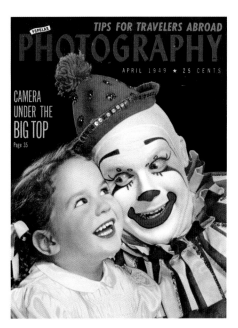

◄ Circus program, illustration by Roland Butler, 1938
Zirkusprogramm, Illustration von Roland Butler, 1938
Programme de cirque, illustration de Roland Butler, 1938

Various magazine covers and circus programs, 1930s–50s
Diverse Zeitschriftentitel und Zirkusprogramme, 1930er bis 1950er Jahre
Diverses couvertures de magazines et programmes de cirque, années 1930–1950

34th Annual
CIRCUS & FIREWORKS

Budd & Janet Goldberg

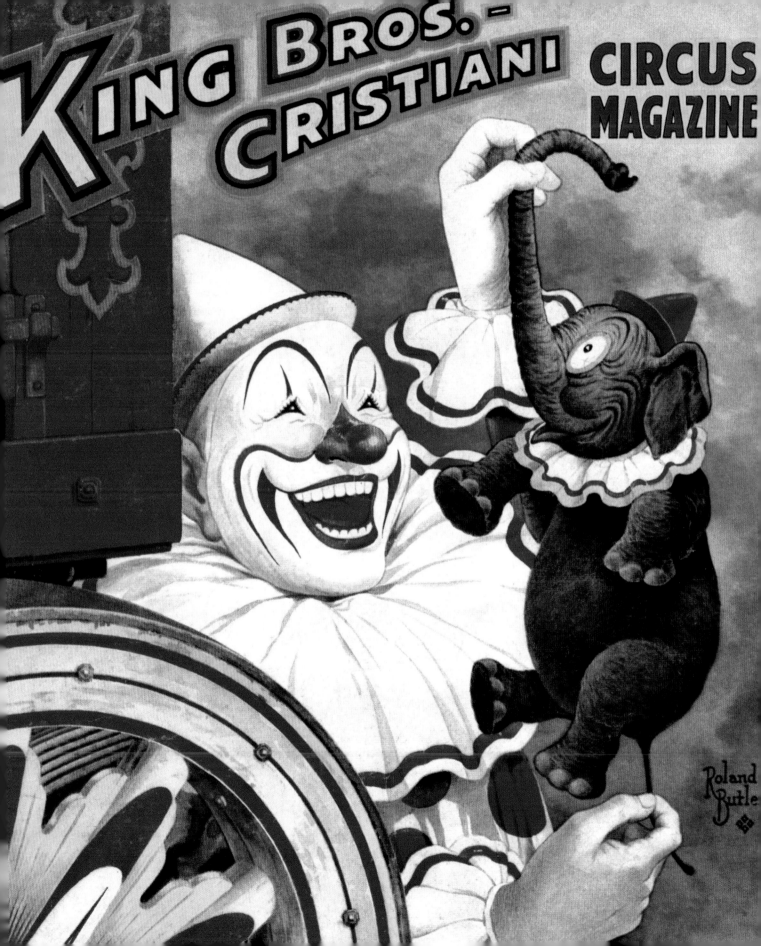

KING BROS. - CRISTIANI

CIRCUS MAGAZINE

Roland Butle

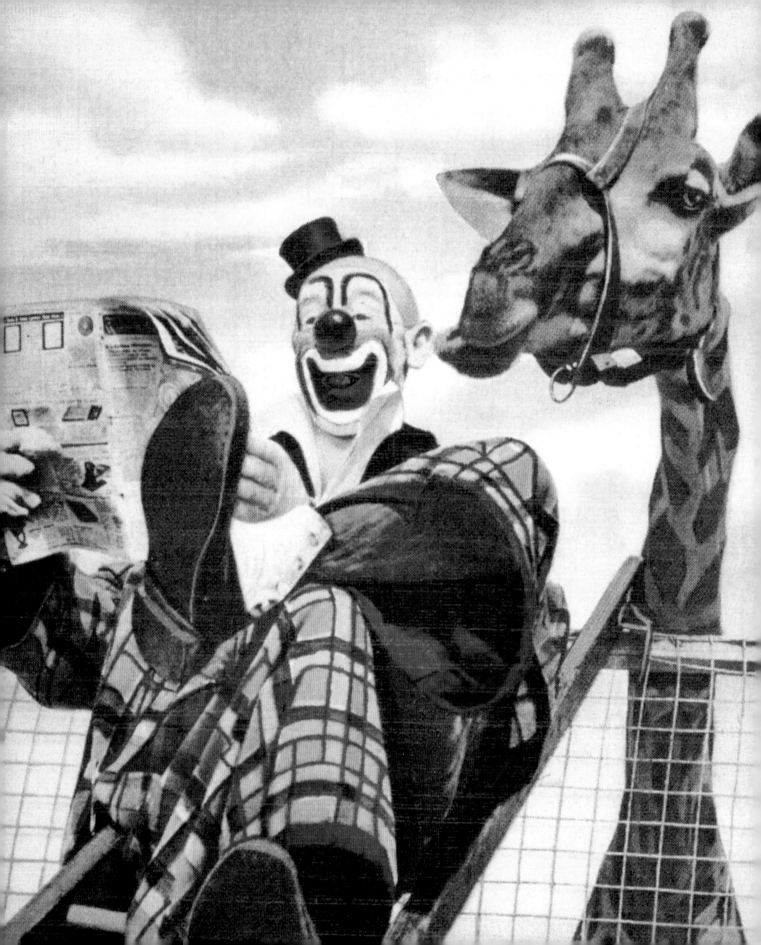

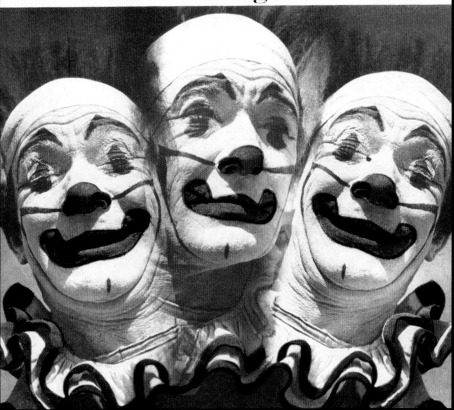

MAY 1948

The Camera

35¢

In U. S. A.

the only photographic magazine with a complete booklet in each issue

Camerette
Feature . . . **Photomontage . . . page 87**

◄◄ Circus program, illustration by Roland Butler, 1953
Zirkusprogramm, Illustration von Roland Butler, 1953
Programme de cirque, illustration de Roland Butler, 1953

◄ Lou Jacobs, linen Curteich postcard, 1940s
Lou Jacobs, Curteich-Leinenpostkarte, 1940er Jahre
Lou Jacobs, carte postale en papier de lin de Curteich, années 40

Magazine cover, photograph by Boris Dobro, 1948
Zeitschriftentitel, Fotografie von Boris Dobro, 1948
Couverture de magazine, photographie de Boris Dobro, 1948

San Francisco Exposition souvenir program, 1940
Souvenirprogramm der San Francisco Ausstellung, 1940
Programme souvenir de l'exposition de San Francisco, 1940

▶ Holiday circus program, 1938
Weihnachtliches Zirkusprogramm, 1938
Programme du cirque Holiday, 1938

Magazine covers, top left: illustration by Ellie Thresher, 1933; top right: illustration
by Adolph Tradling, 1913; bottom left: illustration by Herbert Paus, 1933; bottom
right: Bill Ballantine, photograph by George Karger, 1949

Zeitschriftentitel, oben links: Illustration von Ellie Thresher, 1933; oben rechts:
Illustration von Adolph Tradling, 1913; unten links: Illustration von Herbert Paus,
1933; unten rechts: Bill Ballantine, Fotografie von George Karger, 1949

Couvertures de magazines, en haut à gauche: illustration d'Ellie Thresher, 1933;
en haut à droite: illustration d'Adolph Tradling, 1913; en bas à gauche: illustration
de Herbert Paus, 1933; en bas à droite: Bill Ballantine, photographie de George
Karger, 1949

▶ Magazine cover, illustration by John E. Sheridan, 1939
Zeitschriftentitel, Illustration von John E. Sheridan, 1939
Couverture de magazine, illustration de John E. Sheridan, 193

THE SATURDAY EVENING POST

An Illust...
Founded A° D...

Volume 211, Number 49

June 3, 1939

5 cts.

MAY 21 1921 Vol. LXXXVI, No. 21. Published Weekly at Philadelphia, Pennsylvania. Entered as Second-Class Matter July 7, 1911, at the Post Office at Philadelphia, Pennsylvania, Under the Act of March 3, 1879. *Five Cents the Copy*

The COUNTRY GENTLEMAN
The OLDEST AGRICULTURAL JOURNAL in the WORLD

ORR

Painted by Alfred E. Orr

THE NEW DAY WANES — By PHILIP S. ROSE

◄ Magazine cover, illustration by Norman Rockwell, chronicler of the American scene in the early twentieth century, 1918

Zeitschriftentitel, Illustration von Norman Rockwell, dem berühmten amerikanischen Genremaler des frühen 20. Jahrhunderts, 1918

Couverture de magazine, illustration de Norman Rockwell, chroniqueur du milieu artistique américain au début du 20e siècle, 1918

Magazine cover, sadistic clown painted by Alfred E. Orr, 1921

Zeitschriftentitel, sadistischer Clown, gemalt von Alfred E. Orr, 1921

Couverture de magazine, clown sadique, peinture d'Alfred E. Orr, 1921

Paperback book cover, painting by James Meese, 1955
Einband eines Taschenbuches, gemalt von James Meese, 1955
Couverture d'un livre de poche, peinture de James Meese, 1955

Pulp fiction magazine, illustration by John A. Caughlin, 1927
Pulp-Fiction-Magazin, Illustration von John A. Caughlin, 1927
Magazine à sensations, illustration de John A. Caughlin, 1927

► True crime story magazine, 1962
„Wahre Verbrechen" im Heftchenformat, 1962
Magazine de vraies histoires de crimes, 1962

►► Poster, 1961
Plakat, 1961
Affiche, 1961

►►► Program, 1954
Programm, 1954
Programme, 1954

May, 1962
25 cents

OFFICIAL DETECTIVE STORIES

Combined with Actual Detective

California's Case of
Eileen Ryan:

"LOOK FOR SOMEBODY
WHO SNIFFS GLUE"

BOZO

IN PERSON
KTLA's TELEVISION CLOWN

MAYFAIR MARKET
CULVER CITY

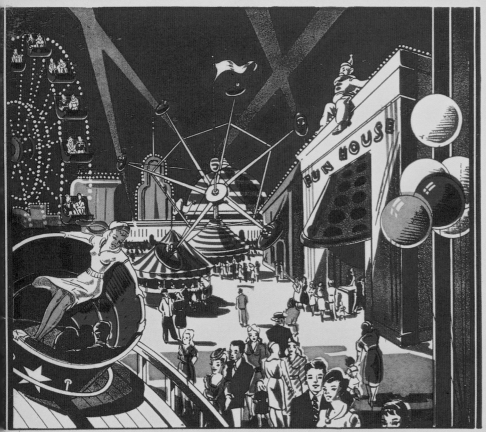

SUTTON'S PACIFIC COAST SHOWS

SAT. 4:00 P.M.
JULY 8

Ask for **FREE** Discount Coupons for Carnival Rides

**RIDES
GOOD CLEAN
FUN**

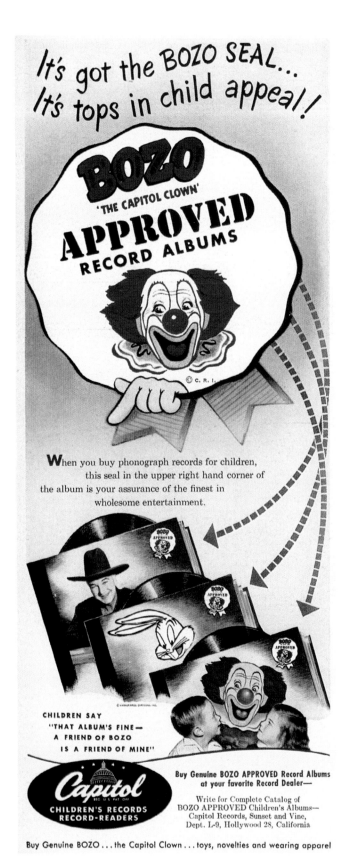

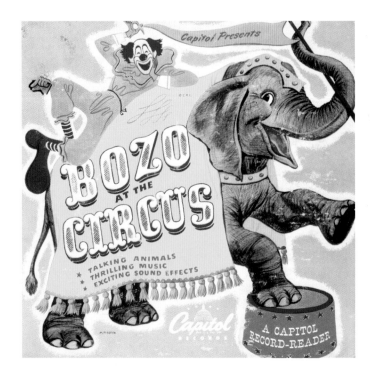

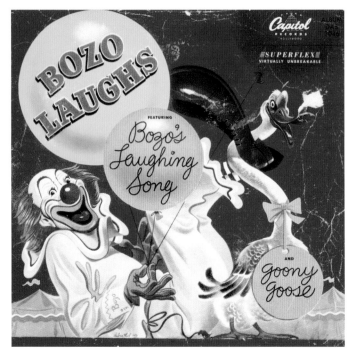

Ad and 78-RPM record sleeves for Capitol Records, illustrations by M. Fischer (top) and Hubinthal (bottom), 1948

Anzeige und Hüllen von 78-RPM-Schallplatten für Capitol Records, Illustrationen von M. Fischer (oben) und Hubinthal (unten), 1948

Publicité et pochettes de disques 78 tours de Capital Records, illustrations de M. Fischer (en haut) et Hubinthal (en bas), 1948

Original painting for 78-RPM record sleeve, gouache, 1948
Originalmalerei für die Hülle einer 78-RPM-Schallplatte, Gouache, 1948
Peinture originale pour une pochette de disque 78 tours, gouache, 1948

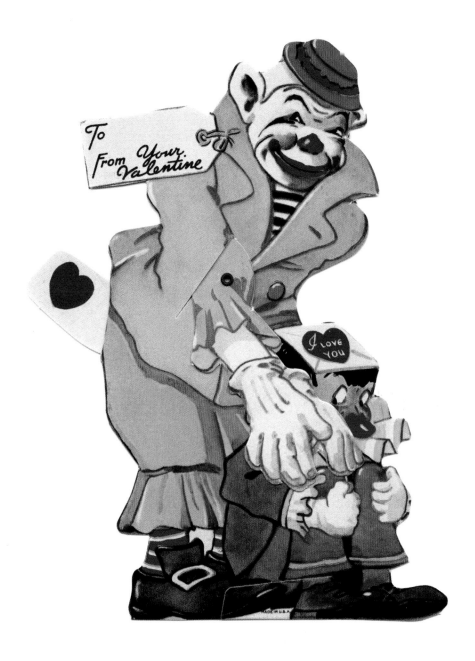

Die-cut Valentine's Day card, 1922
Karte zum Valentinstag in Form eines Glanzbildes, 1922
Carte de Saint-Valentin découpée, 1922

▶ Animated display card Valentine, 1919
Bewegliche Valentinstagskarte, 1919
Carte de Saint-Valentin animée, 1919

▶▶ U.S. postage stamp, commemorating the bicentennial of the circus in America, 1993
Amerikanische Briefmarke zur Feier von 200 Jahren Zirkus in Amerika, 1993
Timbre-poste américain, en commémoration du bicentenaire du cirque en Amérique, 1993

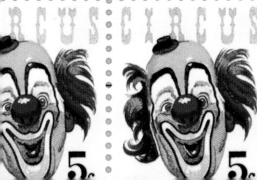
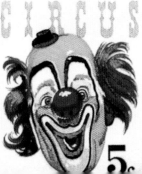
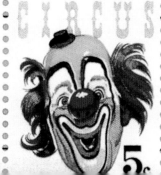

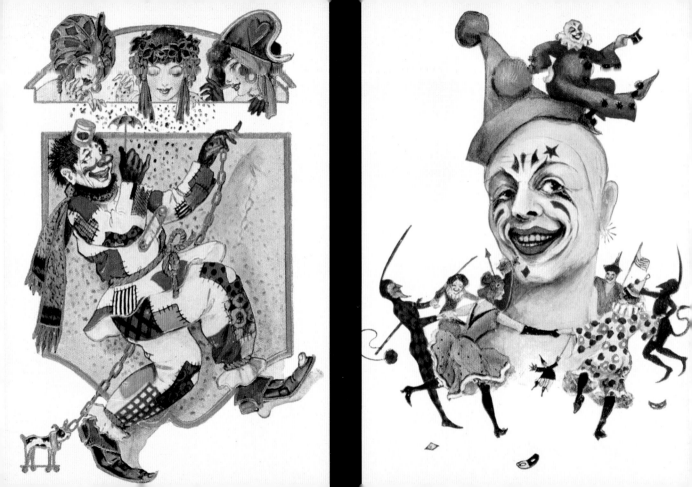

"SHAKE HANDS WITH MR. RINGLING AND TELL HIM HIS CIRCUS IS A BEAUTIFUL THINGLING."
– OGDEN NASH, "THE BIG TENT UNDER THE ROOF" FROM VERSES FROM 1929 ON

"HOCH ERFREUT, MR. RINGLING, IHR ZIRKUS IST EIN SCHÖNES DINGLING."
– OGDEN NASH, "THE BIG TENT UNDER THE ROOF", AUS VERSES FROM 1929 ON

« DIS BONJOUR À M. RINGLING ET DIS-LUI QUE SON CIRQUE A UN BÔÔÔÔÔÔHHH CHAPITÔÔÔÔÔÔÔÔHHHH. »
– OGDEN NASH, "THE BIG TENT UNDER THE ROOF", DANS VERSES FROM 1929 ON

Three-color litho poster, 1940s
Dreifarbiges Lithoplakat, 1940er Jahre
Affiche, lithographie en trois couleurs, années 40

▶ Palace of Fun poster, detail, 1940s
Plakat für einen „Spaßpalast", Ausschnitt, 1940
Affiche du Palace of Fun, détail, 1940

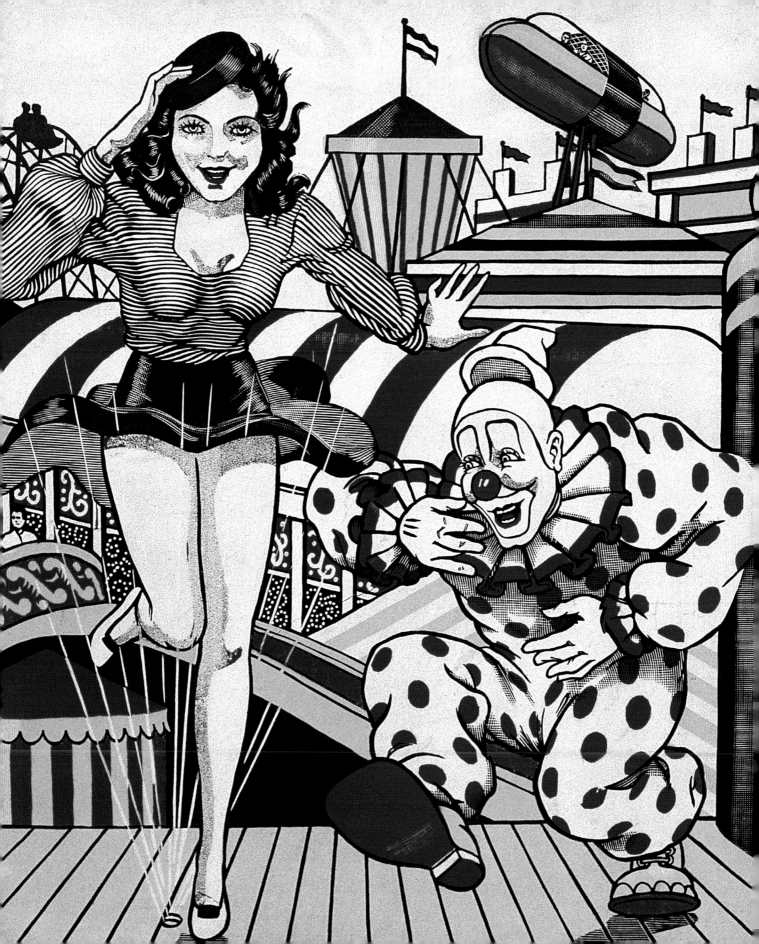

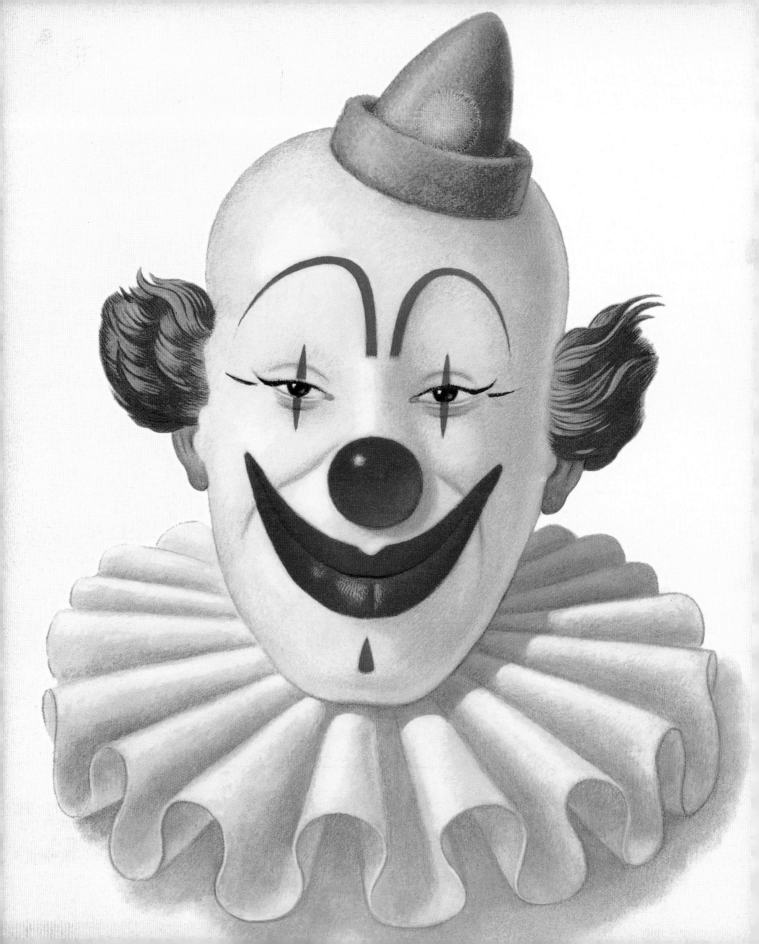

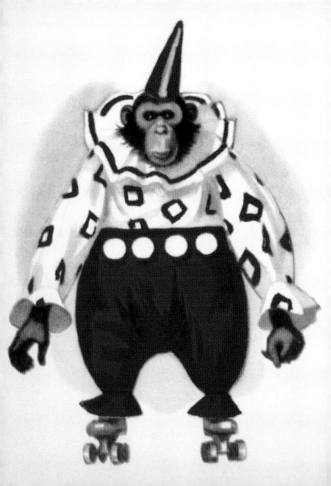

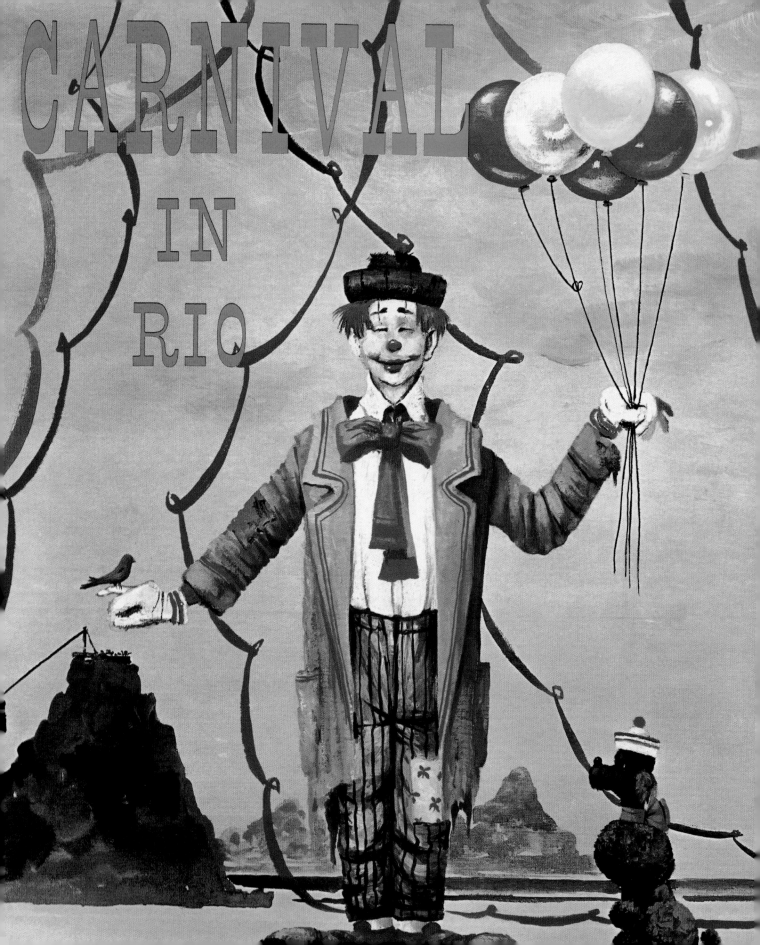

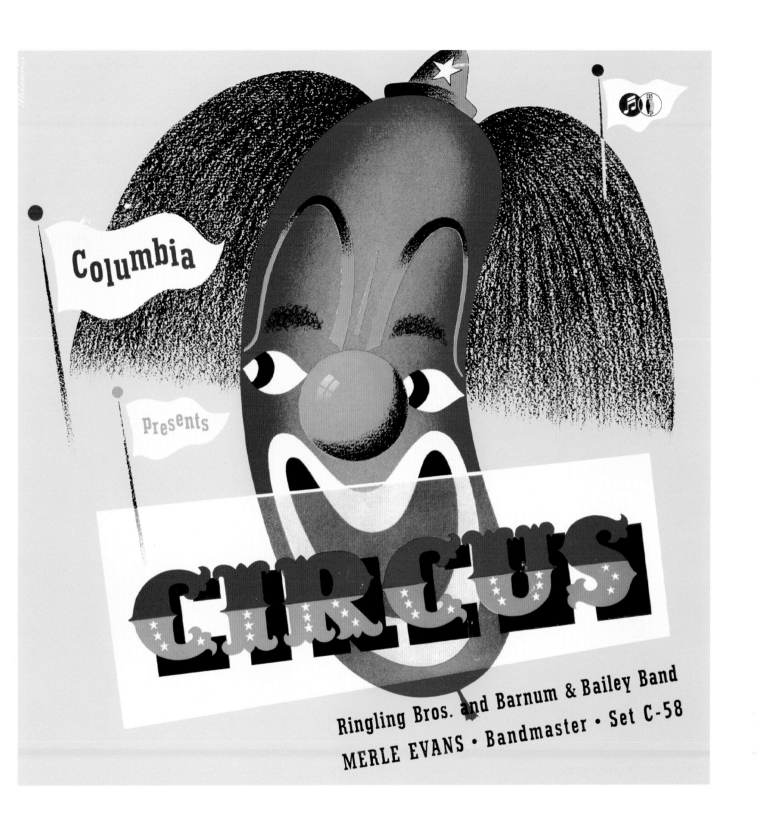

Columbia

Presents

CIRCUS

Ringling Bros. and Barnum & Bailey Band

MERLE EVANS • Bandmaster • Set C-58

◄ Album cover, illustration by John Morris, 1950s
Schallplattenhülle, Illustration von John Morris, 1950er Jahre
Pochette de disque, illustration de John Morris, années 50

Album sleeve, 1948
Schallplattenhülle, 1948
Pochette de disque, 1948

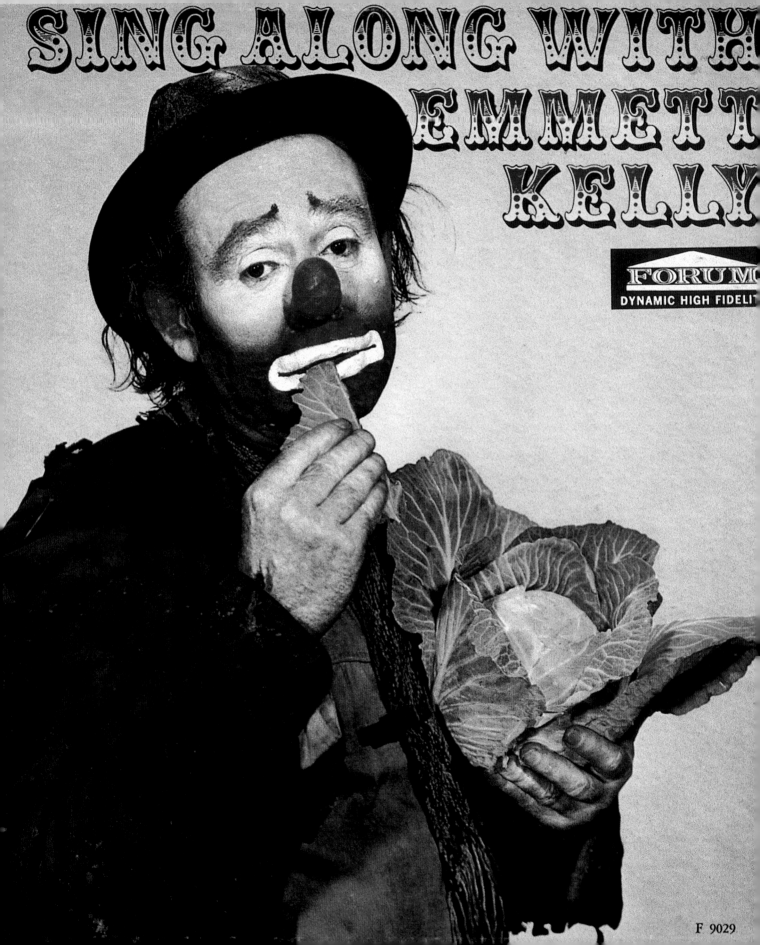

SING ALONG WITH EMMETT KELLY

FORUM
DYNAMIC HIGH FIDELITY

F 9029

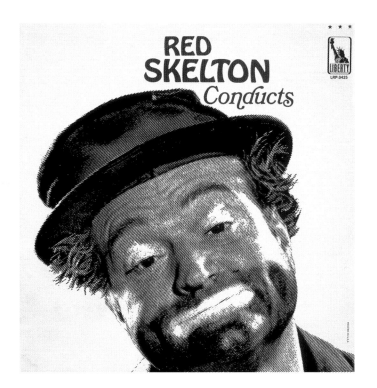

Red Skelton album cover, 1965
Schallplattenhülle eines Red-Skelton-Albums, 1965
Pochette d'un album de Red Skelton, 1965

◄ Ironically titled album by the clown who never spoke in costume, 1960
Schallplatte des Clowns, der nie etwas sagte, mit dem ironischem Titel „Sing mit Emmett Kelly", 1960
Pochette au titre ironique par le clown qui n'a jamais dit un mot en costume, 1960

Frank Sinatra album cover that won first-ever Grammy Award for Art Direction; illustration by Volpe, 1959
Schallplattenhülle des Frank-Sinatra-Albums, das den allerersten Grammy für Art Direction gewann; Illustration von Volpe, 1959
Pochette d'un album de Frank Sinatra, le premier à avoir remporté un Grammy Award pour la conception graphique; illustration de Volpe, 1959.

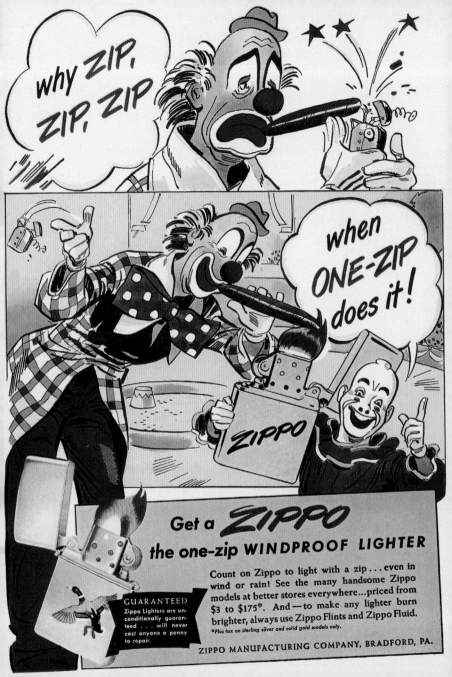

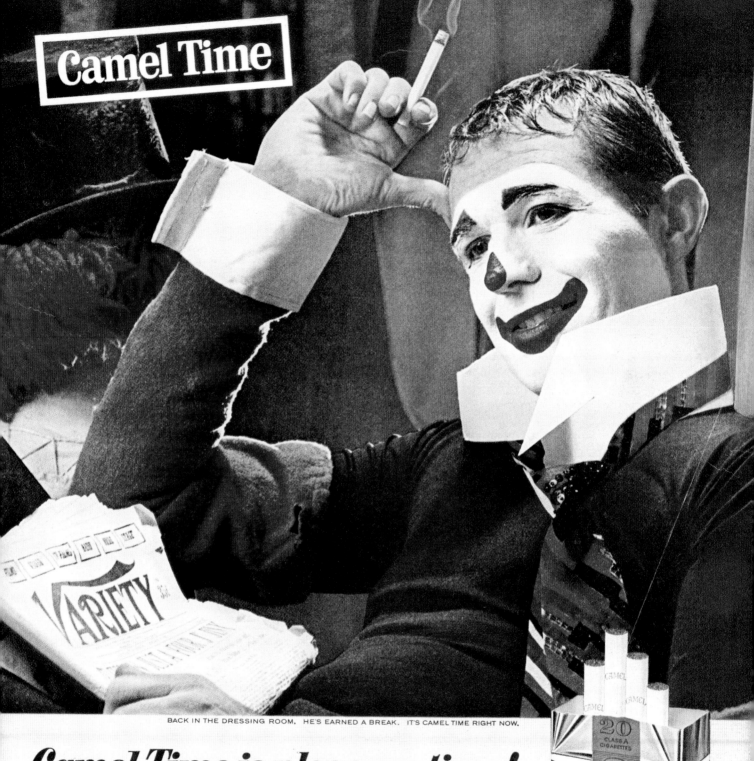

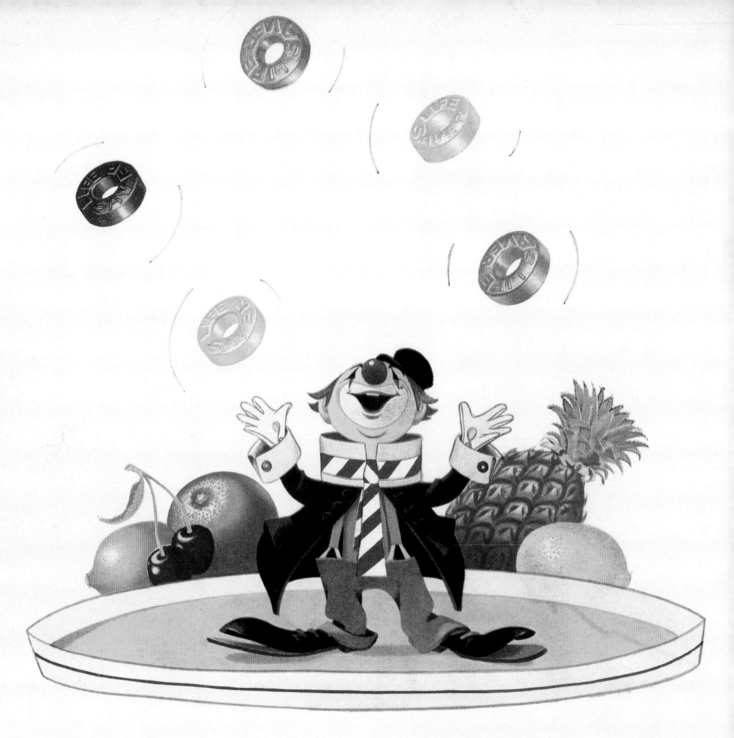

5-star flavor hit

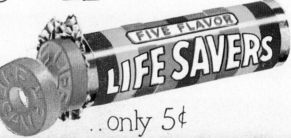

The candy with the hole ...only 5¢

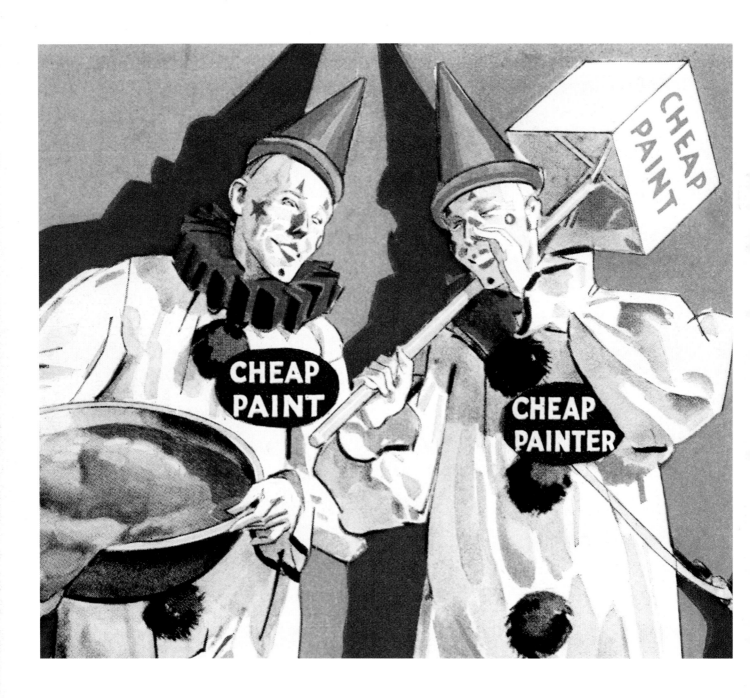

Advertising illustration, 1929
Werbeillustration, 1929
Illustration publicitaire, 1929

◄ Breakfast cereal ad, 1920s
Werbeanzeige für Frühstücksflocken, 1920er Jahre
Publicité pour des céréales de petit-déjeuner, années 20

► Advertising illustration, 1927
Werbeillustration, 1927
Illustration publicitaire, 1927

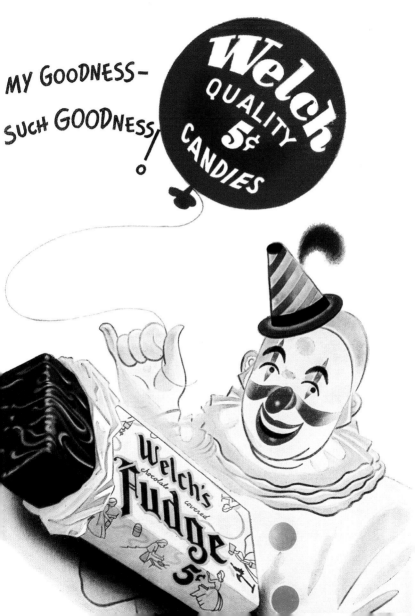

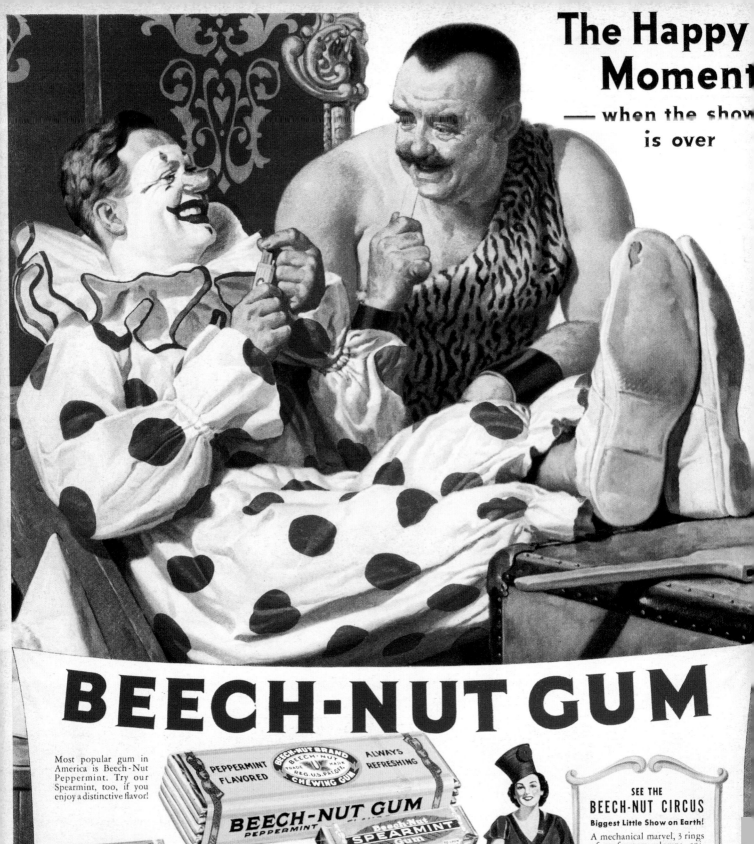

The Happy Moment

— when the show is over

BEECH-NUT GUM

Most popular gum in America is Beech-Nut Peppermint. Try our Spearmint, too, if you enjoy a distinctive flavor!

BEECH-NUT GUM
PEPPERMINT

PEPPERMINT FLAVORED · BEECH-NUT BRAND CHEWING GUM · ALWAYS REFRESHING

Beech-Nut SPEARMINT Gum

BEECHIES
Gum in a crisp candy coating ... doubly delightful that way! Peppermint, Spearmint, Pepsin.

Beech-Nut SPEARMINT 5¢ BEECHIES

Beech-Nut PEPPERMINT

Beech-Nut PEPSIN

Beech-Nut ORALGENE Chewing Gum WITH DEHYDRATED MILK OF MAGNESIA

SEE THE BEECH-NUT CIRCUS
Biggest Little Show on Earth!

A mechanical marvel, 3 rings of performers, clowns, animals, music 'n' everything! Now touring the country. Be sure to see it when it visits your city.

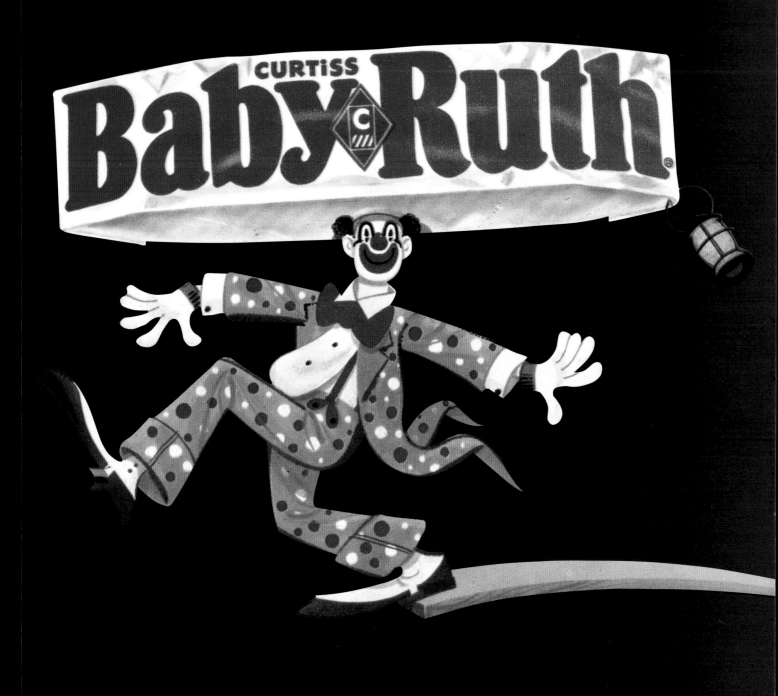

◄ Chewing gum ad, 1936
Kaugummiwerbung, 1936
Publicité pour un chewing-gum, 1936

Candy ad, detail, illustration by Eaton, 1950s
Ausschnitt aus einer Schokoladenwerbung, Illustration von Eaton, 1950er Jahre
Publicité pour des friandises, détail, illustration d'Eaton, années 50

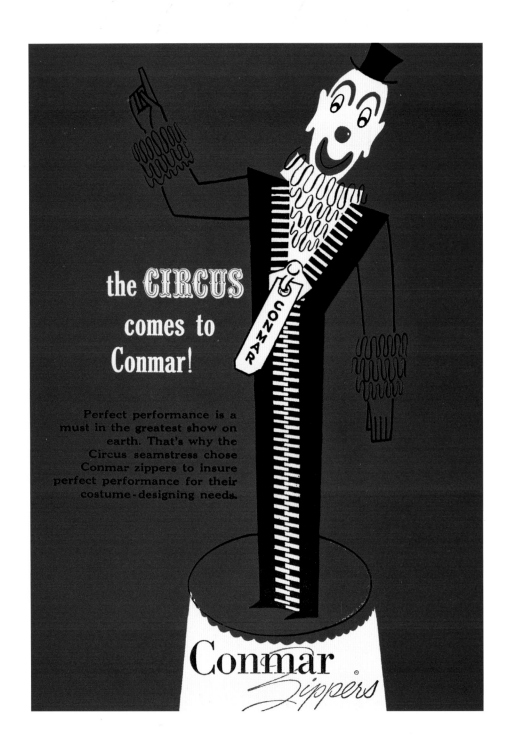

the **CIRCUS**
comes to
Conmar!

Perfect performance is a
must in the greatest show on
earth. That's why the
Circus seamstress chose
Conmar zippers to insure
perfect performance for their
costume-designing needs.

Conmar
Zippers®

Zipper ad, 1950s
Reißverschlusswerbung, 1950er Jahre
Publicité pour une fermeture éclair, années 50

▶ Roller skates ad, 1940s
Werbeanzeige für Rollschuhe, 1940er Jahre
Publicité pour des patins à roulettes, années 40

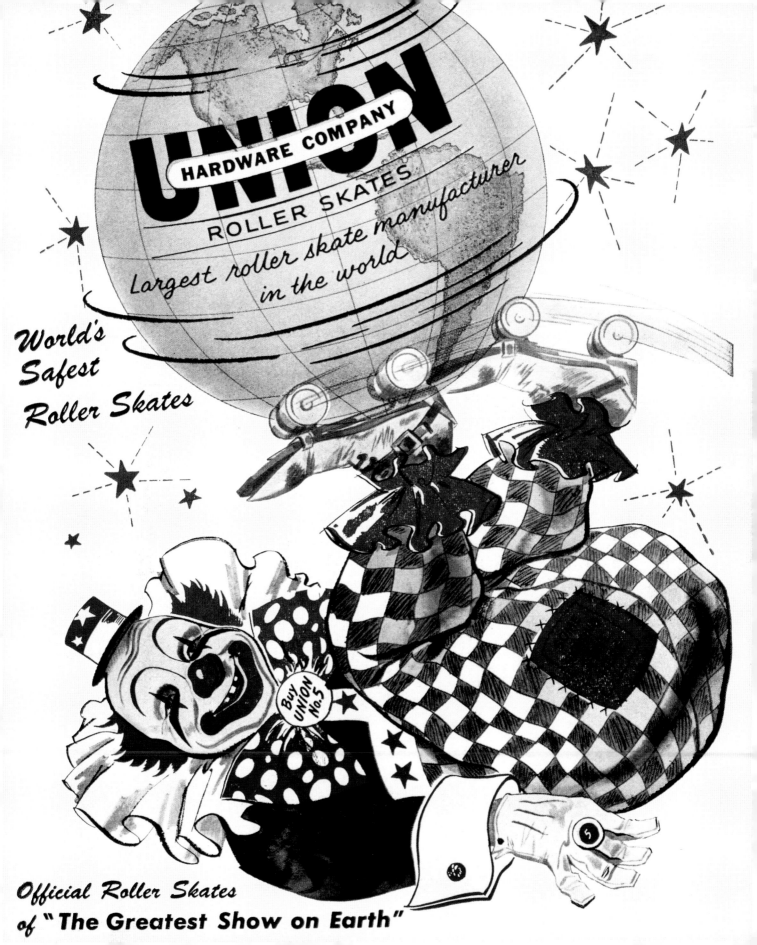

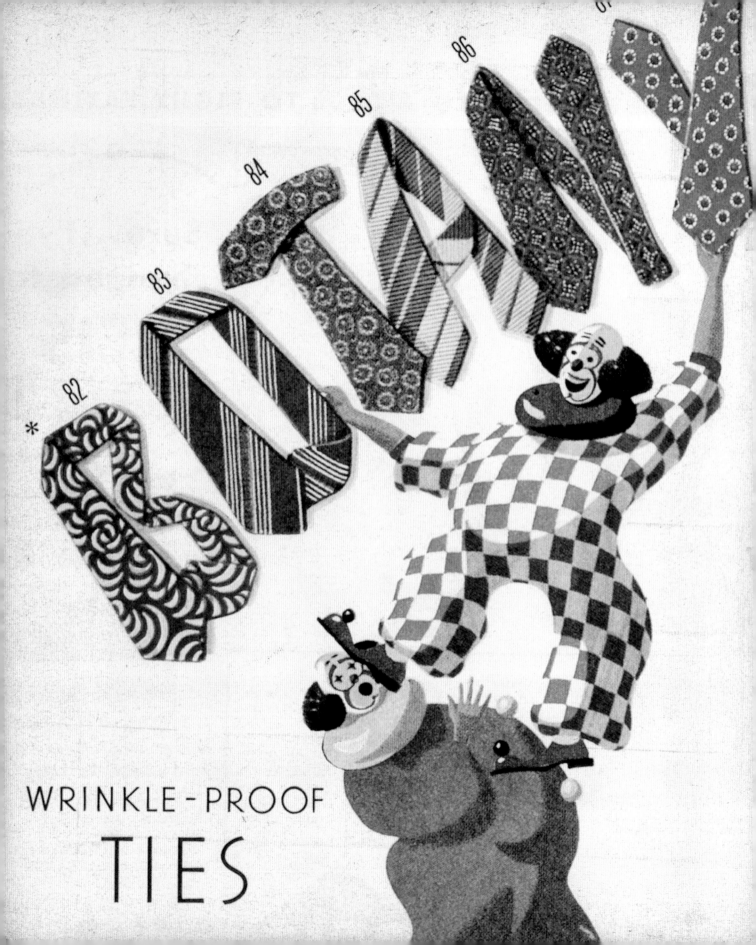

WRINKLE-PROOF
TIES

the greatest show on earth!

now on ties by Signet

circus patterns

Daring young men will swing toward these
daring new patterns by Signet. The
fun and vitality of the Big Tent have been
strikingly captured and tamed.
For youngsters from sixteen to sixty.
"Saddle-Up" men's toiletries by Signet add
a dash of vital masculine grooming!

Signet TIES and toiletries

Arthur Siegman Inc., 16 E. 34th St. • New York City

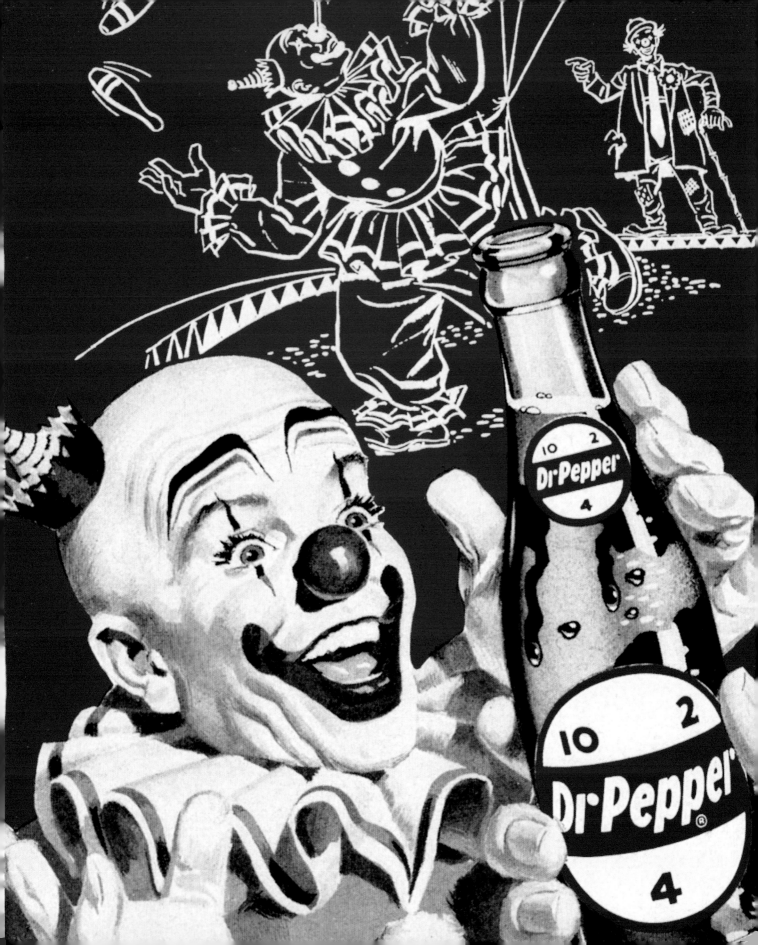

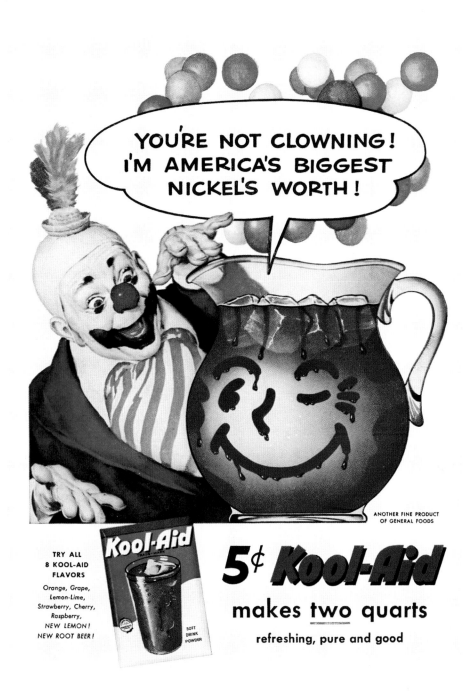

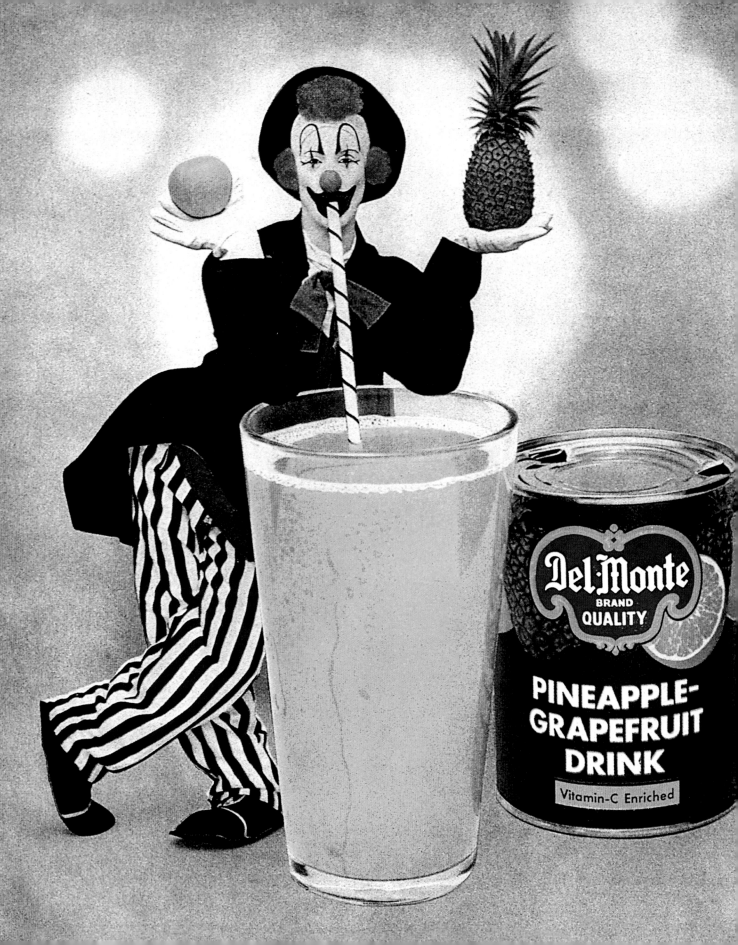

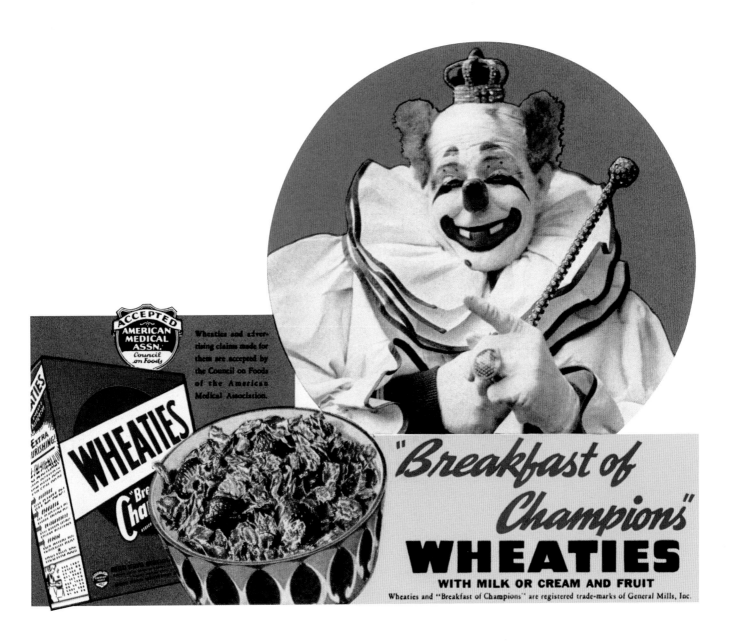

ACCEPTED
AMERICAN MEDICAL ASSN.
Council on Foods

Wheaties and advertising claims made for them are accepted by the Council on Foods of the American Medical Association.

WHEATIES
EXTRA NOURISHING
"Bre Cha

"*Breakfast of Champions*"
WHEATIES
WITH MILK OR CREAM AND FRUIT
Wheaties and "Breakfast of Champions" are registered trade-marks of General Mills, Inc.

Breakfast cereal ad featuring spokesman Felix Adler, 1940s
Werbeanzeige für Frühstückflocken mit Felix Adler als Werbeträger, 1940er Jahre
Publicité pour des céréales de petit-déjeuner représentant leur porte-parole Felix Adler, années 40

◄ Fruit juice ad, 1959
Werbeanzeige für Fruchtsaft, 1959
Publicité pour un jus de fruits, 1959

► Texaco Oil ad, detail, 1950
Werbeanzeige für Texaco Oil, Ausschnitt, 1950
Publicité de Texaco Oil, détail, 1950

SPRING!

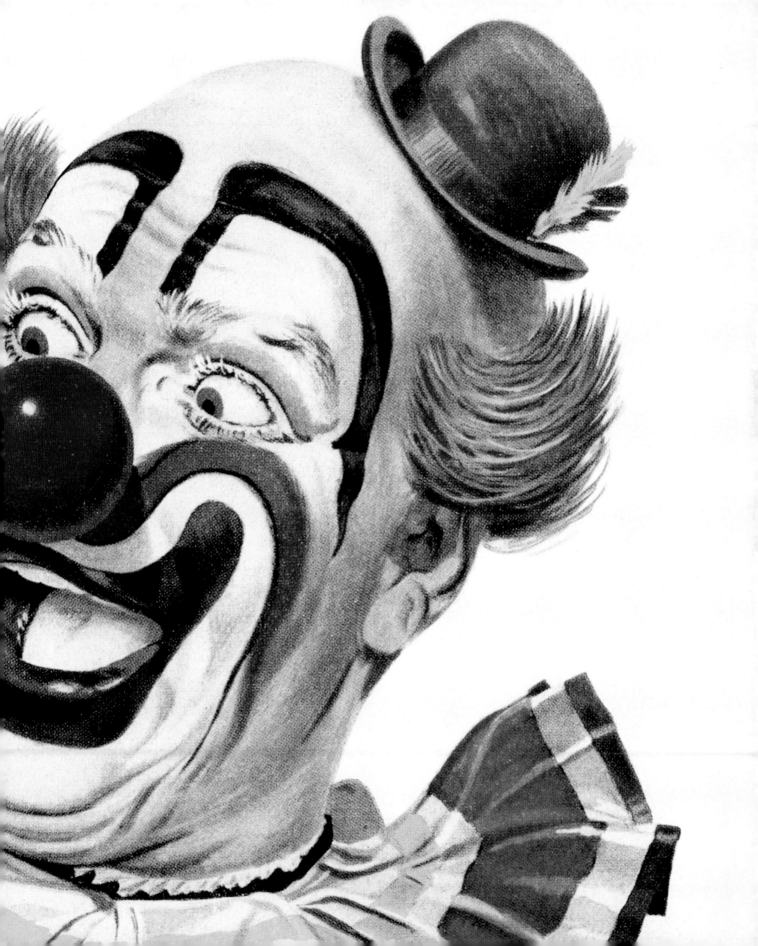

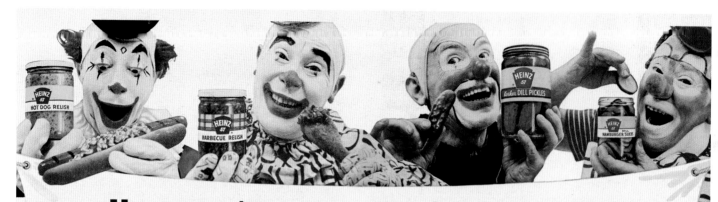

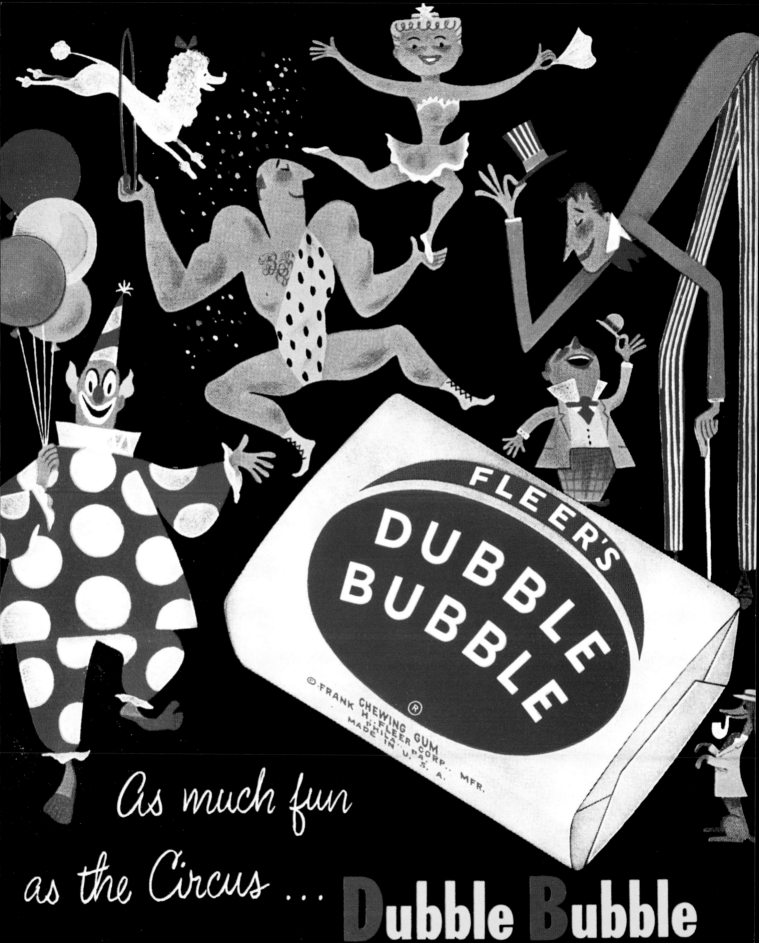

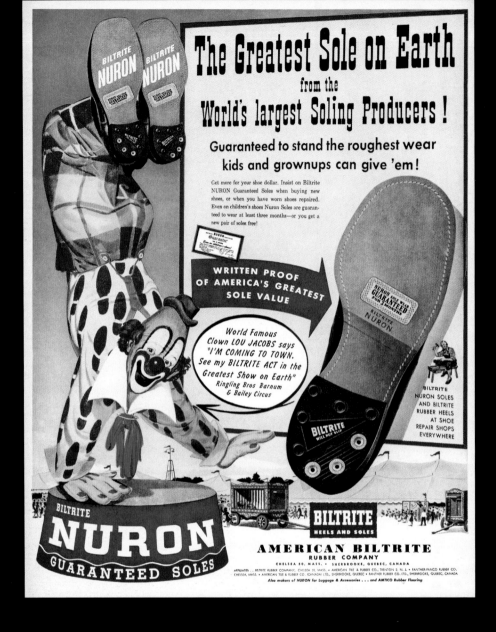

Lou Jacobs as the soleful adman, 1940s
Lou Jacobs als Werbeträger mit „Sohle", 1940er Jahre
Lou Jacobs sur une publicité pour des semelles, années 40

▶ Comedian Red Skelton endorsing the Sands Hotel, Las Vegas as Freddie the
Freeloader, ad, 1962
Komiker Red Skelton wirbt als Freddie the Freeloader für das Sands Hotel in
Las Vegas, 1962
Le comique Red Skelton en Freddie the Freeloader dans une publicité pour
le Sands Hotel, Las Vegas, 1962

Match-cover art, 1930s–40s
Illustrationen auf Streichholzschachteln, 1930er bis 1940er Jahre
Illustrations sur une boîte d'allumettes, années 1930–1940

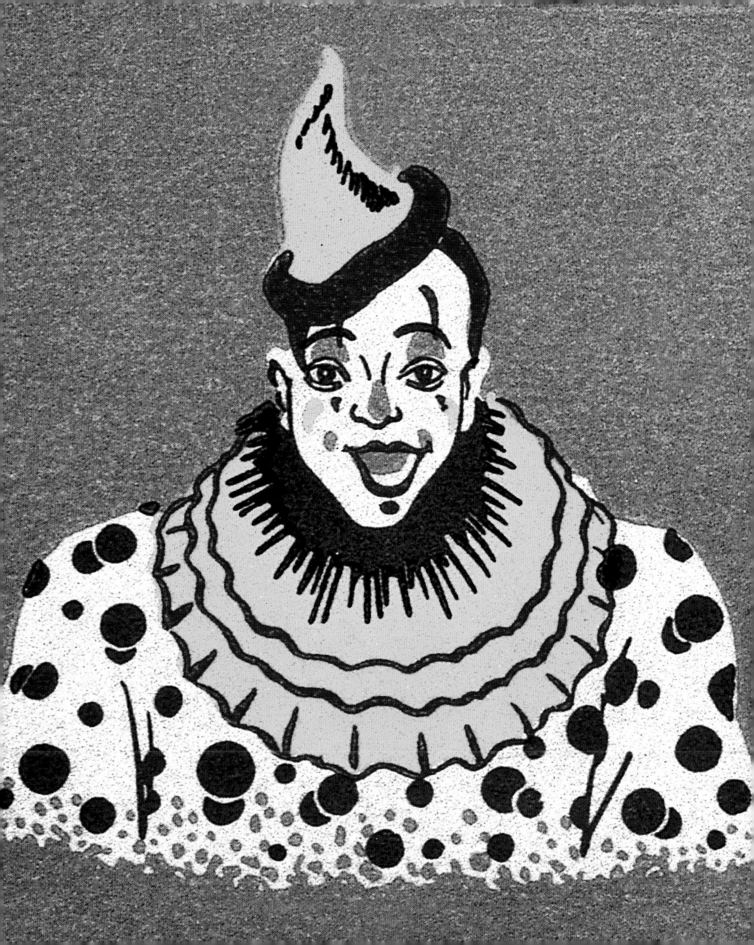

The Fairmont Circus Lounge
NOB HILL
SAN FRANCISCO

◀ Restaurant menu, Long Beach, California, ca.1947
Speisekarte eines Restaurants, Long Beach, Kalifornien, um 1947
Menu de restaurant, Long Beach, Californie, vers 1947

Fairmont Hotel cocktail coaster, San Francisco, California, ca.1945
Glasuntersetzer des Fairmont Hotel, San Francisco, Kalifornien, um 1945
Dessous de verre à cocktail du Fairmont Hotel, San Francisco, Californie, vers 1945

THE CLOWN

"LAUGH AND THE WORLD LAUGHS WITH YOU

LABEL PROTECTED

Country Home magazine cover, detail, illustration by Frank Street, 1934
Country Home Zeitschriftentitel, Ausschnitt, Illustration von Frank Street, 1934
Converture du magazine *Country Home*, détail, illustration de Frank Street, 1934

◄ Cigar box label, ca. 1910
Zigarrenkistenaufkleber, um 1910
Etiquette de boîte de cigares, vers 1910

► Button manufactured by Whitehead & Hoag, 1896
Anstecker, hergestellt von Whitehead & Hoag, 1896
Badge manufacturé par Whitehead & Hoag, 1896

►► Playing-card jokers, 1920s–50s
Joker aus diversen Kartenspielen, 1920er bis 1950er Jahre
Jokers de cartes à jouer, 1920–1950

Card showing Contract Bridge Score may be used as an extra Joker.

◄◄ Gift-wrapping paper, 1940s
Geschenkpapier, 1940er Jahre
Papier cadeau, années 1940

◄ Plastic straw packaging, 1960s
Strohhalmverpackung, 1960er Jahre
Emballage de pailles à boire en plastique, années 60

Stainless steel clown bank, 1962
Spardose in Form eines Clowns, Edelstahl, 1962
Ebauche de clown en acier inoxydable, 1940

ATLANTIC CITY, N.J.

"CUT·TO·FIT·THE·MOUTH"

Toy coin bank lid, 1930s
Rassel aus Blech, 1930er Jahre
Crécelle en étain, années 30

Tin noisemaker, 1930s
Deckel einer Spielzeugspardose, 1930er Jahre
Couvercle de tirelire jouet, années 30

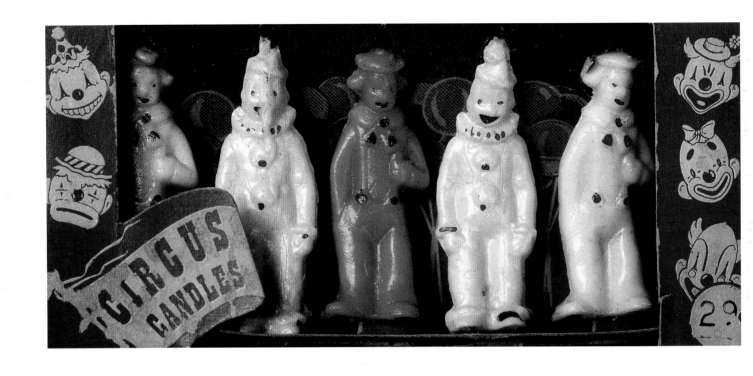

Birthday candles, 1950s
Geburtstagskerzen, 1950er Jahre
Bougies d'anniversaire, années 50

▶ Birthday gift-wrapping paper, 1940s
Geburtstagsgeschenkpapier, 1940er Jahre
Papier d'emballage cadeau d'anniversaire, années 40

Promotional snap gun, 1950s
Spielzeugpistole mit Werbeaufdruck, 1950er Jahre
Matériel publicitaire en forme de pistolet, années 50

Souvenir pennant, felt, 1940s
Souvenirwimpel, Filz, 1940er Jahre
Fanion souvenir, feutre, années 40

◄ Tin dart gun target, 1950s
Zielscheibe für ein Wurfpfeilspiel, Blech, 1950er Jahre
Cible en étain pour pistolet à fléchettes, années 50

Lucky Clown

TRADE MARK

Miniature Pin Ball Game

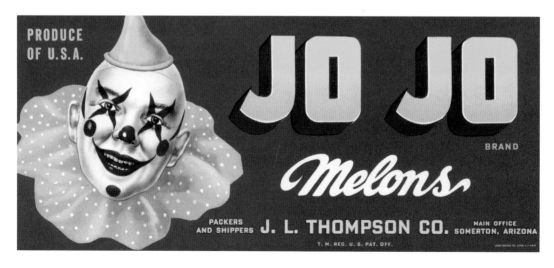

FRESH
Popcorn

JUMBO

POP & CORN

A WONDERFUL Treat

crisp delicious

POP CORN

NO. IE SIZE
INGREDIENTS
popcorn, salt, edible oil
VOLUME 52 CU. IN.

Party pamphlet, 1940s
Partybroschüre, 1940er Jahre
Prospectus, années 40

AMERICA'S CLOWNS

AMERIKAS CLOWNS / LES CLOWNS D'AMÉRIQUE

George Adams
Felix Adler
Amelia Adler
Jack Albin
Bill Alcott
"Prince Paul" Alpert
Dukey Anderson
Bumpsy Anthony
George Anthony
Mark Anthony
Jimmy Armstrong
Bill Bailey
Bill Ballantine
George Barnaby
Jorge Barreda
Roy Barrett
Billy Barty
Harry Bayfield
Larry Benner
Arthur Borello
Ted Bowman
Roy Brown
Roy "Cooky" Brown
Ernie "Blinko" Burch
Don Burda
Eddie Buresh
Billie Burke
Chuck Burnes
Frank Cain
Joe Carbone
Chucko the Birthday
 Clown
Johnny Cicillino
Slim Collins
Pinto Colvig
Pete Conklin

Harold Conn
Art Cooksey
Jackie Cooper
Ray Cosmo
Joe Coyle
Clarence Cummings
Lawrence Cross
Harry Dann
Dick David
Jimmy Davidson
Gabby De Kos
Eddie Dellum
Eddie De Rue
Lazlo Donnert
Marcos Droguett
John Durang
Adam Forepaugh
Freddie Freeman
Anthony Galkowski
Al Gaston
Georgetti Bros.
Jackie Gerlich
Abe Goldstein
Del Graham Jr.
Edwin F. Green
Otto Griebling
Billy Griffin
Brownie Gudath
Walter Guice
Harold Hall
Edwin Hanneford
Bozo Harrell
Jack Harrison
Clem Hartman
Huffey Hoffman
Arne Honkola

Jim Howle
Joe Jackson
Lou Jacobs
Aye Jaye
Paul Jerome
Ab Johnson
Dick Johnson
Spader Johnson
Toby Jorio
Paul Jung
Bobby Kay
Paul Kaye
Bob Keeshan
Bob Kellogg
Happy Kellums
Emmett Kelly
Bernie Klima
Mike Klucker
Happy Knapp
Bruce LaFarra
Horace Laird
Bluch Landolf
Jack Landrus
Ruby Landrus
Harry Langdon
William Langer
David Larible
Art LaRue
George LaSalle
Ernie Lauterman
Freddie La Vine
Jackie LeClaire
Gene "Cousin Otto" Lee
Charlie Lewis
Dick Lewis
Gene Lewis

Joe Lewis
Glen "Frosty" Little
Dale Longmire
Billy Lorette
Locke Lorraine
Barry Lubin
Frank Luley
Carl Marx
Leon "Buttons" McBryde
John McKay
Owen McQuade
Paul "Chesty" Mortier
Alfonato Naite
Joe Nawrath
Paul W. Neibaur
Harry Nelson
Buck Nolen
Novelle Bros.
Myron Orton
Max Patkin
Bobby Peck
Javier Peluga
Michael "Coco" Polakov
Buzzie Potts
Squeezebox Raimer
Gene Randow
Charles Raniner
Ed Raymond
John Reilly
Mel Rennick
Dan Rice
Charlie Rivel
Carl Romig
Irvin Romig
Al Ross
Smokey Rouse

Frankie Saluto
William K. Schultz
Chester Sherman
Joe Sherman
Earl Shipley
Harold Simmons
Ray Sinclair
Tommy Sink
Red Skelton
Steve "T.J. Tatters" Smith
Jose G. Solares
James Spriggs
Carl Stephan
Dennis Stevens
Glen Sunbury
Shorty Sylvester
Jimmy Thomas
John Thomson
Duane "Uncle Soapy"
 Thorpe
Tim Torkildson
John Tripp
Pat Valdo
Lou Walton
Billy Ward
Joe E. Ward
Vern Warner
Horace Webb
Paul Wentzel
Albert White
Tommy Whiteside
Jack Willett
Peggy Williams
Connie Wilson
Dime Wilson
Ernie Wiswell

▶ Color portrait of Paul Jung by George Karger, photograph, 1949
Paul Jung, in Farbe porträtiert von George Karger, Fotografie, 1949
Portrait en couleurs de Paul Jung par George Karger, photographie, 1949

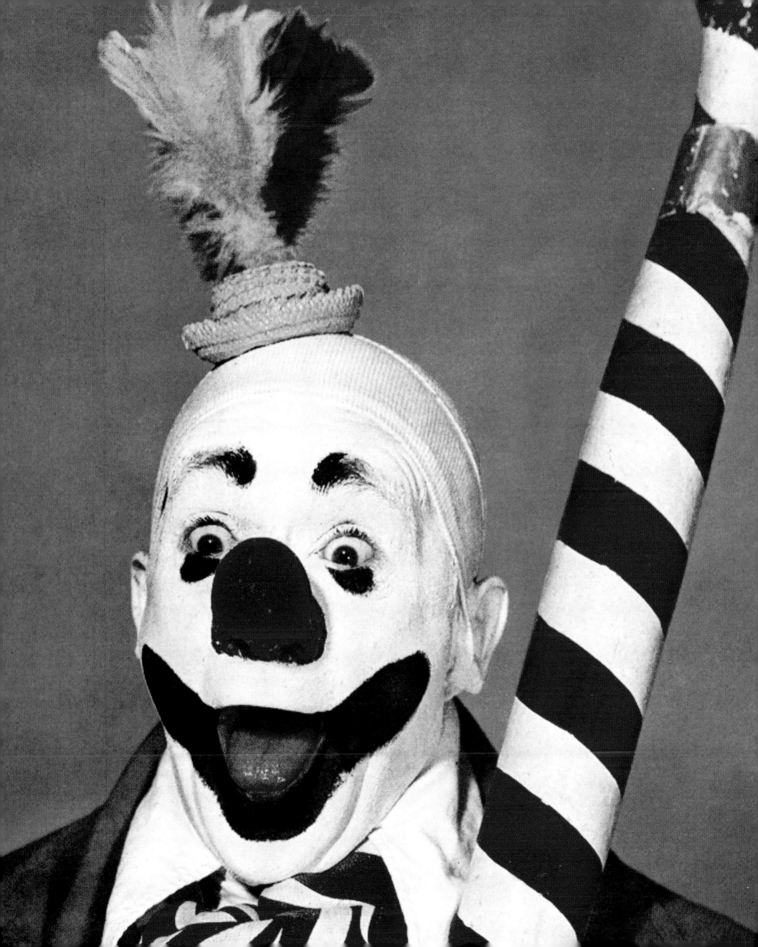

CLOWNS IN MOVIES

FILMCLOWNS / LES CLOWNS AU CINÉMA

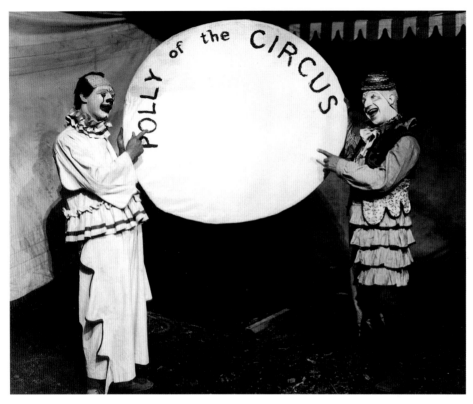

Silent film, *Polly of the Circus*, publicity photograph, 1917
Stummfilm *Polly of the Circus*, Werbefoto, 1917
Photographie publicitaire du film muet *Polly of the Circus*, 1917

Polly of the Circus, 1917 (Mae Marsh)

Circus Clowns, 1922 (Baby Peggy)

He Who Gets Slapped, 1924 (Lon Chaney, Norma Shearer, John Gilbert)

The Sideshow of Life, 1924 (Ernest Torrence)

Laugh, Clown, Laugh, 1928 (Lon Chaney)

The Circus, 1928 (Charlie Chaplin)

Dangerous Curves, 1929 (Clara Bow)

Freaks, 1932

The Big Cage, 1933 (Clyde Beatty)

I'm No Angel, 1933 (Mae West, Cary Grant)

Hell in a Circus, 1933

The Circus Clown, 1934 (Joe E. Brown)

Babes in Toyland, 1934 (Stan Laurel, Oliver Hardy)

Our Little Girl, 1935 (Shirley Temple, Joel McCrea)

The Great Ziegfeld, 1936 (William Powell, Myrna Loy, Fanny Brice)

Charlie Chan at the Circus, 1936 (Warner Oland)

At the Circus, 1939 (Marx Brothers, Margaret Dumont)

The Night of Nights, 1939 (Pat O'Brien)

Alias Boston Blackie, 1942 (Pat Lane, Larry Parks, Billy Lally)

Lady in the Dark, 1944 (Ginger Rogers, Ray Milland)

Till the Clouds Roll By, 1946 (Judy Garland)

Easter Parade, 1948 (Judy Garland, Fred Astaire)

Nancy Goes to Rio, 1950 (Carmen Miranda)

The Fat Man, 1951 (Julie London, Emmett Kelly, Rock Hudson)

Bronco Buster, 1952 (Chill Wills as a rodeo clown)

Limelight, 1952 (Charlie Chaplin, Buster Keaton)

The Greatest Show on Earth, 1952 (Jimmy Stewart, Charlton Heston, Cornel Wilde, Betty Hutton)

The Clown, 1953 (Red Skelton, Billy Barty)

Abbott & Costello Go to Mars, 1953

Circus Girl, 1953 (Kristina Söderbaum, Willy Birgel)

3 Ring Circus, 1954 (Dean Martin, Jerry Lewis)

La Strada, 1954 (Anthony Quinn, Giulietta Masina)

So This Is Paris, 1955 (Tony Curtis, Gloria De Haven, Gene Nelson)

Trapeze, 1956 (Burt Lancaster, Gina Lollobrigida, Tony Curtis)

Man of a Thousand Faces, 1957 (James Cagney, Jim Backus, Dorothy Malone)

The Joker Is Wild, 1957 (Frank Sinatra)

Circus Boy, 1958 (Mickey Dolenz, Noah Beery, Jr.)

The Big Circus, 1959 (Red Buttons, Dave Nelson, Victor Mature, Rhonda Fleming, Vincent Price, Peter Lorre, Gilbert Roland)

Circus of Horrors, 1960

Toby Tyler, 1960 (Kevin Corcoran)

The Clown and the Kid, 1961 (John Lupton, Mike McGreevey, Don Keefer)

Billy Rose's Jumbo, 1962 (Martha Raye, Doris Day, Jimmy Durante, Billy Rose)

The Main Attraction, 1962 (Nancy Kwan, Pat Boone)

Trials of O'Brien, 1965 (Milton Berle)

Circus World, 1964 (John Wayne, Claudia Cardinale, Rita Hayworth)

A Thousand Clowns, 1965 (Jason Robards)

She Freak, 1967 (Claire Brennen)

Berserk, 1968 (Joan Crawford)

The Comic, 1969 (Dick Van Dyke, Mickey Rooney)

Clown Face, 1971 (Charles and Ray Eames)

The Day the Clown Cried, 1972 (Jerry Lewis)

To Kill a Clown, 1972 (Alan Alda)

The Tin Drum, 1979

Carny, 1980 (Robbie Robertson, Gary Busey, Jodie Foster)

Leave Them Laughing, 1981 (Mickey Rooney)

The Clown Murders, 1985 (John Candy)

Killer Klowns from Outer Space, 1988

Big Top Pee-wee, 1988 (Pee-wee Herman)

Her Alibi, 1989 (Tom Selleck, Paulina Porizkova)

Pink Cadillac, 1989 (Clint Eastwood)

Quick Change, 1990 (Bill Murray, Geena Davis)

Shakes the Clown, 1992 (Bob Goldthwait)

Patch Adams, 1998 (Robin Williams)

House of 1000 Corpses, 2002

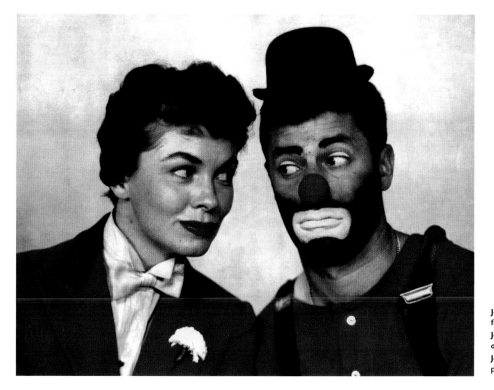

Jerry Lewis and Joanne Dru in *3 Ring Circus*, film still, 1954
Jerry Lewis und Joanne Dru in dem Film *Im Zirkus der drei Manegen (3 Ring Circus)*, Standfoto, 1954
Jerry Lewis et Joanne Dru dans *Le Clown est roi*, photo du film, 1954

CLOWN CODE OF ETHICS

1. I will keep my acts, performance, and behavior in good taste while I am in costume and makeup. I will remember at all times that I have been accepted as a member of the clown club only to provide others, principally children, with clean, clown, comedy entertainment. I will remember that a good clown entertains others by making fun of himself or herself and not at the expense or embarrassment of others.

2. I will learn to apply my makeup in a professional manner. I will provide my own costume. I will carry out my appearance and assignment for the entertainment of others and not for personal gain or personal publicity when performing for either the International club or alley* events. I will always try to remain anonymous while in makeup and costume as a clown, though there may be circumstances when it is not reasonably possible to do so.

3. I will neither drink alcoholic beverages nor smoke while in makeup or clown costume. Also, I will not drink alcoholic beverages prior to any clown appearances. I will conduct myself as a gentleman/lady, never interfering with other acts, events, spectators, or individuals. I will not become involved in or tolerate sexual harassment or discrimination on the basis of race, color, religion, sex, national origin, age, disability, or any protected status.

4. I will remove my makeup and change into my street clothes as soon as possible following my appearance, so that I cannot be associated with an incident that may be detrimental to the good name of clowning. I will conduct myself as a gentleman/lady at all times.

5. While appearing in makeup and costume, I will carry out the directives of the producer or his designated deputies. I will abide by all performance rules without complaint in public.

6. I will do my very best to maintain the best clown standards of makeup, costuming, properties, and comedy.

7. I will appear in as many clown shows as I possibly can.

8. I will be committed to providing an atmosphere free of discrimination and harassment for clowns of all ages to share ideas and learn about the art of clowning.

* Clown alley is the common name for the area outside the circus tent where clowns congregate.

▶ Circus Clown Club of America insignia, 1960s
Stempel der Vereinigung Circus Clown Club of America, 1960er Jahre
Insigne du Club des Clowns de Cirque d'Amérique, années 60

DER VERHALTENSKODEX DER CLOWNS

1. Solange ich Kostüm und Schminke trage, folgen meine Nummern, Darbietungen und mein Verhalten den Regeln des guten Geschmacks. Ich vergesse zu keinem Zeitpunkt, dass ich in die Vereinigung der Clowns allein zu dem Zweck aufgenommen wurde, anderen, vorwiegend Kindern, saubere, lustige, clowngemäße Unterhaltung zu bieten. Ich bin mir bewusst, dass ein guter Clown andere dadurch unterhält, dass er sich selbst zum Narren hält und seine Witze nicht auf Kosten anderer macht.

2. Ich verpflichte mich, das professionelle Auftragen der Maske zu erlernen. Ich stelle selbst ein Kostüm zur Verfügung. Ich spiele meine Rolle zum Zweck der Unterhaltung anderer und nicht zur persönlichen Bereicherung oder zur Steigerung des eigenen Ansehens, wenn ich im International Club oder bei Gassenveranstaltungen* auftrete. Ich bemühe mich stets darum, anonym zu bleiben, solange ich Kostüm und Schminke trage. Ausnahmen sind möglich, da Situationen auftreten können, in denen dies nicht durchführbar ist.

3. Solange ich Kostüm und Schminke trage, trinke ich keine alkoholischen Getränke und rauche nicht. Auch vor einem Auftritt als Clown trinke ich keine alkoholischen Getränke. Ich verhalte mich höflich und zurückhaltend und störe andere Nummern, Vorführungen, Zuschauer oder Personen nicht. Ich verpflichte mich, keine sexuelle Belästigung selbst auszuführen oder zu dulden und niemanden aufgrund von Rasse, Hautfarbe, Religion, Geschlecht, Herkunft, Alter, Behinderung oder einem anderen schützenswerten Status zu diskriminieren.

4. Nach meinem Auftritt entledige ich mich so schnell wie möglich der Schminke und des Kostüms, damit es nicht zu Vorfällen kommen kann, die dem guten Ruf der Clownerie abträglich sein könnten. Ich verhalte mich stets wie ein Gentleman bzw. wie eine Dame.

5. Ich erkläre mich bereit, allen Anweisungen des Produzenten bzw. seiner Beauftragten nachzukommen, solange ich Kostüm und Schminke trage. Ich werde mich an alle Regeln der Aufführung halten, ohne öffentlich Beschwerde dagegen einzulegen.

6. Ich werde alles in meiner Macht Stehende tun, um den höchsten Ansprüchen an einen Clown hinsichtlich Schminke, Kostümierung, Requisiten und Komödie zu genügen.

7. Ich verpflichte mich zum möglichst häufigen Auftreten als Clown.

8. Ich setze mich für die Schaffung einer Atmosphäre ein, in der Clowns aller Altersstufen ohne Diskriminierung und Belästigung frei Ideen austauschen und die Kunst der Clownerie erlernen können.

* Die „Clownsgasse" ist der Insiderbegriff für eine Stelle außerhalb des Zirkuszelts, an der die Clowns sich treffen.

▶ Classic clown decal, Coney Island, 1940s
Klassischer Clownaufkleber, Coney Island, 1940er Jahre
Clown, décalcomanie, Coney Island, années 40

CODE DE DÉONTOLOGIE DU CLOWN

1. Je garderai une attitude correcte dans mes numéros, mon spectacle et mon comportement lorsque je serai en costume et maquillé. Je n'oublierai jamais que j'ai été accepté comme membre du club des clowns dans le seul but d'amuser les autres, en particulier les enfants, en leur offrant un spectacle décent de comédie clownesque.

2. J'apprendrai à me maquiller de manière professionnelle. J'aurai mon propre costume. Je ferai mon numéro dans le but d'amuser les autres et non pas par gain personnel ou pour ma propre publicité, que ce soit pour le Club International ou dans l'allée*. Je ferai de mon mieux pour préserver mon anonymat lorsque je serai costumé et maquillé en clown, bien qu'il puisse y avoir des raisons pour lesquelles cela ne soit pas toujours possible.

3. Je ne consommerai jamais de boissons alcoolisées ni ne fumerai costumé et maquillé en clown. De surcroît, je ne boirai jamais de boissons alcoolisées avant une représentation. Je me comporterai en personne bien élevée, je ne perturberai jamais les numéros des autres, les manifestations, les spectateurs ou les personnes. Je ne participerai ni ne tolérerai le harcèlement sexuel ou la discrimination fondée sur la race, la couleur, la religion, le sexe, la nationalité, l'âge, le handicap ou n'importe quel statut protégé.

4. Je me démaquillerai et passerai mes vêtements de ville le plus rapidement possible après ma représentation, pour éviter d'être mêlé à des incidents qui pourraient entacher la réputation des clowns. Je me conduirai correctement en toutes occasions.

5. Lors d'une représentation en costume et maquillage, je suivrai les directives du producteur ou celles de ses représentants. Je me conformerai à toutes les règles du spectacle sans me plaindre en public.

6. Je ferai tout mon possible pour maintenir les meilleures pratiques de la profession dans le maquillage, le costume, les attributs et la comédie du clown.

7. Je me produirai dans autant de spectacles de clown qu'il me sera possible.

8. Je m'engage à créer une ambiance dénuée de toute discrimination et d'agressivité pour que les clowns de tous âges puissent échanger des idées et apprendre l'art de la clownerie.

* L'allée des clowns est le nom habituel de l'endroit en dehors du chapiteau, là où les clowns se retrouvent entre eux.

▶ Travel club decals, 1950s
Aufkleber eines Reiseclubs, 1950
Décalcomanies d'un club de voyages, 1950

ACKNOWLEDGEMENTS

Special thanks to my friend, Jim Heimann, for shepherding this project through the maze with humor and expertise. The endearing moniker "Faulpelz" definitely does not apply. Extra special thanks to Cindy Vance for her infinite patience and dedication to producing a truly enormous amount of work of the highest quality and thoughtfulness. Most grateful appreciation to Robert Berman (and his assistant, Julie Dickover) for his generosity in lending photos and artwork from his vast clown collection. This book wouldn't have been the same without them. His collection of paintings are showcased in the book *Clown Paintings* by Diane Keaton. Thanks to Nina Wiener for fine-tuning and juggling this project among all the other plates she keeps spinning with help from fact-checkers Danielle Hylton, Kate Soto, and Tarra Stevenson.

Gratitude and thanks to my friend, Brad Benedict – collector, recluse, troglodyte – for use of his images, especially the gift of the incredible color photo of Jimmy Stewart, and to Brian Zick, who helped get them to me. Recognition and thanks to Ray Kadlec and Roberta's Circus Archives for use of the photos. Thanks to Laura Smith and Michael Doret for their midget clowns snapshot; to Fred Taraba at Illustration House, NYC; to Ralph Eubanks at the Library of Congress; to Eric Baker for encouragement; to Steven Vance for behind-the-scenes support; to Steve Fitch for sharing his artwork; to the Circus World Museum; and finally, to Max Kim-Bee, Mark Ryden, and Kate Turning for wanting to share their images

IMAGE CREDITS

Brad Benedict: pp. 178–179. Robert Berman Gallery: pp. 31, 46, 47 (top right), 48, 49, 52, 58, 59, 70, 81, 117 (bottom right), 118, 155, 159–73, 177, 180–84. Steve Fitch © 1973: p. 65. Illustration House: Page 152. Movie Star News: p. 106. Roberta's Circus: pp. 70, 96, 109, 280. Laura Smith and Michael Doret: p. 68.

Every effort has been made to name the clowns in this book; however, many remain anonymous. Identifications for future editions would be most appreciated. All images are from the H. Thomas Steele collection unless otherwise noted. Any omissions are unintentional and appropriate credit will be given in future editions if any holders of copyright contact the publisher.

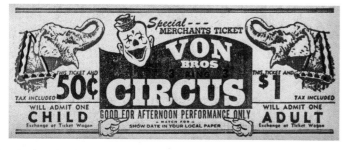

Circus ticket, 1950s
Eintrittskarte für den Zirkus, 1950er Jahre
Ticket de cirque, années 50

► Clown salute, snapshot, 1920s
Clownsgruß, Schnappschuss, 1920er Jahre
Salut de clown, instantané, années 20

"The most exquisite books on the planet."

—Wallpaper, London

1000 FAMILIES
Uwe Ommer / Hardcover, format: 19.6 x 25 cm
(7.7 x 9.8 in.), 576 pp.
€ 19.99 / $ 29.99 / £ 14.99 / ¥ 3.900

1000 SIGNS
Ed. Colors Magazine / Flexi-cover, Klotz, format:
14 x 19.5 cm (5.5 x 7.7 in.), 512 pp.
€ 19.99 / $ 29.99 / £ 14.99 / ¥ 3.900

ALL-AMERICAN ADS OF THE 20s
Steven Heller / Ed. Jim Heimann / Flexi-cover,
format: 19.6 x 25.5 cm (7.7 x 10 in.), 640 pp. /
€ 29.99 / $ 39.99 / £ 19.99 / ¥ 5.900

ALL-AMERICAN ADS OF THE 30s
Steven Heller / Ed. Jim Heimann / Flexi-cover,
format: 19.6 x 25.5 cm (7.7 x 10 in.), 768 pp. /
€ 29.99 / $ 39.99 / £ 19.99 / ¥ 5.900

ALL-AMERICAN ADS OF THE 40s
W. R. Wilkerson III / Ed. Jim Heimann / Flexi-cover,
format: 19.6 x 25.5 cm (7.7 x 10 in.), 768 pp. /
€ 29.99 / $ 39.99 / £ 19.99 / ¥ 5.900

ALL-AMERICAN ADS OF THE 50s
Ed. Jim Heimann / Flexi-cover, format:
19.6 x 25.5 cm (7.7 x 10 in.), 928 pp. /
€ 29.99 / $ 39.99 / £ 19.99 / ¥ 5.900

ALL-AMERICAN ADS OF THE 60s
Steven Heller / Ed. Jim Heimann / Flexi-cover,
format: 19.6 x 25.5 cm (7.7 x 10 in.), 960 pp. /
€ 29.99 / $ 39.99 / £ 19.99 / ¥ 5.900

ALL-AMERICAN ADS OF THE 70s
Steven Heller / Ed. Jim Heimann / Flexi-cover, format:
19.6 x 25.5 cm (7.7 x 10 in.), 704 pp. /
€ 29.99 / $ 39.99 / £ 19.99 / ¥ 5.900

"This was advertising as an art in its own right, not the plagiarising magpie industry of today. And its ceaseless sunny optimism in the face of adversity is something from which we jaded cynics could learn."
—World of Interiors, London

THE LEARNING CENTRE
TOWER HAMLETS COLLEGE
POPLAR CENTRE
POPLAR HIGH STREET
LONDON E14 0AF

www.taschen.com

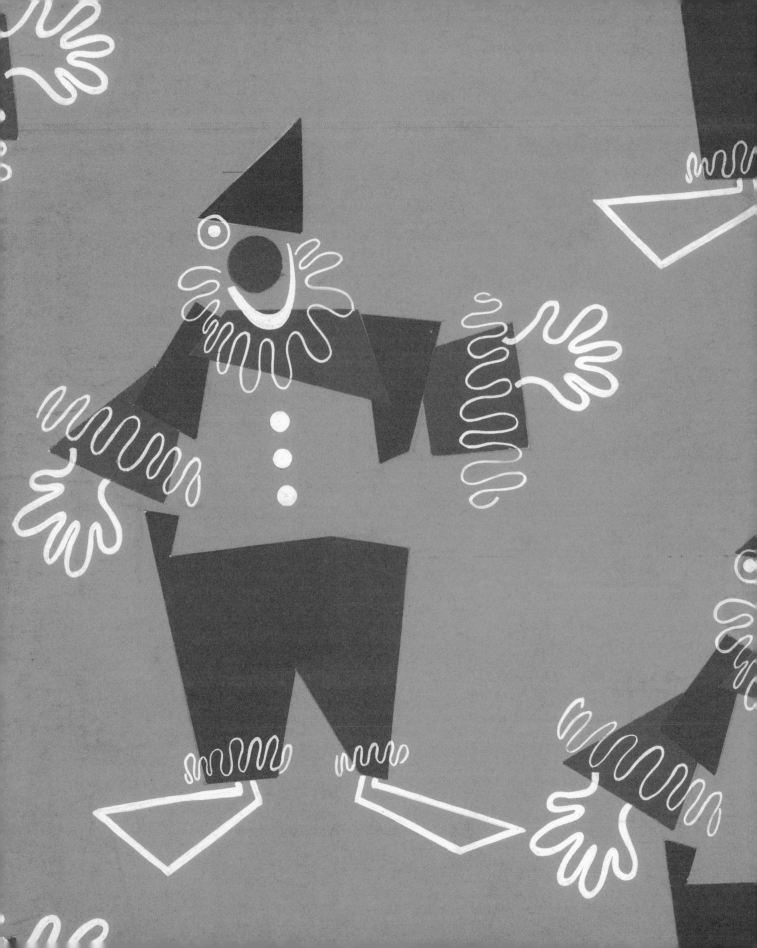